IMAGES
of America

NASHVILLE'S
INGLEWOOD

ON THE COVER: BOYS ON BICYCLES AT HOWARD AVENUE. This photograph shows a group of boys sitting on their bikes in front of the Karsch family home at 1300 Howard Avenue in the 1930s. This is one of several photographs appearing in the book that were recovered from the attic of the Karsch family home by the home's new owners, who generously donated the pictures to this project. Howard Avenue is one of the original streets that formed Inglewood Place, the subdivision that gave Inglewood its name. (Holly Barnett.)

IMAGES
of America

NASHVILLE'S INGLEWOOD

Crystal Hill Jones, Naomi C. Manning,
and Melanie J. Meadows

ARCADIA
PUBLISHING

Copyright © 2009 by Crystal Hill Jones, Naomi C. Manning, and Melanie J. Meadows
ISBN 978-1-5316-4493-2

Published by Arcadia Publishing
Charleston, South Carolina

Library of Congress Control Number: 2008937076

For all general information contact Arcadia Publishing at:
Telephone 843-853-2070
Fax 843-853-0044
E-mail sales@arcadiapublishing.com
For customer service and orders:
Toll-Free 1-888-313-2665

Visit us on the Internet at www.arcadiapublishing.com

To the people of Inglewood who have enriched my life with their
stories and histories told to me largely at Riverside Pharmacy's
fountain, and to my father, known to the community as
Doc Jones, who taught me to appreciate true characters and
whose generosity to the people of Inglewood opened many
doors for me while compiling information for this book.
—C. J.

This book is for my mother, who taught me the value of
knowing my heritage, and for the residents of Inglewood.
—M. M.

To my family: Mary, Erica, Jonah, Louise, Matt, Paul, Anna,
Brent, Fallyn, Natalie, and Olivia, and to God, who led me
to Inglewood in 1975. Special thanks to Maggie Bullwinkel
from Arcadia Publishing for prodding to write this book.
—N. M.

CONTENTS

Acknowledgments 6

Introduction 7

1. Before Inglewood 9

2. A Place to Call Home 39

3. Community Life 69

4. Isaac Litton High School 97

5. Inglewood Today 123

Bibliography 127

ACKNOWLEDGMENTS

The following people made an invaluable contribution to this book by sharing time, resources, stories, and whenever possible, photographs: Holly Barnett, Tom and Nan Garrett Batey, Jeanette Boleyjack Bean, Billy Benz, Jan Brooks, Aaron Brown, Ann Brush, Martha Ann Caldwell, Susan Craft, Laura Drake, Diane Easterling, Bill Emery, Inez Garner, Patricia Harris, Dan Heller, Joe Herndon, Pudge High, James Hoobler, Jim Howell, Bill Hunt, Ida May Infanti, Beatrice Jones, Ann Luna, David Luna, Mike Malone, Patsy McCullough, Jack McMahan, Jane Clark Mills, Adam Myer, Nancy Nabor, Betty Odom, Joyce Patton, Curt Porter, Ted Ridings, Roy Mack and Bettye Shacklett, Tom Sharp, Jerry Simpson, Wayne and Judy Smith, Carolyn Warren, Hope Welch, JudyMac Wherry Reinhard, Mary Elizabeth Womack, and Mary Bates Woods.

We express our appreciation to the families who created the history in Inglewood—Cannons, Burches, Coopers, Warrens, Ellises, Bates, Malones, Sofges, Hendersons, and hundreds more. Thanks to Carol Roberts and the staff of the Tennessee State Library and Archives and to Ken Fieth and Debie Cox of Metro Archives.

Unless otherwise attributed, the images in this volume appear courtesy of Metro Nashville Archives (MNA), Tennessee State Library and Archives (TSLA), Holly Barnett (HB), Garrett and Batey families (GBF), Jeanette Boleyjack Bean (JBB), C. Beverly Briley family (CBBF), the Burch family (BF), the Hassell Brush family (HBF), the Raymond Cannon family (RCF), Larry Collier and Sammy Swor family (LC), the Ellis family (EF), Ceacy Henderson Hailey (CHH), the Maude Robinson Hopkins (MRH), Jim Howell (JH), Bill Hunt (BH), the Charles Jones family (CJF), Mike Malone (MM), Jane Clark Mills (JCM), the Lloyd Warren family (LWF), Inglewood Baptist Church (IBC), Jackson Park Church of Christ (JPCC). If no photograph credit is given, the image is provided courtesy of the authors.

We give special thanks to Victor Jordan, Larry Collier, Ceacy Hailey, and the Litton alumni for their wonderful stories; to Grace Hawkins, who connected us to many Litton graduates; and to Edith Caywood, for her wisdom and friendship—we will never forget her generosity and grace. Lastly, and most especially, thanks to Joe T. and Martha Ellis, who exemplify the true meaning of Inglewood—their stories illuminate these images, and we will never forget them.

INTRODUCTION

Between themselves, the authors have accumulated nearly a century of life in Inglewood. They can speak of the houses and people who have formed their memories of the neighborhood. They can also explain the wonders of the rolling hills, the variety of architectural styles, and the connection between the families who have lived here for generations. Whether one comes to Inglewood through birth or happenstance, the result is the same: a belief that one has come home. Families have made their homes here for more than a century, and the qualities that lured settlers in the 1700s are still attracting people today.

The first people to settle in Inglewood came about 1782. The town of Haysborough was chartered in 1799, and families have been coming home to Inglewood ever since. Inglewood is above all a friendly community that promotes stability and neighborliness. Tree-lined streets, expansive lawns, and an easy commute into the city combined to make the area a desirable place to call home. The three authors have seen many changes over the years. Gallatin Road became four lanes, Briley Parkway bisected the land to separate Inglewood from the Madison community, and the neighborhood has lost many of the original homes and business buildings to fire, neglect, and progress. Life became more hurried. Gone are the days of stay-at-home mothers, neighborhood schools, and shared community experiences as Nashville grew and became America's first city/county consolidated government.

Growth is often a two-edged sword. It means increased opportunities and more far-reaching experiences; it can also mean the loss of close community ties and continuity for citizens. The consolidated government brought the promise of increased services to the area, but it also ended many neighborhood traditions. The Inglewood Police and Fire Departments were no longer needed. Isaac Litton, the beloved local high school with its rich academic and athletic traditions, fell to the wayside as the era of large comprehensive high schools began. Neighborhood schools were challenged by the need to equalize and integrate schools. Local independent businesses closed as national chains moved closer. Finally, some of Inglewood's founding families moved to more distant suburbs, and other families were attracted by the newer homes and modern services offered in the newly developing parts of town.

In many ways, Inglewood's story parallels America's story of growth through the 20th century: sacrifice and determination through two world-wide conflicts, growing awareness and apprehension with the advent of the cold war, measured acceptance of the sweeping social and intellectual changes happening in the United States, and urban decline as the century drew to a close. Some cities and towns did not recover from their declines. This was not to be the fate of Inglewood. While never incorporating as a separate entity, Inglewood has survived as one of Nashville's strongest communities.

Perhaps it's just a swing of the pendulum, or just maybe it's a special type of kismet, but the magic of Inglewood remains today. The story is not done, merely transformed. The authors hope this book will serve to champion the renewal of a neighborhood and show the embodiment of

a new neighborhood spirit destined to carry Inglewood into the 21st century with aplomb. This book tells this story with text and photographs from the beginning through today. The authors have chosen some photographs from the collections of state and local archives; many more have been lovingly shared by some of Inglewood's families. The hope is to document the neighborhood's history for its longtime members while preserving memories for new generations. The authors believe this book will rekindle memories for the ones who have made their home in Inglewood for years and help the new transplants to understand what makes this such a cherished home. They also hope they can help readers understand why Inglewood continues to be a wonderful place to call home.

One

BEFORE INGLEWOOD

Following the Cumberland River and an old bison trail that would become Gallatin Pike, families came to this area seeking prosperity. It was a harrowing time for these early pioneers, as raids by Native Americans were always a threat. Many of the area's first settlers lost their lives, but others followed, because the land was worth the risk. This was especially true for the land that would become Inglewood. Due to the annual flooding of the Cumberland River, this land was incredibly fertile. Water, always essential to human life, was found here in abundance; not only did the river provide a wonderful source, but the first settlers would find numerous natural springs here as well. Many of these springs still flow in Inglewood today. These are the same springs that served the Native Americans who settled the area more than a thousand years ago. Spring Hill Cemetery is named for one of the most famous springs that form Love's Branch, where Haysborough would eventually be founded.

Most of the first settlers to the Inglewood area were land-grant holders who came here in the 1780s and were granted 640-acre tracts. These men were either given the land for their service during the Revolutionary War or had purchased the grants from veterans or speculators. Some of Inglewood's grant holders would leave their mark on Tennessee history, including William Cocke, whose land grant would later become part of the Haysborough settlement. Cocke would become one of Tennessee's first U.S. senators. There was also Ephraim McLean, who was granted land where Riverwood Farm would eventually exist. He would serve as the first treasurer for Davidson Academy, the first organized school in the Nashville area. The school eventually became Peabody College.

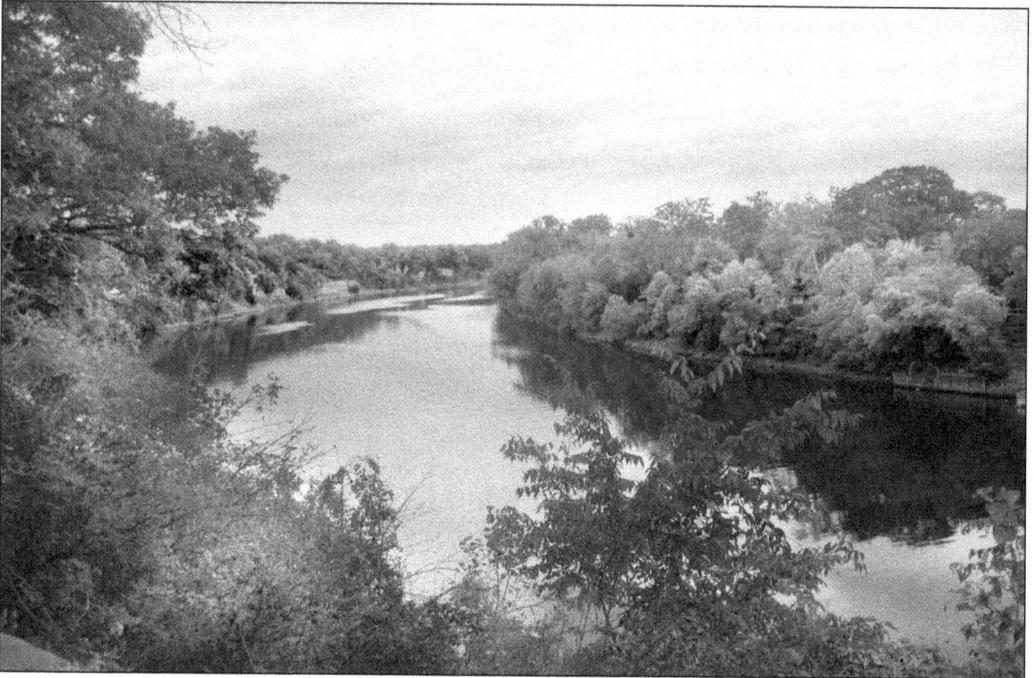

CUMBERLAND RIVER AT PENNINGTON BEND. Named for the Duke of Cumberland, the Cumberland River brought generations of families to the area that would become Inglewood. They came seeking opportunity and built their homes along the Cumberland in order to transport crops and goods. The river brought prosperity to the first settlers and still plays an important role in commerce today.

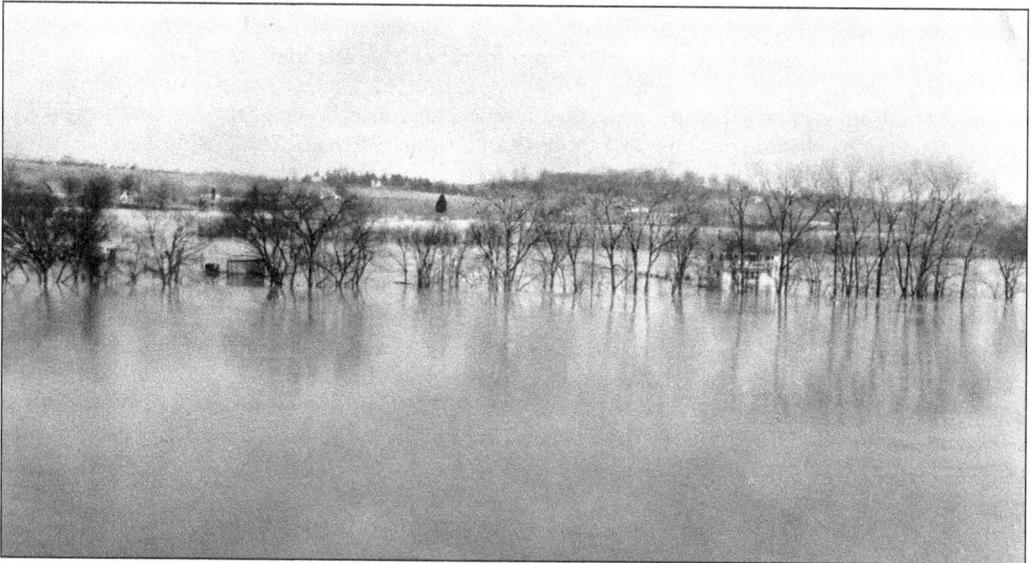

CUMBERLAND RIVER FLOODED AT CORNELIA FORT AIRPORT. Prior to the construction of the Tennessee Valley Authority (TVA) dams in the 1950s, the river flooded thousands of acres each year, creating some of the most fertile land in the country. Here in 1946, the river flooded Cornelia Fort Airport and parts of the Henderson farm, known as Wild Acres. (Harry J. Blazek Jr.)

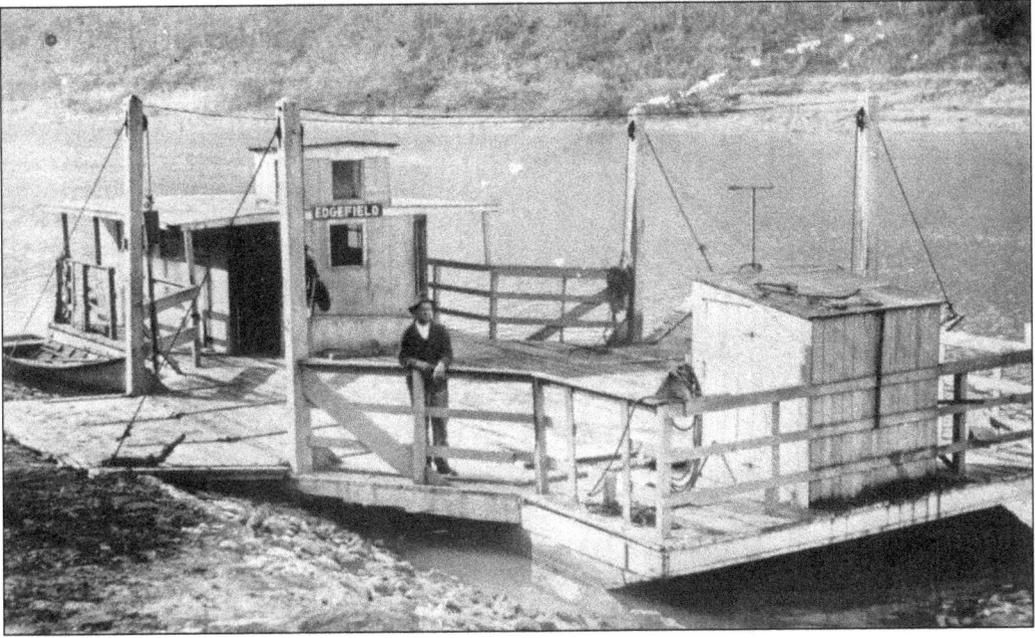

EDGEFIELD FERRY. Shortly after the settlers came to the area, ferries began crossing the Cumberland River. By the 1880s, ferries were running at the end of Maxey Lane (later called McGavock Pike). Operated by the Williamson family, the Edgefield ferry carried horses, cattle, people, and eventually up to three cars. The Karsch family of Inglewood walks along McGavock Pike near the ferry landing in the 1930s. (Above, MNA; below, HB.)

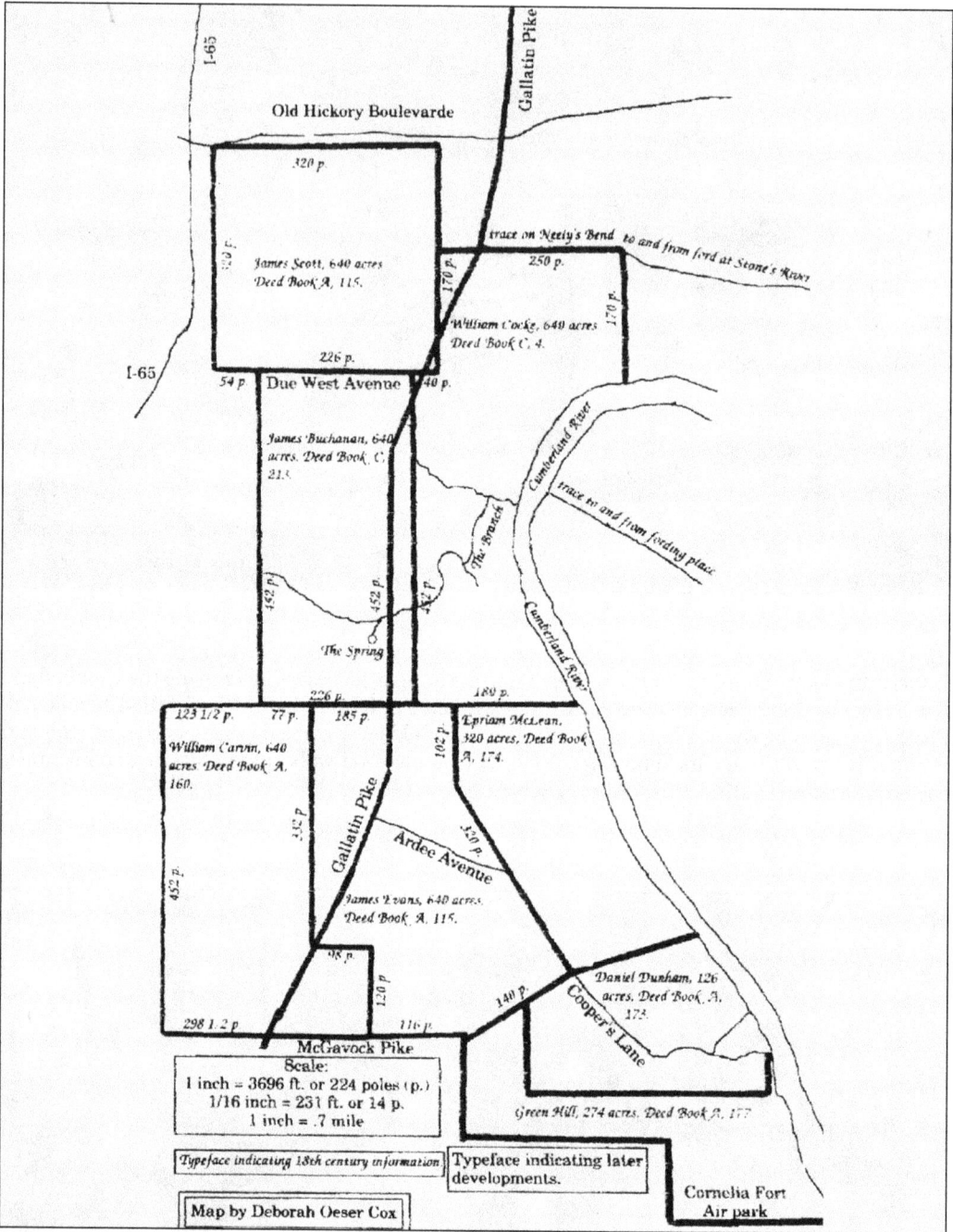

Preemptors Map. Early settlers, many of whom received land grants for their service during the Revolutionary War, cleared the massive forests around the river in order to reap the benefits of the fertile land. These settlers include John Evans, whose land grant was where much of present-day Inglewood is today; Ephraim McLean (McLean's Bend), the first treasurer for Davidson Academy, who cleared land where Riverwood mansion would eventually stand; and William Carvin, who would lose his life to Native Americans. (Deborah Oeser Cox.)

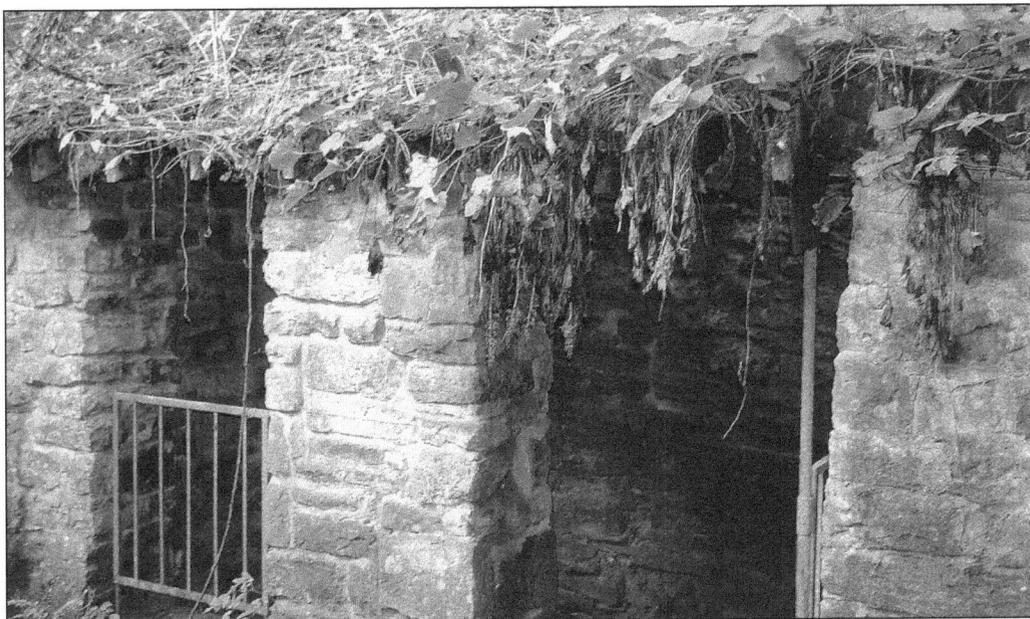

EVERGREEN PLACE SPRING HOUSE. In the early 1780s, several families came down the Cumberland and settled north of Nashborough beside the spring at Evergreen Place. This land was originally a preemptor grant to William Cocke of 640 acres on the north bank of the Cumberland River 6 miles north of Nashville. Cocke deeded it to Col. Robert Hays. Colonel Hays, a Revolutionary War hero, came to the Inglewood area around 1784. The town of Haysborough was named after him. (MNA.)

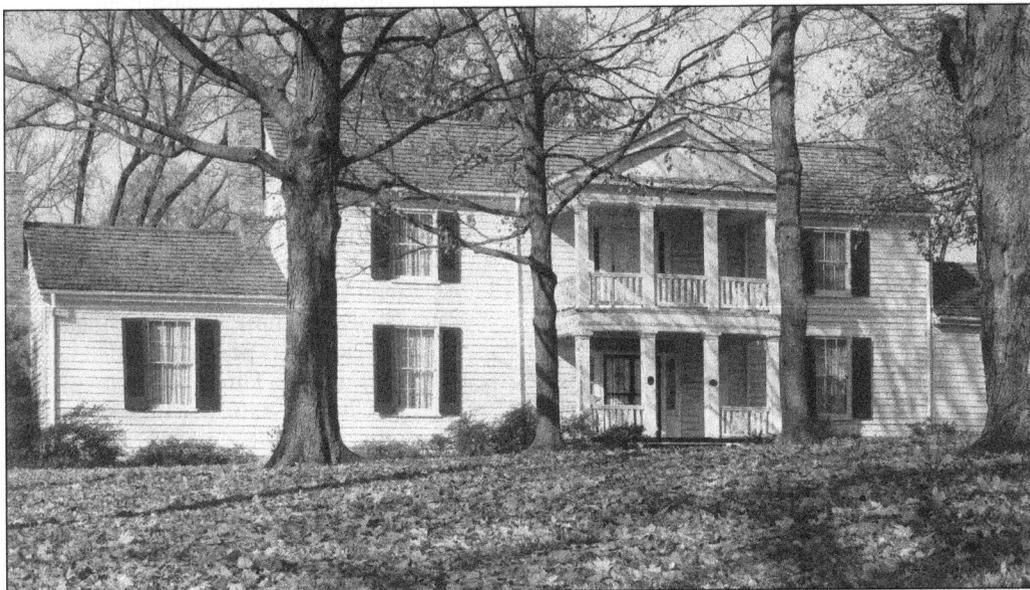

EVERGREEN PLACE. Torn down in 2005 to make way for a major retail building, Evergreen Place's original structure was built in 1795, making it one of Nashville's oldest homes. Situated on Gallatin Road at the border between Inglewood and Madison, the house was built by Rev. Thomas Craighead, who came to Haysborough to be the first preacher of the Spring Hill Presbyterian Church. He also taught at Davidson Academy. (MNA.)

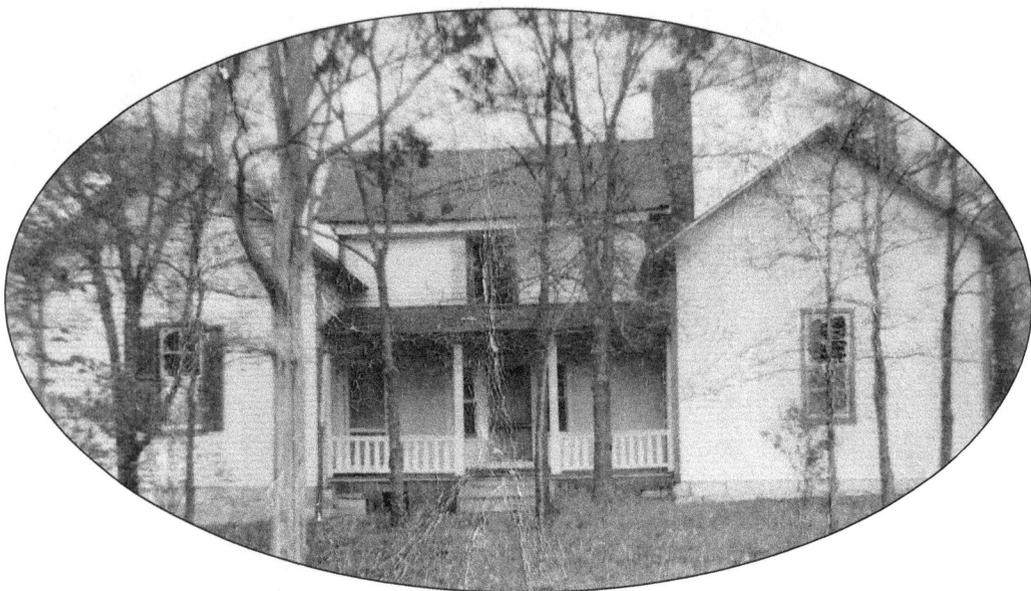

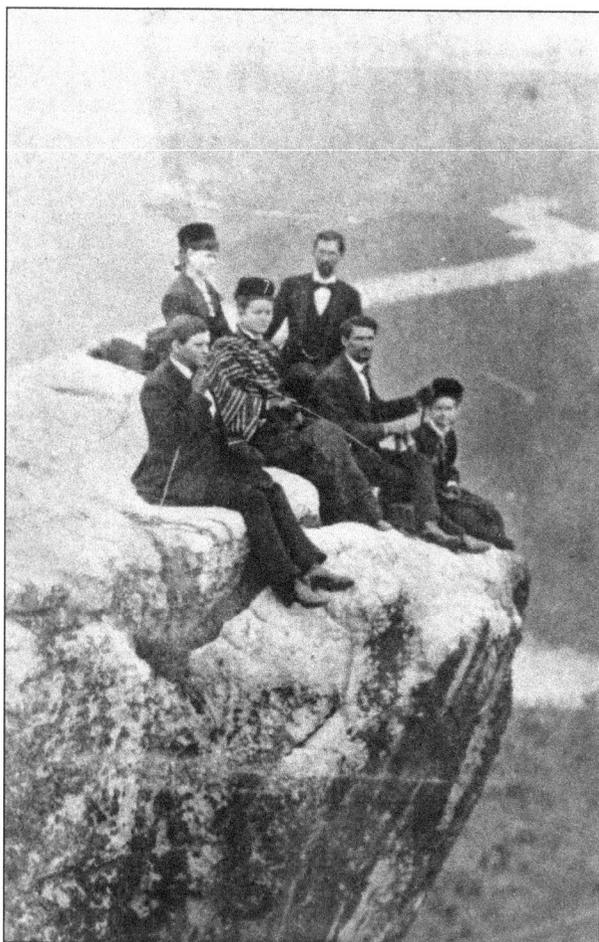

THE LOVE FAMILY OF INGLEWOOD.
By the 1830s, Haysborough was almost deserted. James T. Love bought the lots and surrounding farms as people moved. He used poplar and mahogany from these homes in his farmhouse, pictured above. His descendants A. J. and Marina McGaughey would inherit the Love farm and subdivide a piece of it in the 1920s for summer cottages on the river bluff. They called it Haysboro-on-the-Cumberland. The Love family is pictured at left in the 1870s at Lookout Mountain. The man standing is Exum Love, who owned the mill in Haysborough. The family is posing in the same spot where a famous photograph of Ulysses Grant was taken shortly after the Civil War. (Above, Wherry family; below, GBF.)

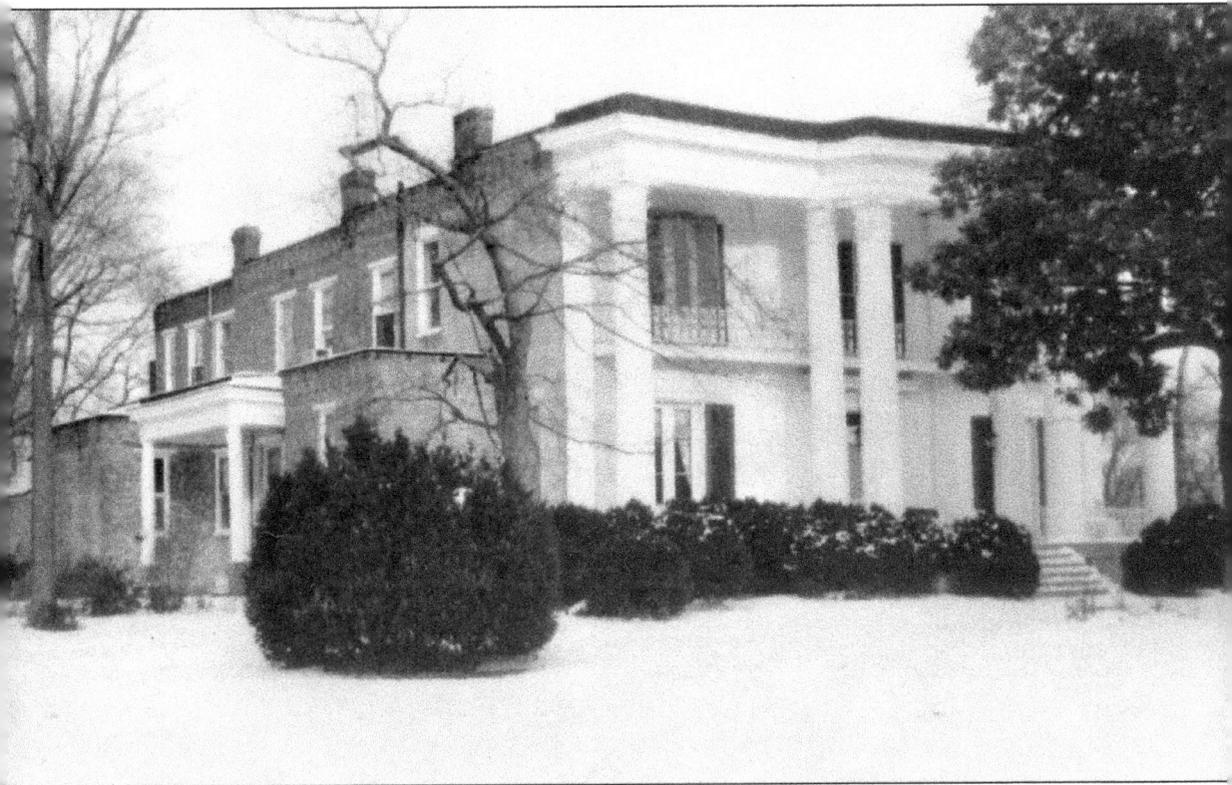

RIVERWOOD MANSION. Riverwood Mansion is one of the oldest homes in the Middle Tennessee area. Riverwood dates back to 1795, when Philip Philips, a wealthy land speculator, purchased the land from Ephraim McLean and built a brick two-story house near the river. The land remained in the family until 1820, when the property was sold to Dr. Boyd McNairy, who probably only used it as a weekend country retreat. In 1829, he sold the house and the surrounding 580 acres to Alexander Porter, a wealthy linen merchant. Alexander's grandson would transform what had been a modest Federal-style house into a stunning Greek Revival mansion with six large Corinthian columns and railings made of cast iron. Today Riverwood is a popular event venue with more than 10 acres of landscaped lawn and gardens surrounding the house. (BF.)

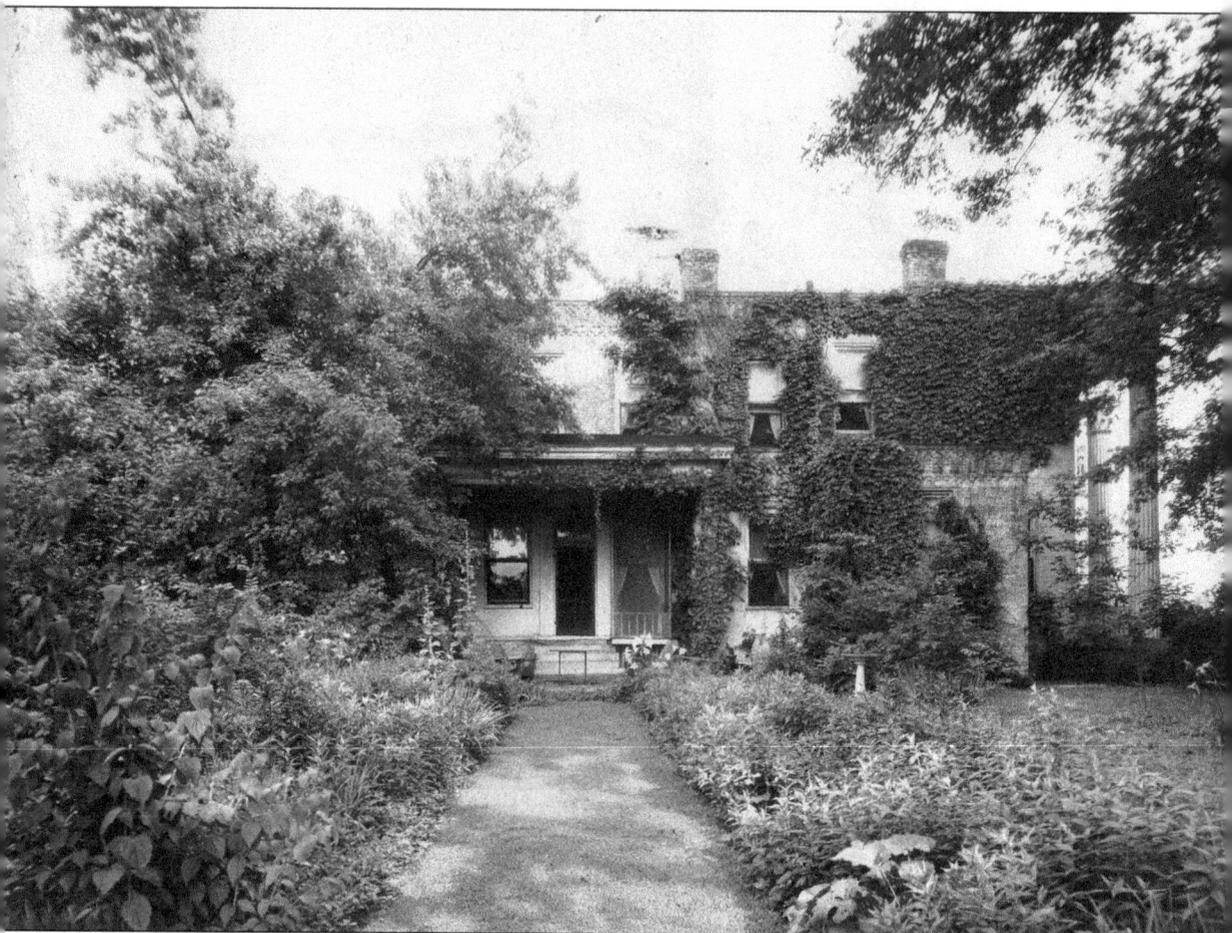

RIVERWOOD SIDE AND GARDEN VIEW. After Porter's death in 1833, his wife, Susan Porter, built a large home next to the original Philips home and named it Tammany Wood. It is believed that this side of Riverwood is the original structure built by Phillips facing the river. It was also during this time that the garden, said to be based on the gardens at the Hermitage, was planted. In the 1850s, the Porters' grandson Alexander Porter performed a massive renovation and combined the two homes. Porter Road in East Nashville is named for the Porter family, and the farm entrance was originally on this road near where Stratford High School is today. (Photograph by Wiles Photography; BF.)

THE GREY LADY. The Riverwood ghost, known as the Grey Lady, was often seen on the front portico and is thought to be Martha Watson Porter, the last Porter wife in the home. The Cooper-Burch family believes the Grey Lady might be a visitor to Riverwood who learned her intended had died in a logging accident. She died at Riverwood shortly after hearing the news, presumably of a broken heart. (TSLA.)

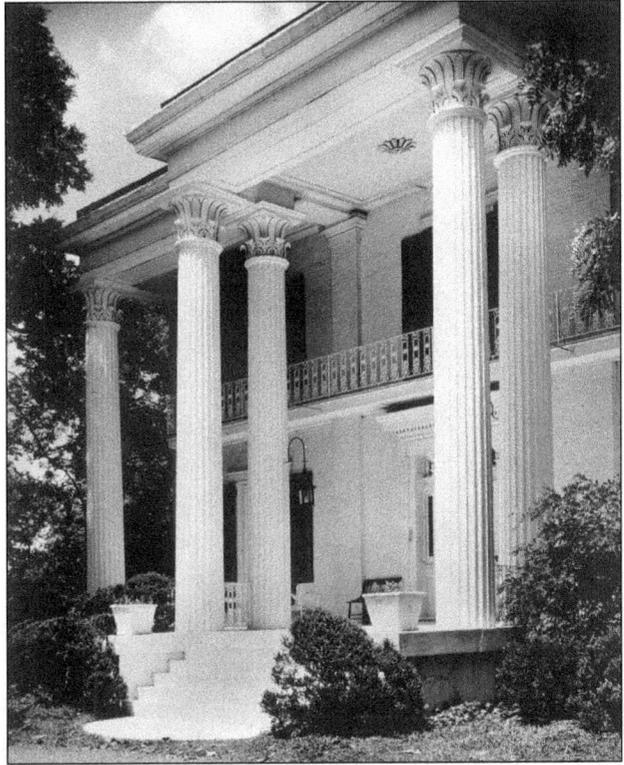

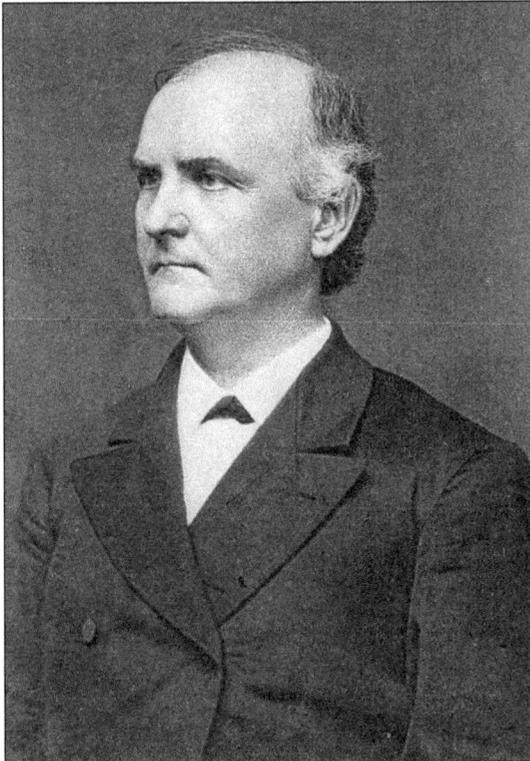

JUDGE WILLIAM FRIERSON COOPER. In 1859, Alexander Porter sold Tammany Wood to Judge William Frierson Cooper, a chief justice on the Tennessee Supreme Court. The Coopers originally came from South Carolina and settled in Haysborough. Judge Cooper was born in Franklin, Tenn., and graduated from Yale University. He bought Tammany Wood as a retreat and renamed it Riverwood after the beautiful Cumberland River and remaining forests. (TSLA.)

17

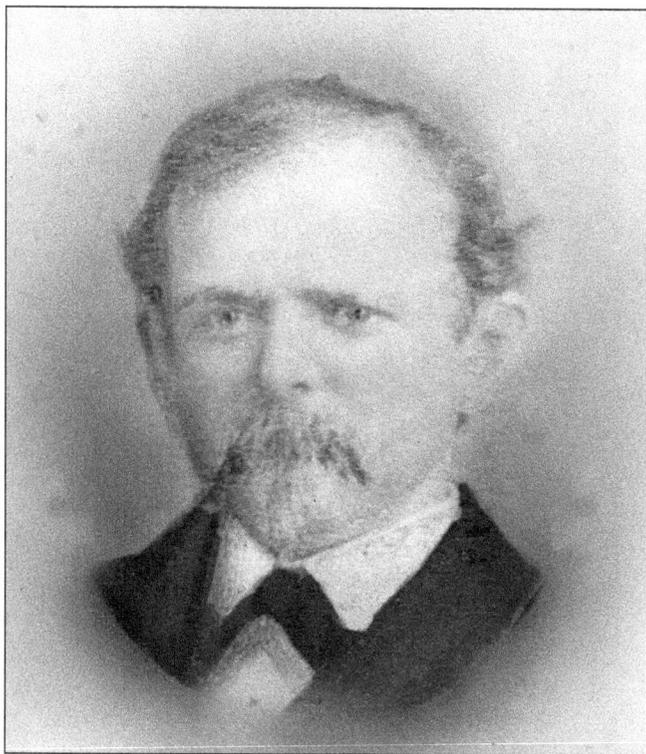

COL. DUNCAN COOPER.
According to the Burch family, when Judge Cooper died a bachelor in 1909, the land was divided into five lots; each heir drew for his lot. Col. Duncan Cooper drew the lot with Riverwood on it. Colonel Cooper was a Confederate War hero who left college early to join the Confederacy. He served as colonel of a regiment in Nathan Bedford Forrest's cavalry. Colonel Cooper would eventually serve in the Tennessee House and Senate and publish the *Nashville American*. He brought his family to Riverwood in 1909. (BF.)

MARY POLK JONES COOPER.
Mary Polk Jones Cooper was the second wife of Col. Duncan Cooper. Although she died 16 years before Colonel Cooper inherited Riverwood, her daughter would eventually own it. Mary Cooper was related to Capt. John Donelson, a founder of Nashville; Rachel Donelson Jackson, wife of Pres. Andrew Jackson; and Pres. James K. Polk. (BF.)

Two men Sitting on the Front Steps of Riverwood. Duncan Cooper and his son, Robin, became national figures when Robin shot and killed Sen. Edward Carmack. Carmack, a staunch Prohibitionist, was the editor for the *Nashville Tennessean* newspaper at the time of his death. He published many scathing editorials linking Colonel Cooper to the supposed corruption of Tennessee governor Malcolm Patterson's administration, inciting Cooper's anger. When they met by chance one day on the street, Carmack shot Robin Cooper twice. Then Robin Cooper shot Carmack in self-defense and killed him. Both Duncan Cooper, who never fired a shot, and Robin Cooper were convicted of murder. Colonel Cooper was pardoned by the governor, and Robin's conviction was overturned by the court of appeals. (BF.)

SARAH POLK BURCH. According to the family, in order to settle his debts, Colonel Cooper sold Riverwood and approximately 150 acres of its land to his son-in-law and daughter, Dr. Lucius and Sarah Polk Burch. Sarah Burch, known to her family and friends as "Miss Sadie," was a force to be reckoned with. She was no shrinking violet and voiced her opinion readily. According to Edward Boleyjack, who began employment as a servant in the house in 1925, Miss Sadie "ruled the house" and was always "helpful to people. All her life she was helpful." Nashville was very segregated then, and Ed lived in the local African American community called Rock City. Miss Sadie used her power and influence to get city water to Rock City. (BF.)

BURCH GRANDDAUGHTERS SIT BY THE
CHRISTMAS TREE, AND EPH GRIZZARD
AND ED BOLEYJACK PREPARE FOR THE
BURCH CHRISTMAS PARTY. Riverwood
was the center of Nashville social life,
and invitations to the Burches' annual
Christmas parties were in high demand.
Once invited, one was invited for life.
The menu was the same each year,
starting out with oyster stew, celery
hearts, and oysterettes, and then moving
on to a very traditional main course of
turkey and cornmeal dressing. (BF.)

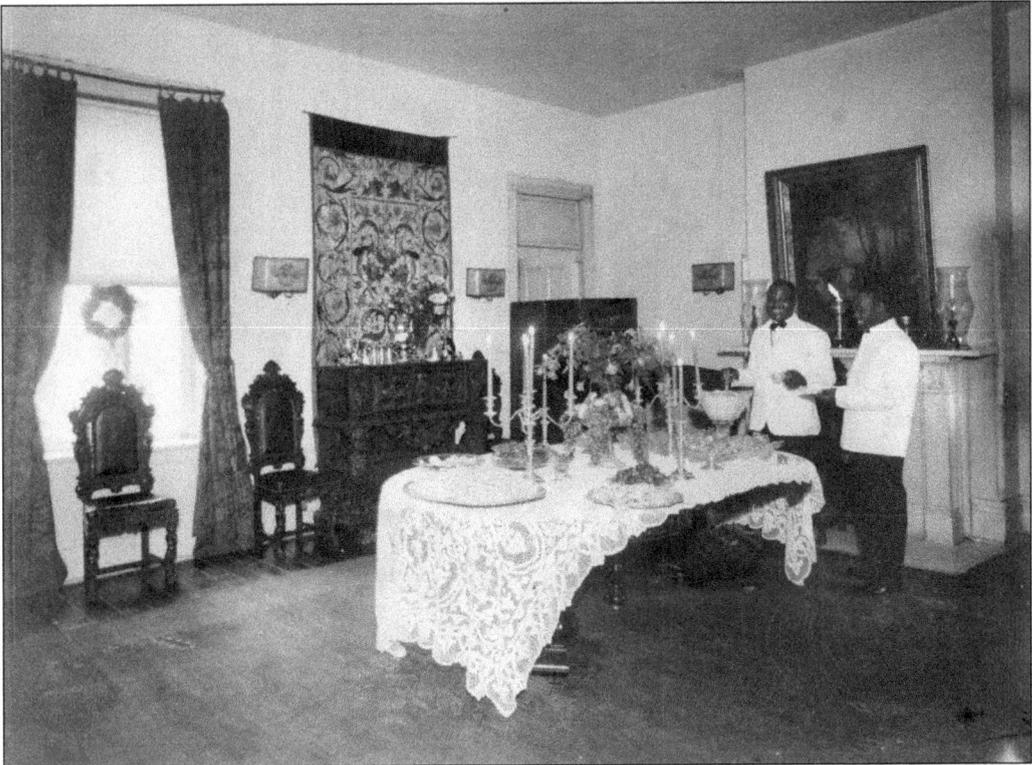

A NEW GRANDCHILD COMES TO RIVERWOOD. All Burch babies born in Nashville lived at Riverwood until old enough to go home. Dr. Lucius Burch was a graduate of Vanderbilt Medical School, served as dean, and practiced obstetrics. He was instrumental in helping the school secure accreditation. Dr. Burch often reported seeing the Grey Lady. Later in life, he claimed his health would always rebound once she visited him. (BF.)

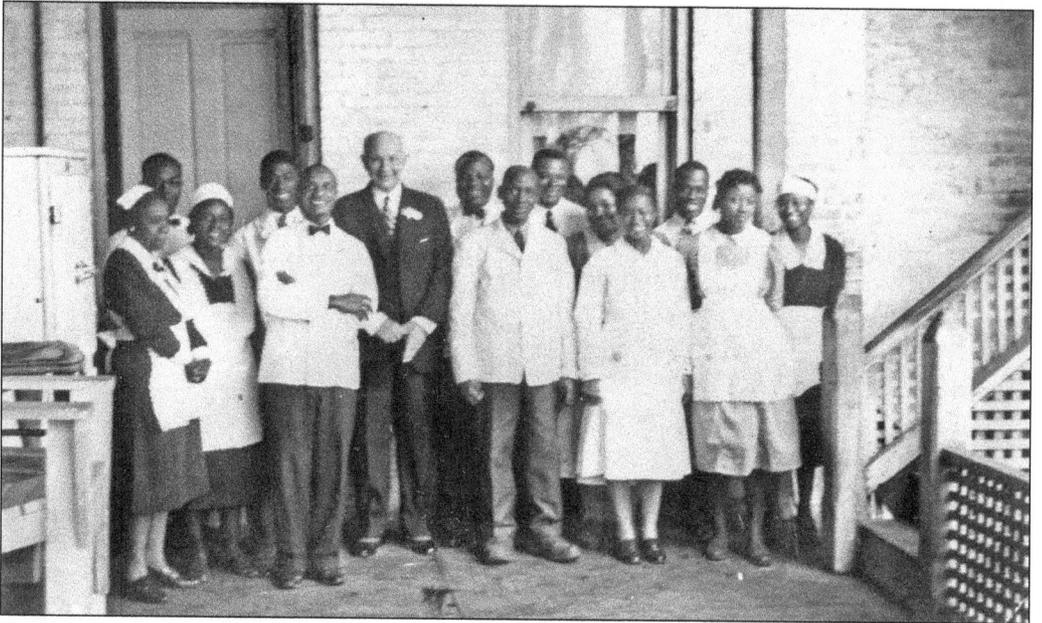

DR. LUCIUS BURCH WITH RIVERWOOD STAFF. Dr. Lucius Burch is standing on Riverwood's back porch near the kitchens and servant quarters with his staff. They were part of the family at Riverwood. Many lived at Riverwood or nearby in Rock City, and they kept the house, the farm, and the dairy business functioning for generations. (BF.)

Lucius Burch Jr.: Attorney, Civil Rights Activist, and Conservationist. Lucius Burch Jr. was born and raised at Riverwood, and all of his daughters spent their summers here. An accomplished attorney, Lucius became famous when he volunteered to represent Martin Luther King in a fight to lift an injunction against marching in Memphis, Tennessee. Growing up at Riverwood, Lucius already showed his compassion for those less fortunate; he was known for giving money to locals in need. The remaining woods surrounding Riverwood must have been a perfect setting for this energetic man, who was passionate about the outdoors and championed conservation throughout his life. (BF.)

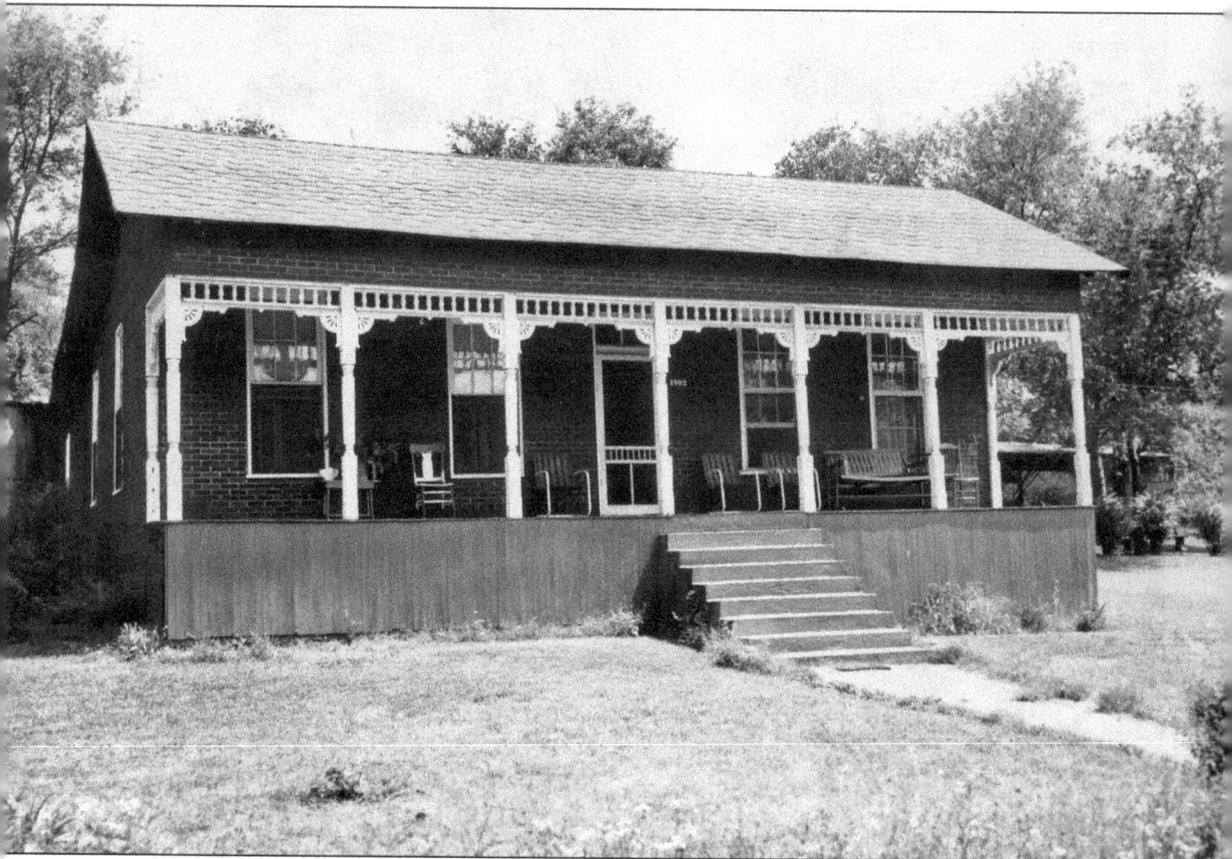

DICK BRIDGEWATER'S HOUSE JUST OUTSIDE ROCK CITY IN SOUTH INGLEWOOD. With just one cow, Dick Bridgewater served the Rock City community as dairyman, providing them with milk, buttermilk, and butter for many years. Rock City, an African American community that lies behind Inglewood Elementary along Branch Street, dates back to the 1800s. The community was founded around an old rock quarry that existed where the South Inglewood Community Center lies today. Many members of the community worked at the Riverwood mansion. Throughout the early 20th century, as Southern communities remained deeply segregated, this community thrived with few if any public funds due to the hard work, effective organization, and abiding love and care of its people. (JBB and the Bridgewater family.)

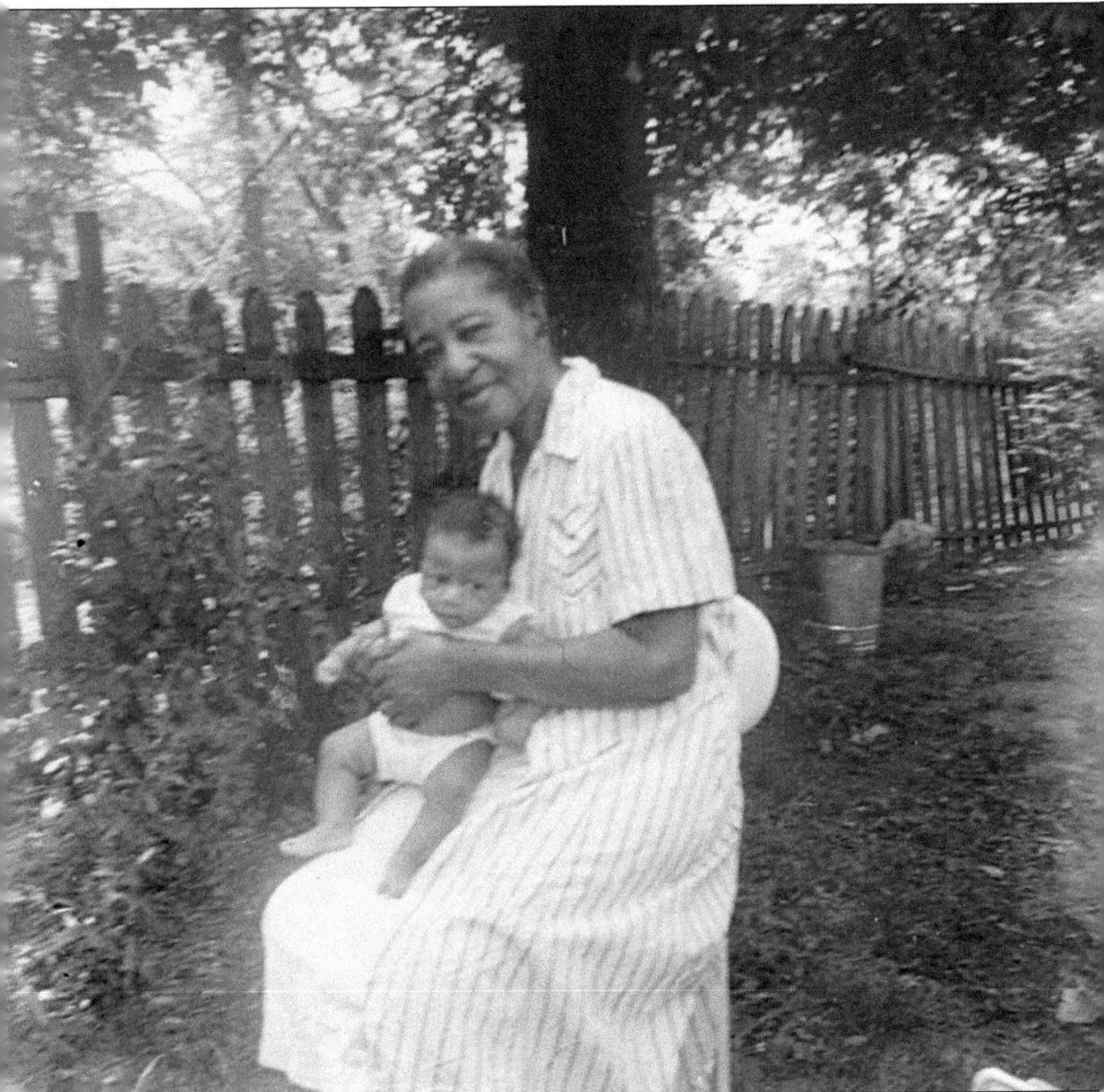

ELLA KIRBY WITH BABY. Forty families called Rock City home for generations, and their relatives, such as the Crawfords, Hardings, Grizzards, Boleyjacks, Sweeneys, Kirbys, Stewarts, and Bridgewaters, can still be found in the area. People took care of each other in Rock City; your neighbor's troubles were your troubles. The men and women in this community worked for some of Nashville's most prominent politicians and businessmen and their wives. Through their genuine dedication and hard work, Rock City leaders gained these people's trust and affection. H. G. Hill Jr. gave money to the Rock City Men's Club every year, and it was through such associations that Rock City was able to finally get city services. Today Rock City's community organizations are still hard at work and have enabled youth to go to college through the T. E. Sweeney Scholarship Program, provided computer training and helped reduce crime through the Concerned Citizens of South Inglewood. (JBB.)

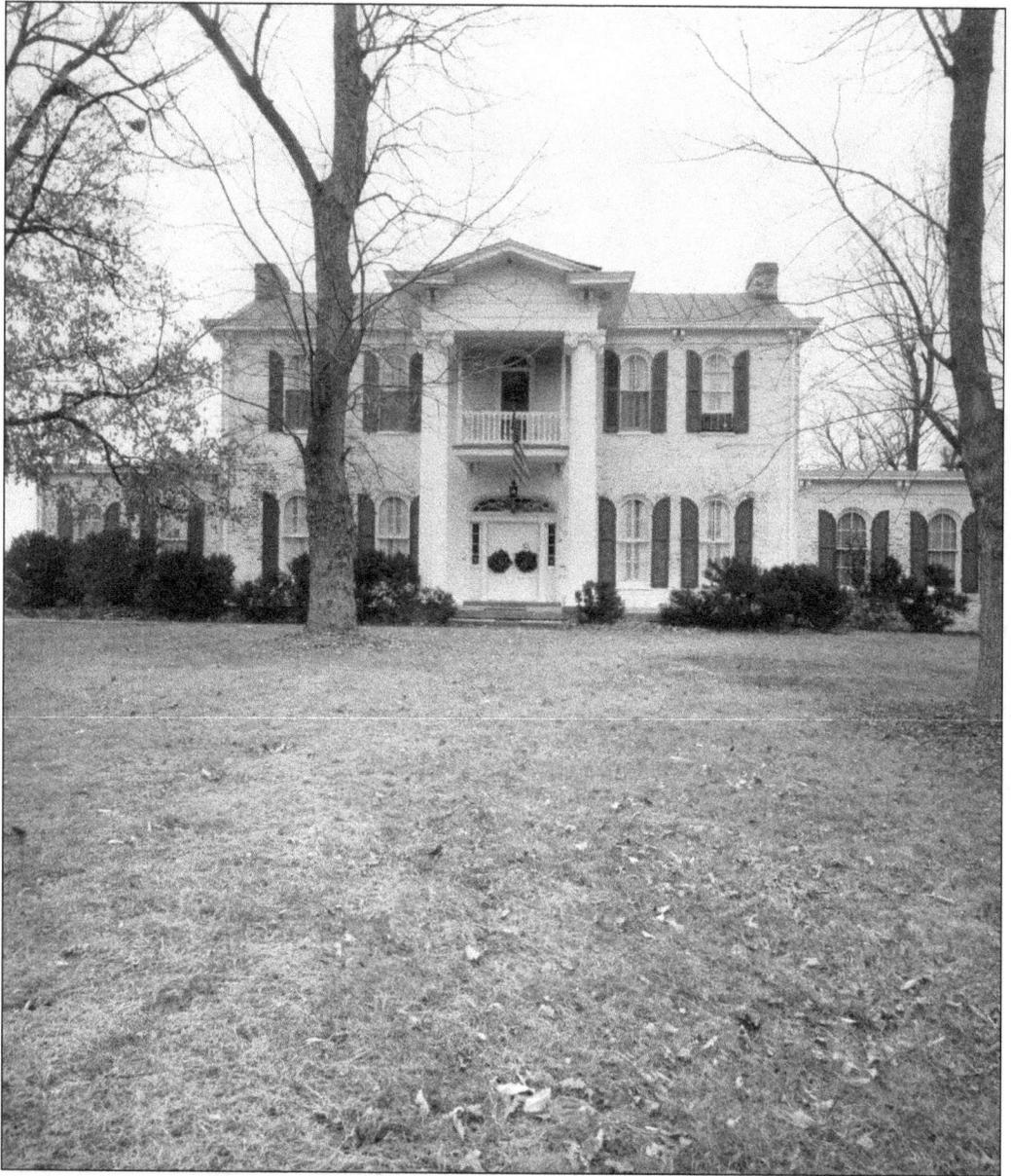

FAIRFAX HALL, ALSO KNOWN AS THE WEAKLEY TRUETT CLARK HOUSE. Situated on Rosebank Avenue, Fairfax Hall's original structure was built in 1802 by Samuel Weakley, an early settler and surveyor. Weakley owned more than 600 acres that extended all the way to the Cumberland River. The house and lands would eventually be inherited by his brother, Robert Weakley. Robert Weakley served in the first Tennessee General Assembly and was also a Representative in the 11th U.S. Congress. In 1855, Ezekiel Truett bought the house and 36 surrounding acres; he later changed what had originally been a Federal-style home to an Italianate-style home with classical features. Truett added the two-story portico with columns. (JCM.)

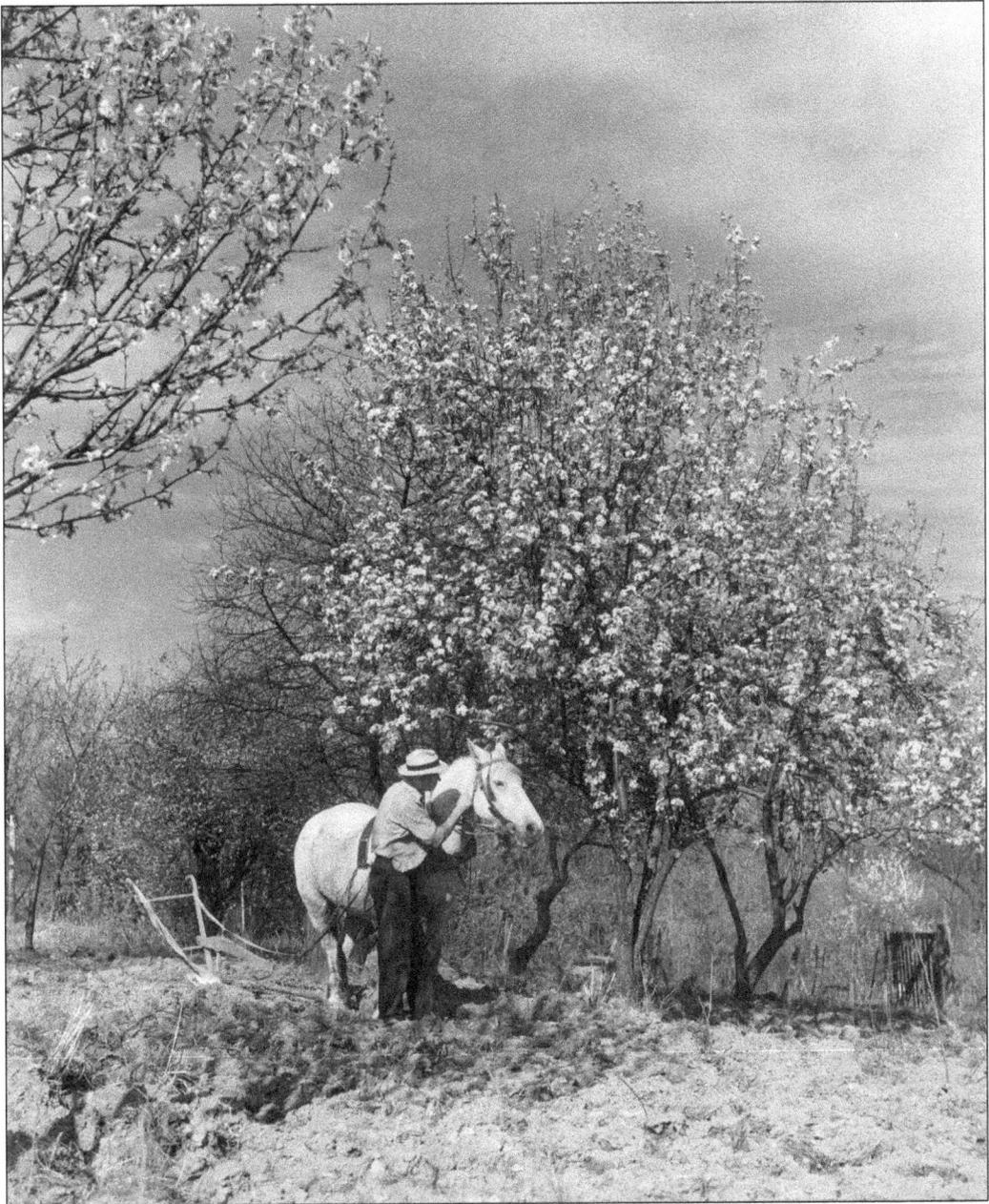

A Man in an Orchard on Rosebank Avenue. Ezekiel Truett established the Rosebank Nursery before the Civil War. The rich river-bottom land proved perfect for one of Tennessee's first nurseries, and it shipped nursery goods throughout the Midwest and southeastern states. The nursery grew roses all along the hill beside Rosebank Avenue, and it is said that this is how the street got its name. (TSLA.)

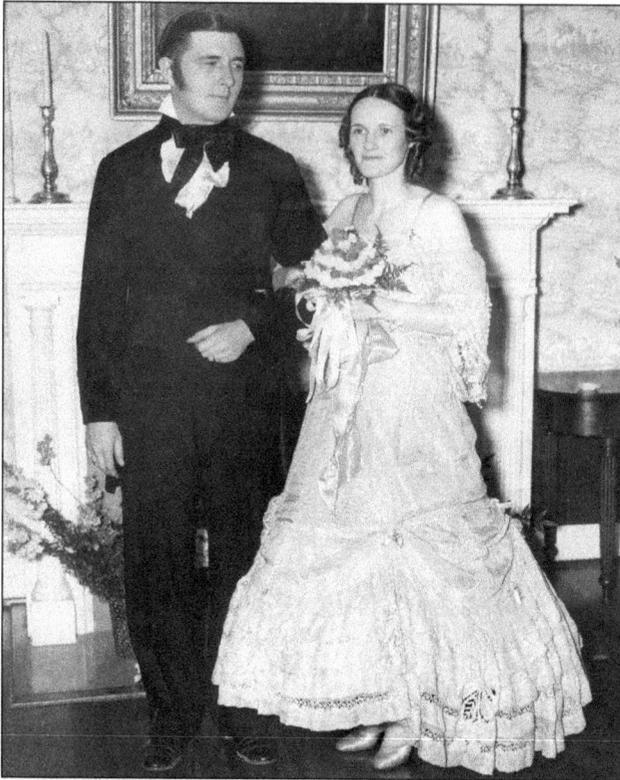

MR. AND MRS. SHEFFIELD CLARK JR. AT FAIRFAX HALL. Sheffield Clark and his sister inherited the house in 1933. Sheffield, in the wholesale hardware business, would eventually buy out his sister. Sheffield and his wife are pictured here in the front parlor of the house in 1937. The Clarks began renovating the house in 1936, adding modern conveniences such as bathrooms and two one-story wings. To celebrate the completion of the renovations, the Clarks hosted a costume ball where the partygoers enjoyed an evening of dancing. (Both JCM.)

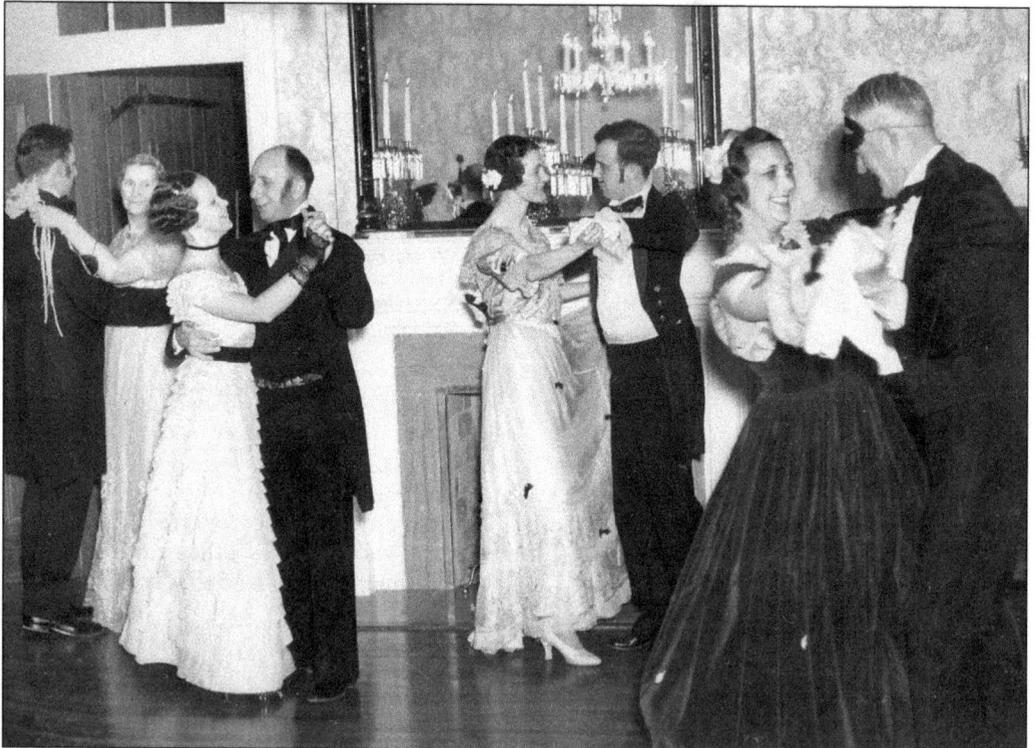

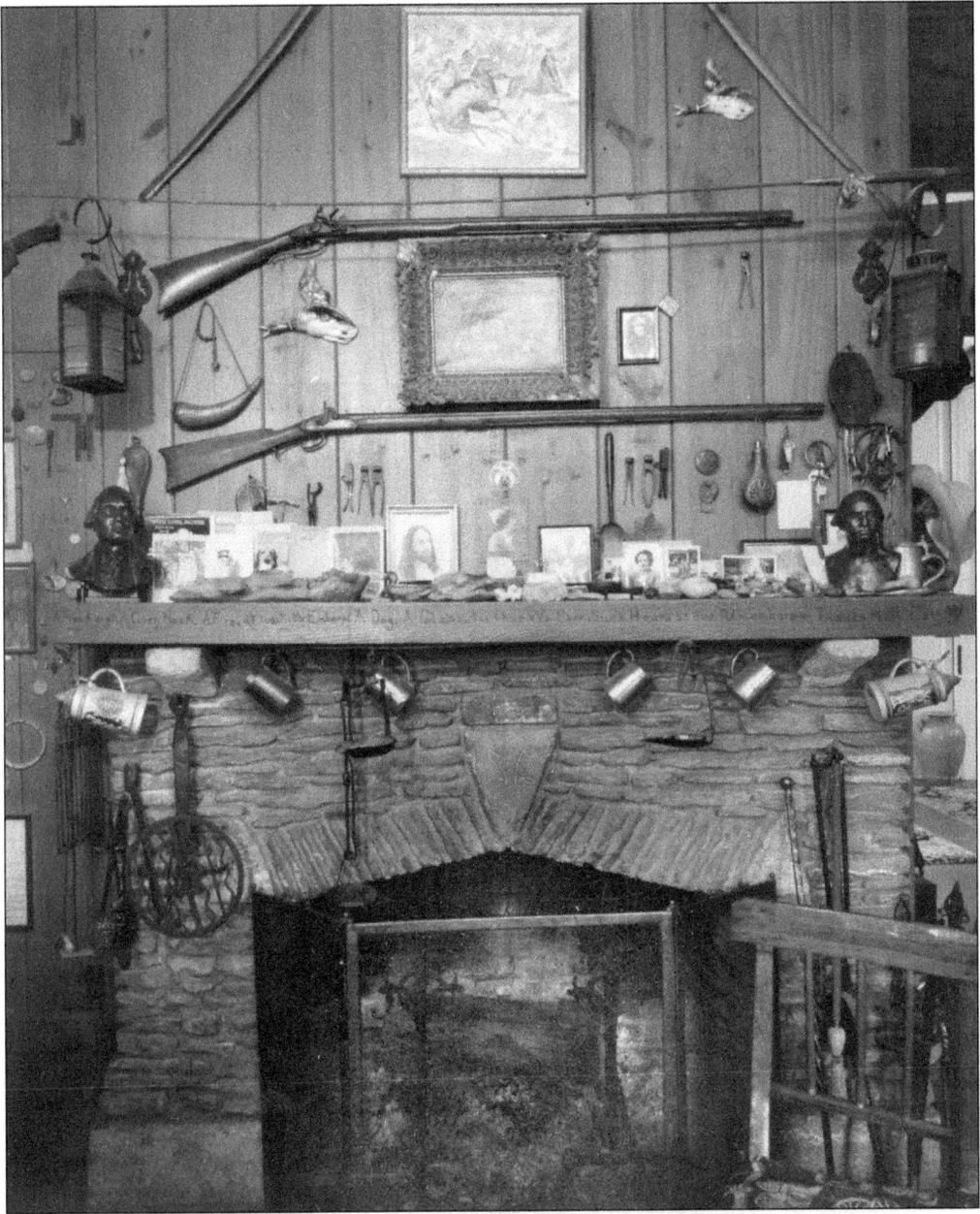

THE FIREPLACE IN THE CLARK DEN. Sheffield Clark was a Civil War history buff and collected many artifacts from the war, as his den reflects. The den is one of the two one-story additions the Clarks built onto the house. Sheffield built this mantle himself. It reads "A Pipe, A Book, A Cozy Nook. A Fire, at least its Embers. A Dog, A Glass, Tis thus we Pass Such Hours as one Remembers." It is a quote from Thomas Hall, Esquire, and gives much insight to Sheffield's personality and values. (JCM.)

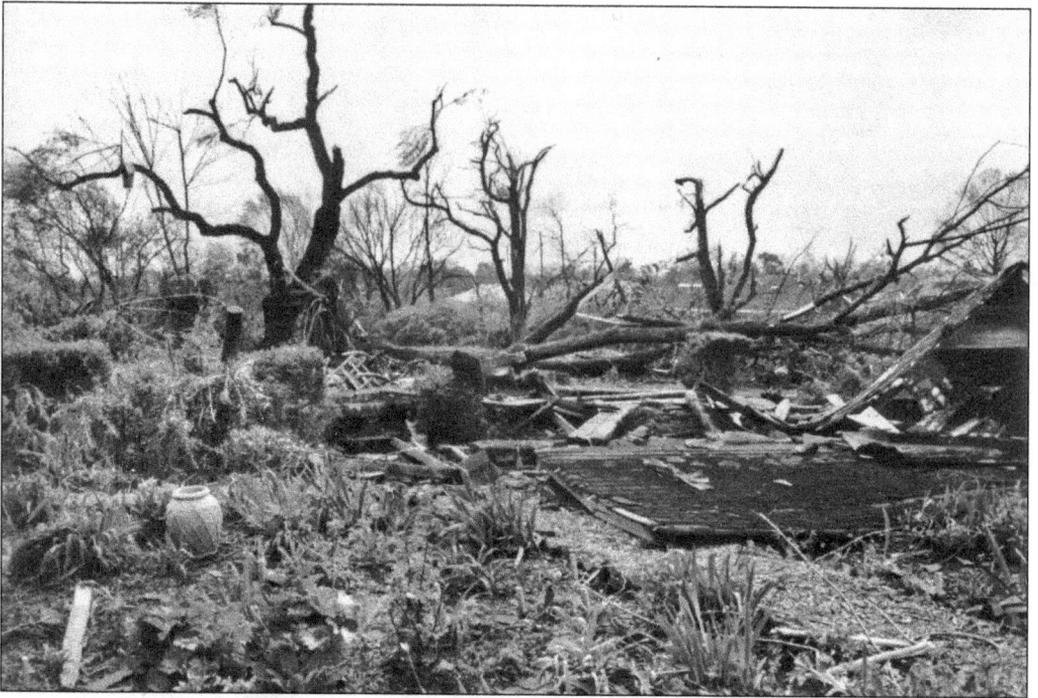

THE 1998 TORNADO DAMAGE AT FAIRFAX HALL. Tornados are a common occurrence in Middle Tennessee, and powerful storms in 1933 and 1998 ripped through Inglewood and East Nashville. The storms followed nearly the same path and both damaged Fairfax Hall. Here is the aftermath of the 1998 tornado that destroyed what was left of the gardens and orchards the Clarks had planted. (Both Mary Teloh.)

VIRGINIA MANOR. This home was built in 1855 by Aaron Stretch, a pharmacist from Pennsylvania. It did not originally have a front porch; this was added in the 1930s. Note the rose glass that adorns the doorway; this was a very popular and expensive feature at the time. The house and farm were eventually bought in the 1920s by a young widow, Virginia Robinson, who moved there with her two small children to make a living raising hogs and chickens. The family twice sold off parts of the land to subdivide. The house stayed in the family until 2003 and sits today on Warden Drive.

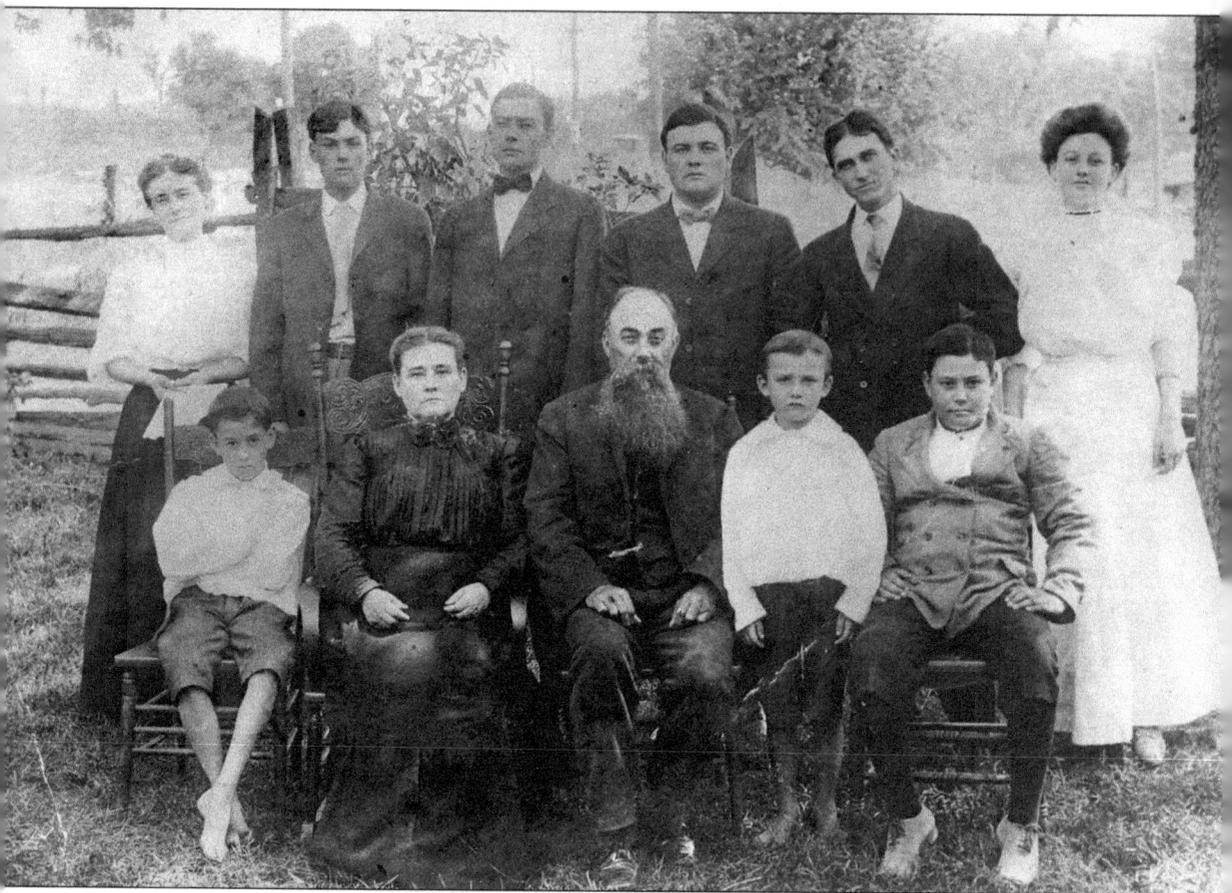

THE SHACKLETT FAMILY IN 1908. The Shacklett family owned a house that once stood at 1130 Shelton Avenue and had served as the administration building for Nashville's Poor Asylum farm. The Poor Asylum sheltered and fed Nashville's poor from 1874 to 1895. After 1895, the county sold the property to the Shelton family, who subdivided the land in 1908; the home was probably sold to the Shackletts at this time. The Shackletts in turn eventually sold the home and remaining lands to the Ellis family. The home was probably originally built sometime before the Civil War by Thomas Bransford, a merchant and railroad executive. Unfortunately, the last known photograph of the home was recently lost. After the land was subdivided, many residents would find artifacts from the asylum when digging in their yards. Victor Jordan, who grew up on Kirkland, remembers his father making a gruesome discovery when he inadvertently unearthed the unmarked grave of a former asylum resident. Many of these graves were discovered as homes were built in the area. (Shacklett family.)

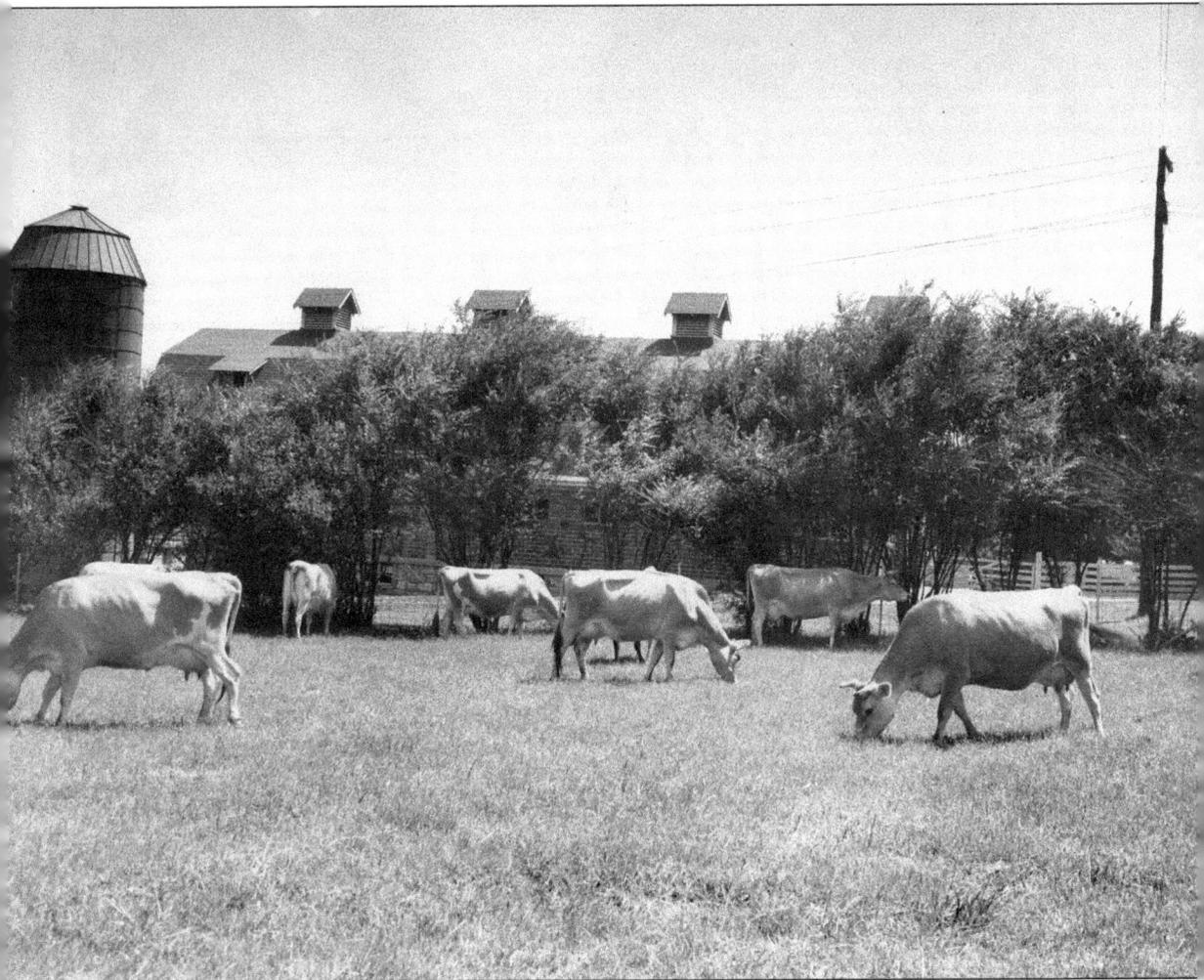

JERSEY CATTLE AT FORTLAND FARM. Fortland Farm was the home of Dr. Rufus and Mrs. Louise Fort from 1909 until it burned in 1942. The house was built in 1852 by Hiram Vaughn. The Vaughns lived on the farm from 1810 until they sold it to the Forts. The farm had more than 350 acres along the Cumberland River and originally backed up to John Shelby's plantation in East Nashville. This farm would eventually be subdivided in the 1950s. Today, Fortland Drive, located off Riverside Drive, loosely follows what was the original grand entrance to the estate. Fortland Farm was famous for its registered, award-winning Jersey herd, and Dr. Fort was thought to be the foremost authority on the breed. He started importing the cattle from the Island of Jersey and improving the breed in 1911. His Jerseys were sold and bred through the country and even in Mexico and Argentina. (TSLA.)

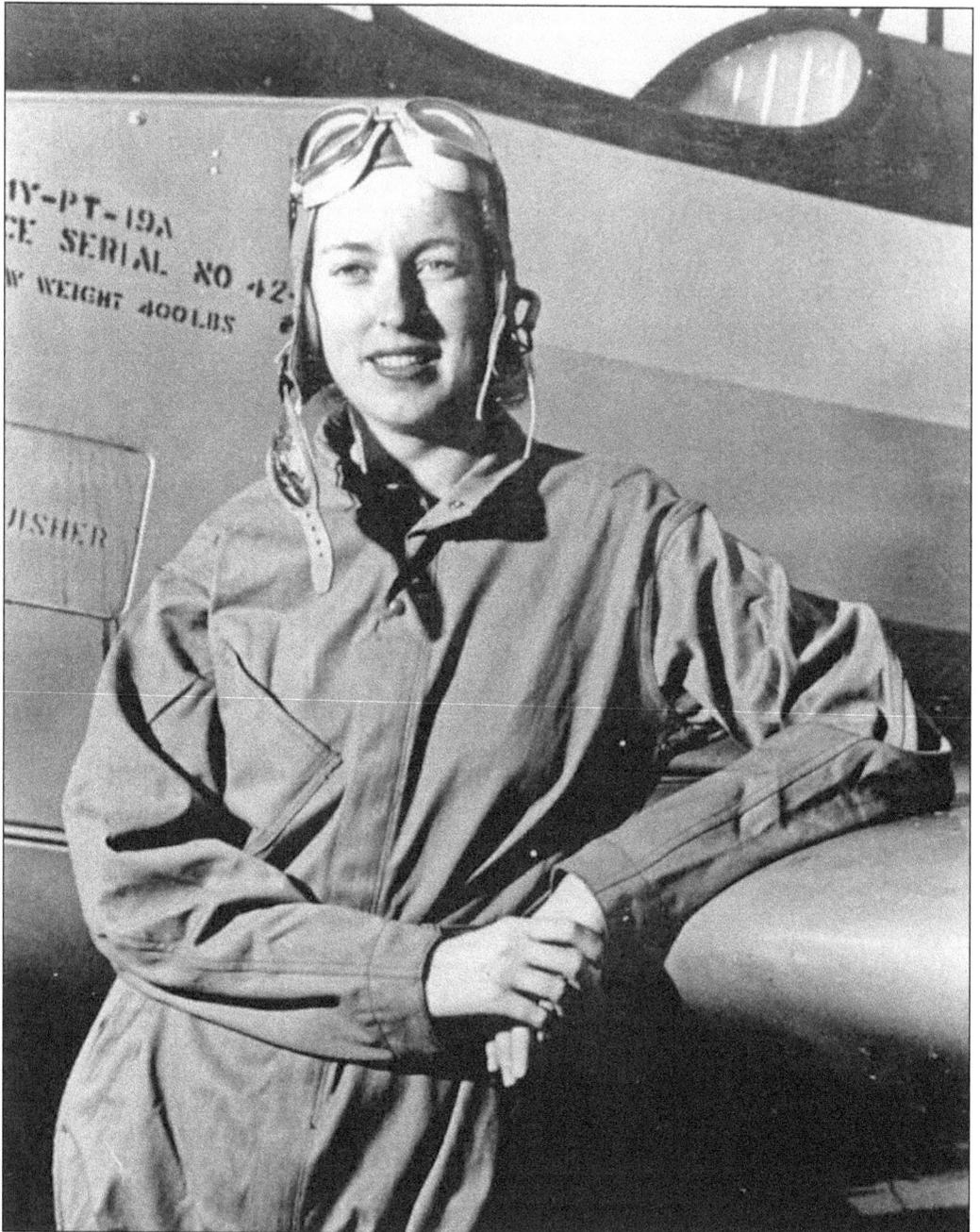

FAMOUS FLYER CORNELIA FORT. The Forts' oldest daughter, Cornelia, was raised to be a gentlemen's wife. Much to the surprise of her friends and family, she became one of the country's most famous pilots. She survived the invasion of Pearl Harbor though nearly colliding with a Japanese pilot in midair. Eager to serve her country, she joined the Women's Auxiliary Ferrying Squadron (WAFS) in 1942. The WAFS were responsible for ferrying new warplanes to bases around the country. While performing this duty, Cornelia's airplane was clipped by a male pilot's landing gear on March 23, 1943, resulting in her death. She was the first U.S. female pilot to die in service to her country. (MNA.)

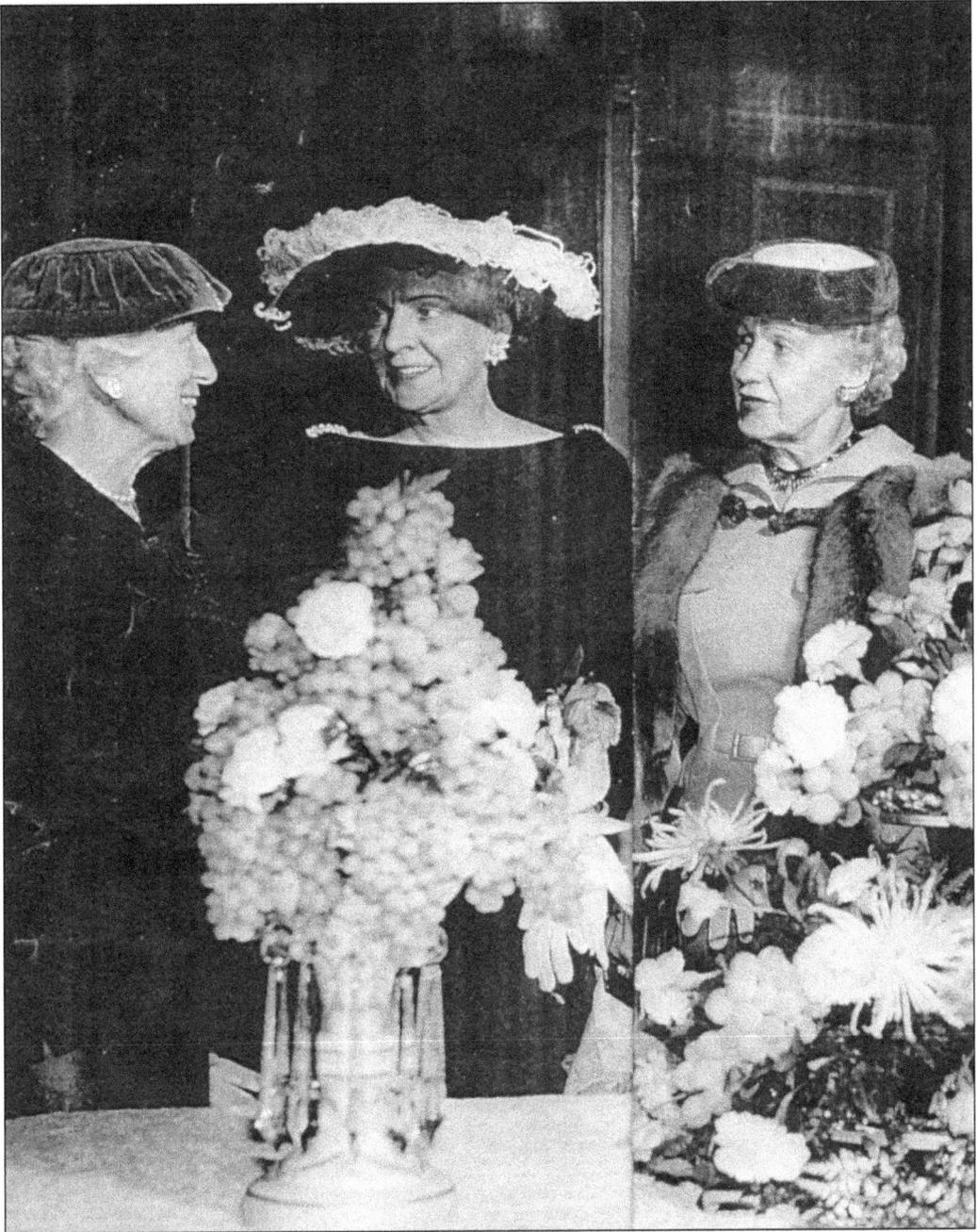

LOUISE FORT, CEACY HENDERSON, AND OLIVE (OLLIE) BARRICK. Three of Nashville's most prominent society ladies in the early 20th century were, from left to right, Louise Fort of Fortland, Ceacy Henderson of Wild Acres, and Olive Barrick of Oakland Farms. Their estates were all located on or just off Rosebank Avenue, and all had river frontage. Like Cornelia Fort, the Hendersons were aviators. It is no accident that Cornelia Fort Airport is located on land once leased from the Hendersons and named for a Fort. (CHH.)

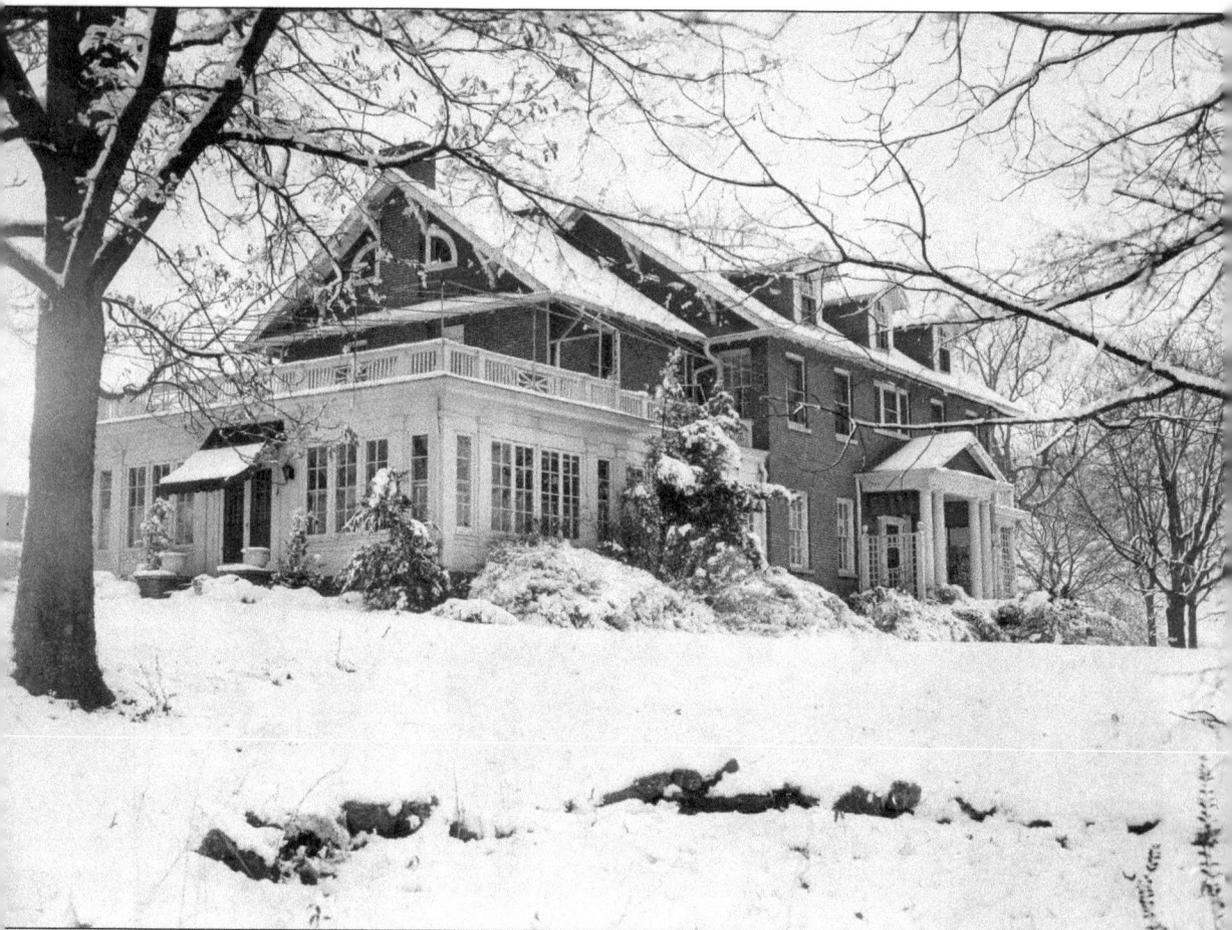

WILD ACRES, THE HENDERSON FARM. Mr. J. B. and Mrs. Ceacy Henderson acquired Wild Acres in the late 1930s and soon fell in love with the virgin woods and the Cumberland River. Situated on Porter Road just behind Riverwood, Wild Acres included 508 acres. J. B. Henderson made his wealth as the owner and president of the Southwestern Company. The company still exists today as Southwestern/Great American, Inc. (CHH.)

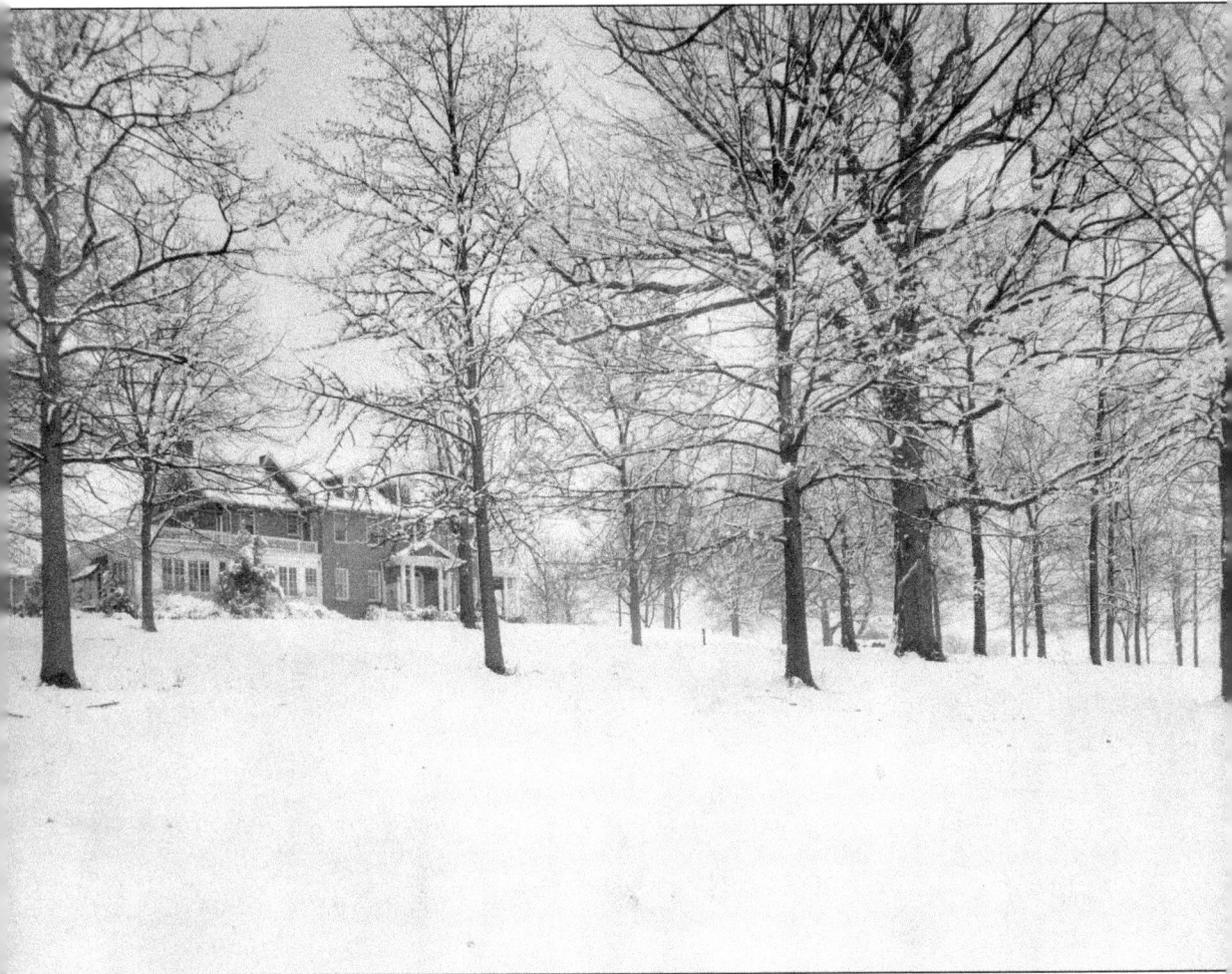

WILD ACRES IN SNOW. Wild Acres was not just an estate, it was also a working farm. Corn, wheat, rye, and barley were grown here. The Hendersons irrigated the land from the river using clay pipes and also raised Hereford cattle. Before a family meal, Mrs. Henderson was fond of saying that everything on the table was off the farm. (CHH.)

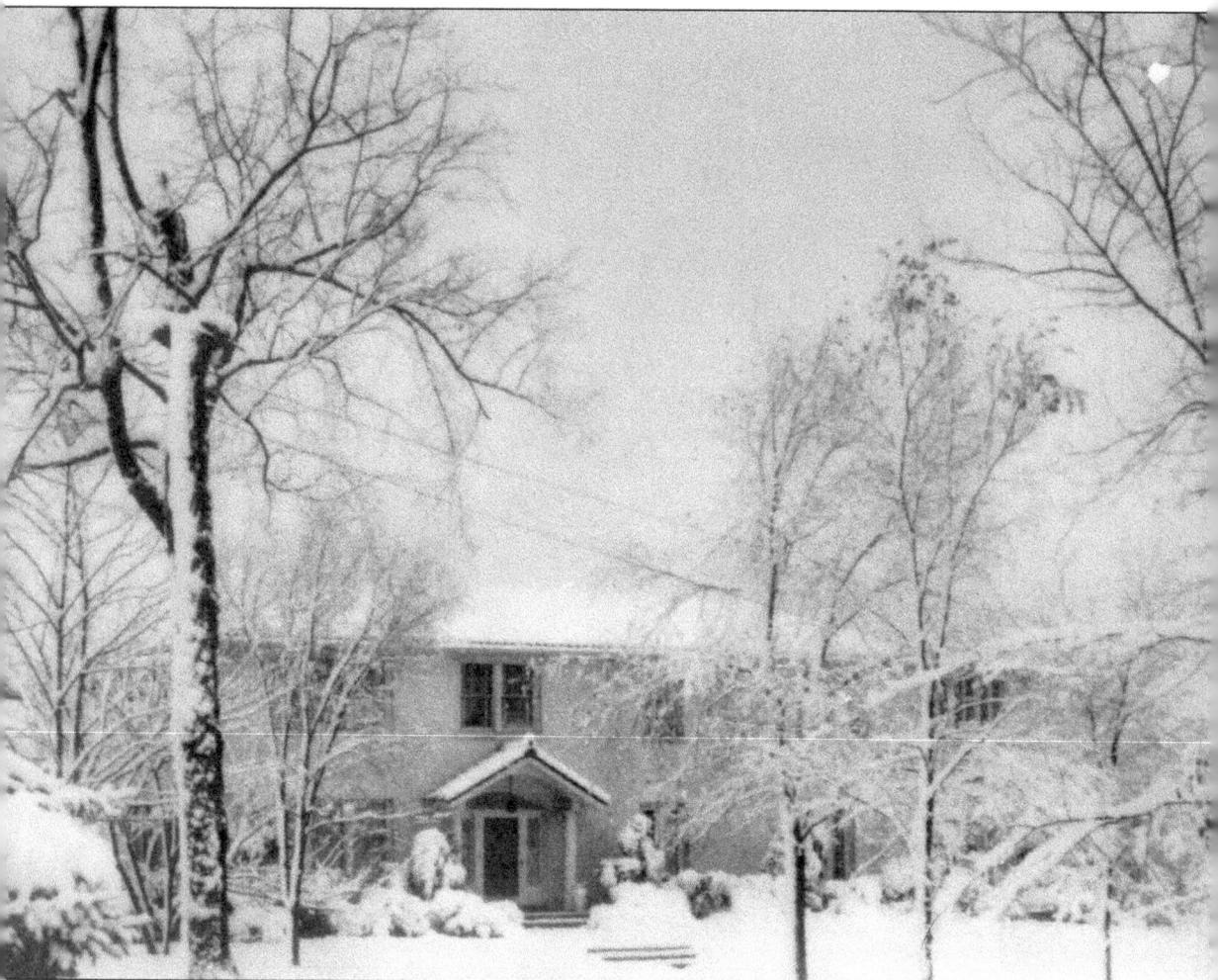

OAKLAND FARMS. Dick and Olive Barrick purchased Oakland Farms along with 150 acres in 1943. Dick Barrick was a prominent Nashville jeweler who owned a store in Nashville's Historic Arcade. This photograph was taken during the blizzard of 1951. (Martha Ann Caldwell.)

Two

A Place to Call Home

The history of Inglewood is the history of the American suburb. Inglewood started as a streetcar suburb when Jere Baxter and other investors funded the construction of a streetcar line from downtown Nashville. This line, built in 1891, went down Gallatin Road to Howard Avenue, making Baxter's vision of a new suburb, called Maplewood Park, a reality the following year. Other streetcar suburbs soon followed, such as Inglewood Place, which gave Inglewood its name. Inglewood Place was centered at the end of the Maplewood streetcar line at Howard Avenue. Lots in these suburbs were sold individually, with families building in whatever style they chose. While the home styles are mostly Tudor Revival and Craftsman, which were popular at the time, they are also unique. By the 1940s, Inglewood was already a thriving community with paved streets and city services. Inglewood's heyday begins after World War II, when it became one of Nashville's first modern suburbs. The remaining area farms were quickly subdivided into communities that reflected the new suburb model, where a single homebuilder often created row after row of identical homes.

Life in Inglewood from its beginning through its heyday was idyllic. In the summer months, people would cool off in the river or at one of the numerous spring-fed creeks. Moore's swimming hole on Cooper Lane was a favorite. The more adventurous kids would take their bikes across the Cumberland River on the Williamson ferry in order to see the exotic animals at Rudy's Farm.

Just as streetcars and automobiles turned Inglewood from a small farming community into a major suburb, transportation would also lead to Inglewood's decline. After desegregation, the "White Flight" drove more and more families toward the perceived safety of the new bedroom communities. These new communities were possible because of the new superhighways that were open around Nashville by the 1960s.

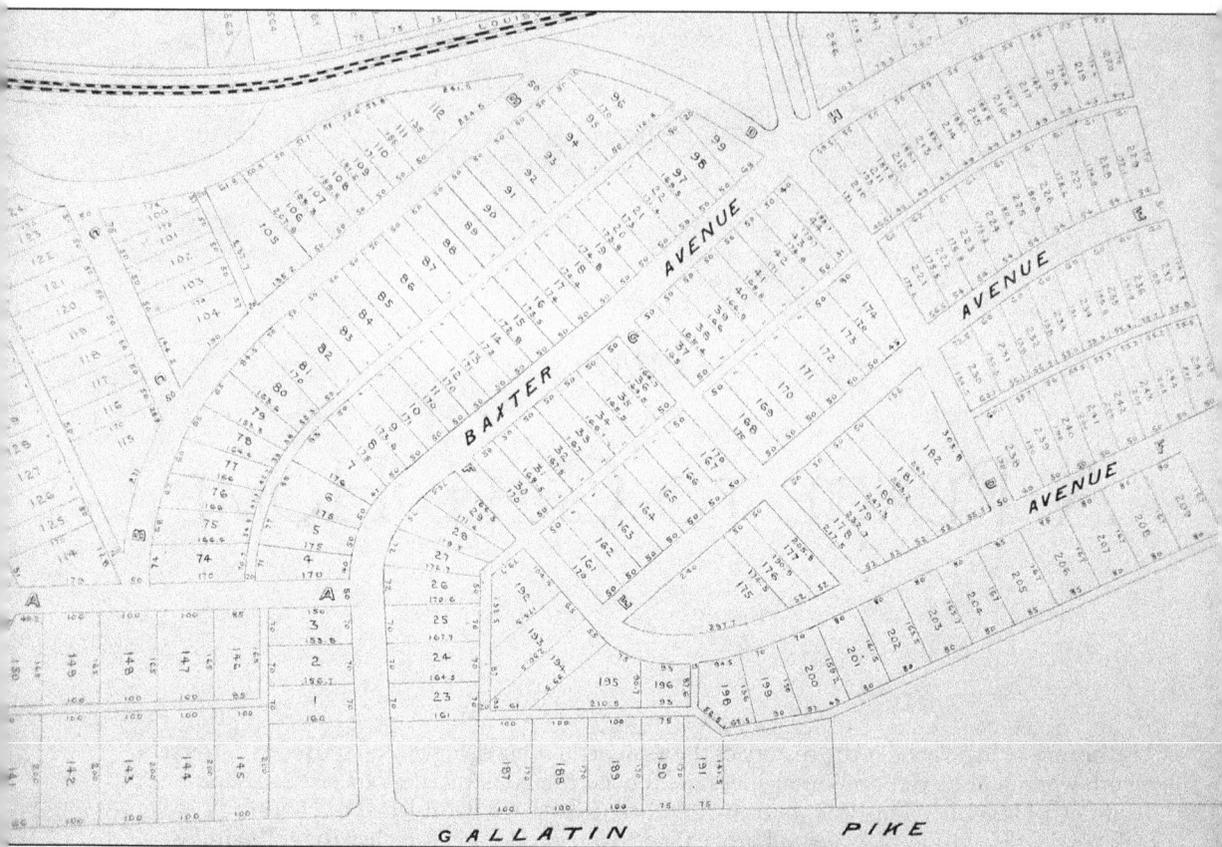

INGLEWOOD'S FIRST SUBURB. Inglewood area's first streetcar suburb was Maplewood Park, located on the west side of Gallatin Road. It began in 1892, when the Maplewood Improvement Company was chartered by Jere Baxter, J. C. Bradford, and others as a land development company. Maplewood farm was already owned by Jere Baxter, and he subdivided the land shown on this plat. The year before, Jere Baxter and several partners had chartered the Maplewood Electric Railway Company, which brought a streetcar from Public Square in downtown Nashville to the Maplewood farm. (MNA.)

ENTRANCE TO THE MAPLEWOOD SUBDIVISIONS AND THE MASONIC WIDOWS AND ORPHANS HOME.
Jere Baxter always dreamed big, and Maplewood Park was no exception. Here is the entrance
to Maplewood as it appeared in 1938. The building on the right is the old Jere Baxter School,
which burned down in 1941. A new two-story school, which still stands today, would be built on
this site. Today this road is called Hart Lane. This also served as the entrance to the Masonic
Widows and Orphans Home. Home Road near Gallatin Road gets its name from the Masonic
Home. (HB.)

MASONIC WIDOWS' AND ORPHANS' HOME.

THE MASONIC WIDOWS AND ORPHANS HOME. Jere Baxter donated the land for the home to
care for the families of deceased Masons. Many locals recall that when the home closed in 1936,
numerous Inglewood families stepped forward to take in the children. Isaac Litton High School
graduates particularly remember the families' generosity, as many of their classmates from the
home were able to stay and graduate. (TSLA.)

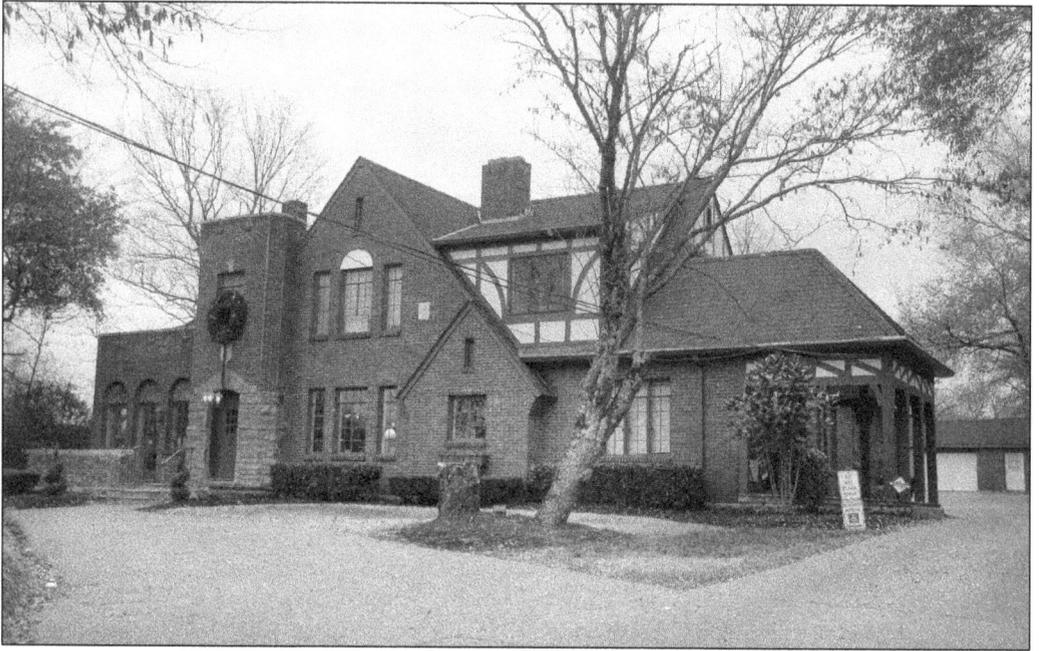

MAPLEWOOD HOMES. Although much of the original Maplewood Park plat never came to fruition, parts of the Maplewood subdivisions that did are still some of the most charming streets in Inglewood. Other subdivisions in Maplewood would soon follow, such as the Burrus and McMahan Maplewood subdivisions. These pictures show a Tudor-style house on Gallatin Road (above) and another, more modest Tudor in the McMahan subdivision (below). Tudor-style homes were very popular in the 1920s and 1930s, especially for the newly rich, and Inglewood has some of the loveliest in the Nashville area. Notice the stone work in both of these homes.

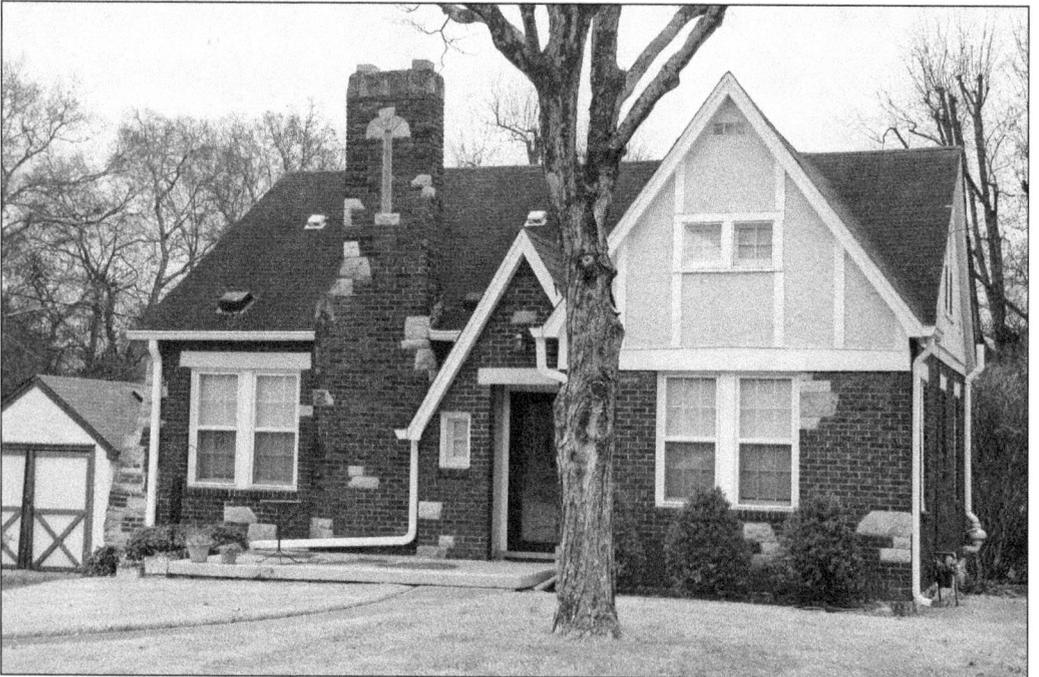

INGLEWOOD PLACE SUBDIVISION HOMES. Named for the Englewood Forest in the English countryside, Inglewood Place subdivision began life in 1908, when the Inglewood Land Company was formed. The company raised $200,000 in capital stock from many well-known names in the Nashville area, such as H. G. Hill, H. W. Burtorff, and John Early. There were also many names that locals would certainly recognize, including P. A. Shelton and W. C. Kirkland, as these names became Inglewood streets. Notice the streets were not paved. Many of the Inglewood Place streets would not be paved until the mid-1930s. (Right, EF; below, HB.)

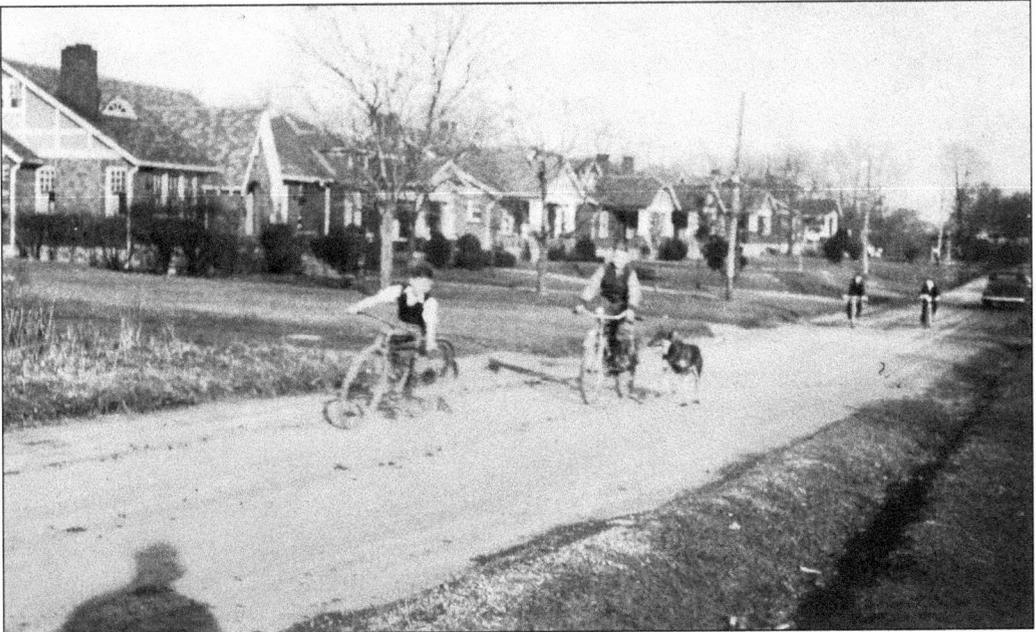

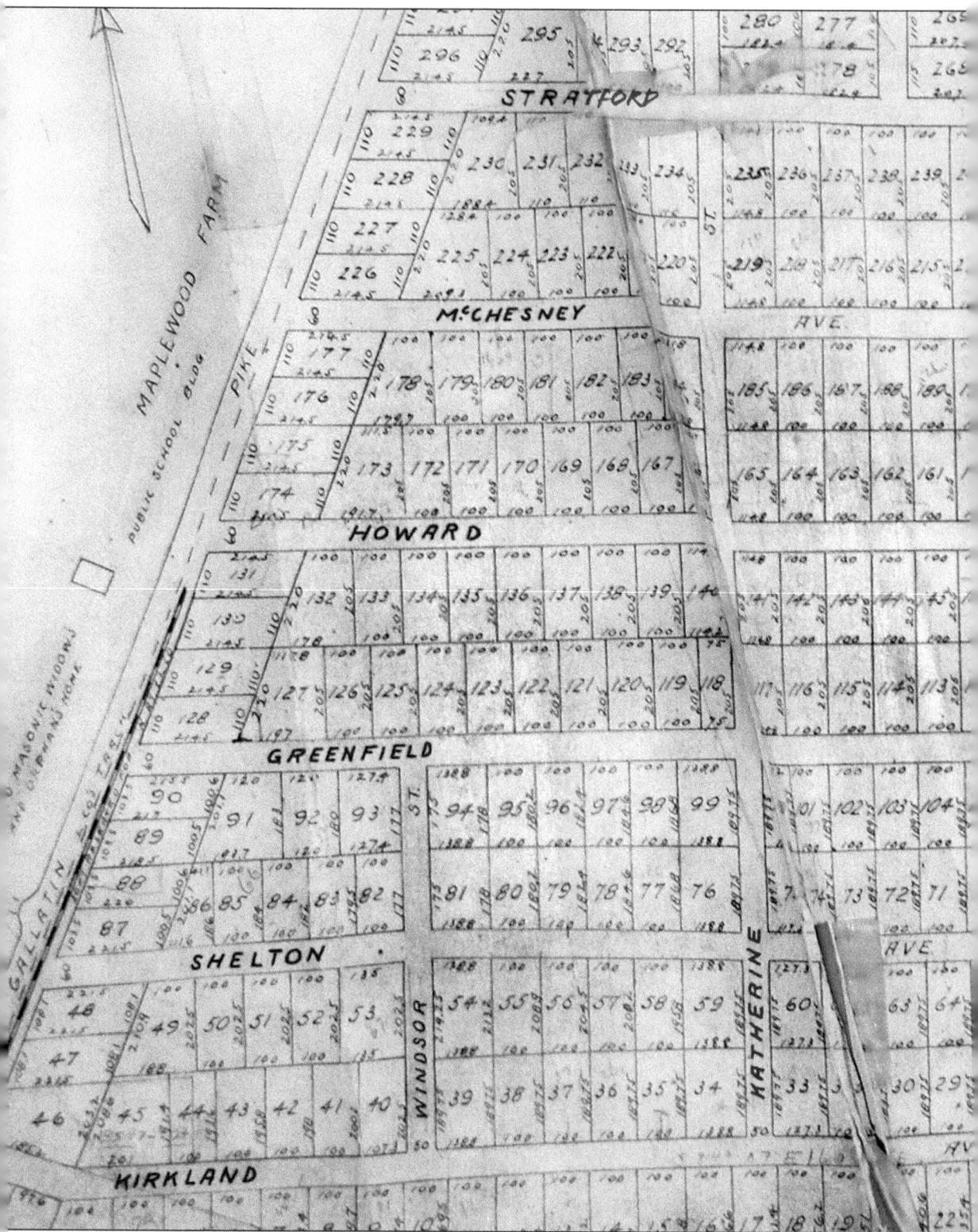

MAPLEWOOD FARM

PIKE

PUBLIC SCHOOL BLDG.

U. MASONIC WIDOWS AND ORPHANS HOME

GALLATIN

STRATFORD

McCHESNEY AVE.

HOWARD

GREENFIELD

SHELTON

KIRKLAND

WINDSOR ST.

KATHERINE AVE.

ST.

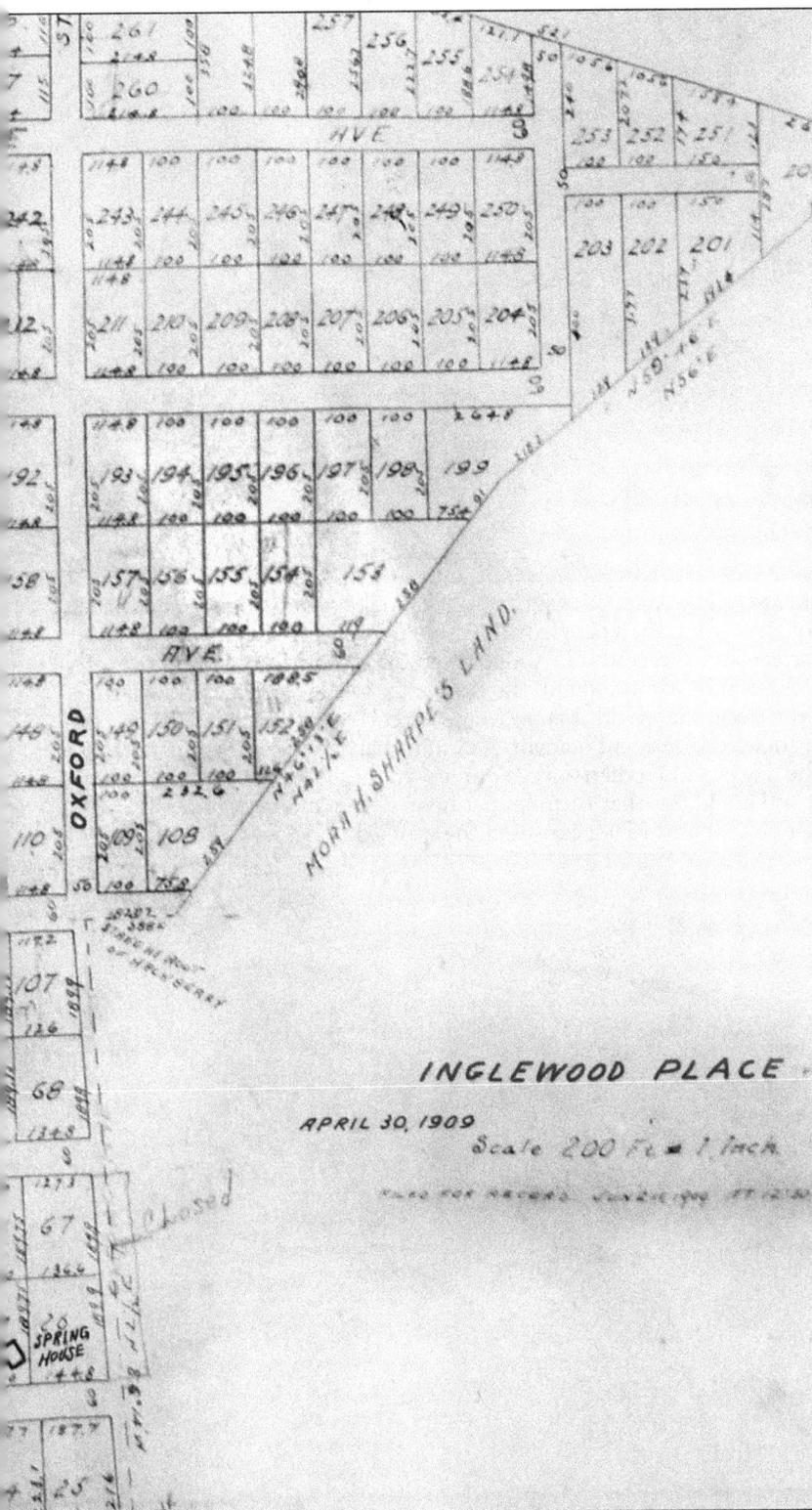

INGLEWOOD PLACE SUBDIVISION GIVES INGLEWOOD ITS NAME. Lots in this new subdivision were sold individually, and people built their homes in whatever style they chose. Since most homes were built in the 1920s and 1930s, the predominant styles in architecture in Inglewood Place were Craftsman and Tudor. Originally, Inglewood was just seven streets from Marion Avenue in the north to Kirkland Avenue in the south. Inglewood Place ended at Oxford Street. Note the springhouse at the end of Kirkland Avenue. Although the springhouse is no longer there, the spring still is, and it feeds the creek that still flows across the street. (MNA.)

GREENFIELD AVENUE HOMES AND A NASHVILLE STREETCAR IN 1930. Sidewalks still adorn both sides of Greenfield Avenue, a holdover from when people had to walk to meet the streetcar. Inglewood Place residents caught the streetcar at Greenwood Avenue or Howard Avenue to go downtown. To turn the streetcar around, the conductor would pull the connector to the electricity down, then push up the connector in the front. He would then move his coin box to the other side, and off the car went back to town. Inglewood residents caught the Interurban Streetcar if going north to Springhill Cemetery for the day or to Goodlettsville. From town, the Interurban used the same tracks as the local service and could travel at 65 miles per hour. Streetcars went under the east side of the railroad overpass on Gallatin Road; cars used the west side. (Below, CJF.)

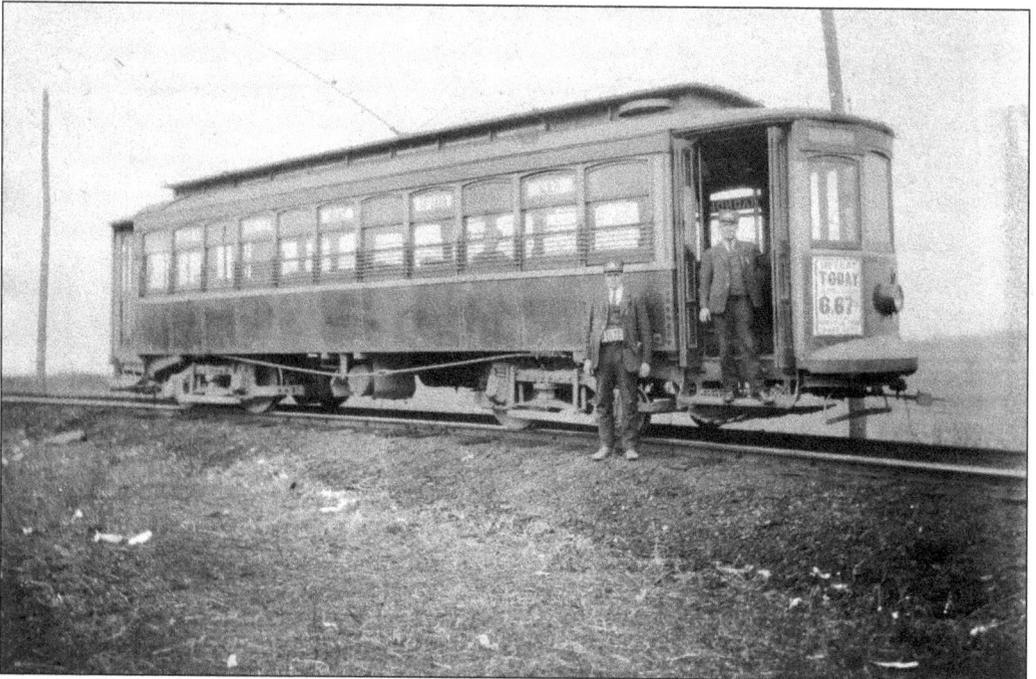

COUNTRY LIVING ON IVERSON, KIRKLAND, AND ROSEBANK AVENUES. In the early days of the subdivisions, many homeowners bought or leased extra lots in Inglewood to farm or to raise chickens or goats for extra money. The Ellis family owned Ellis Coal and ran a dairy on Iverson and Maynor Avenues. Joe T. Ellis (left) and his brother are pictured here near the tobacco field that the Ellises farmed at the end of Kirkland Avenue, where there were several undeveloped lots near Cooper Creek. The Bateses raised goats on their lot on Rosebank Avenue to provide milk and cheese for the family. Victor Jordan, a longtime resident of Inglewood, remembers his father planting sweet potatoes on their back lot on Shelton Avenue. Nearly everyone had a vegetable garden. (Left, EF; below, Mary Bates Woods.)

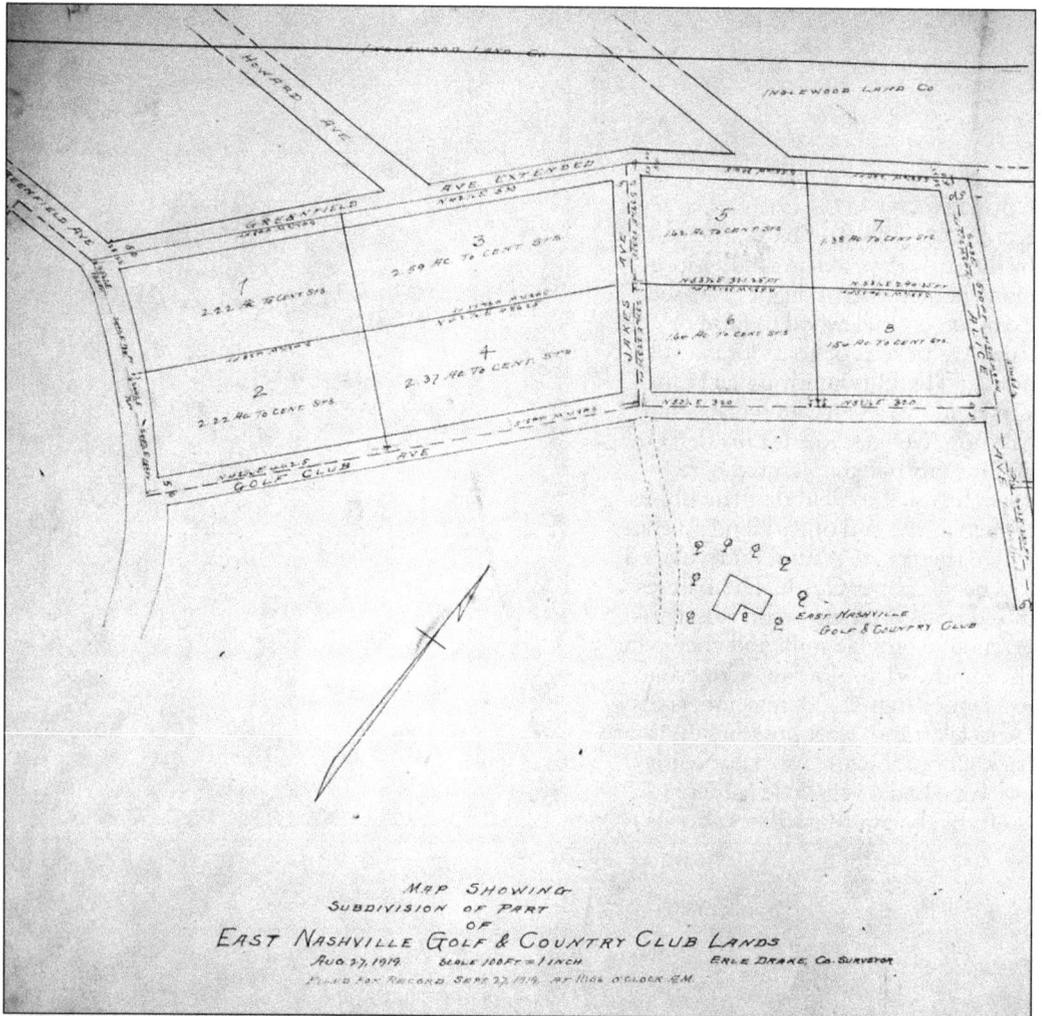

EAST NASHVILLE GOLF AND COUNTRY CLUB PLAT. Chartered in 1919, the East Nashville Golf Club, later renamed Inglewood Golf Club, was formed as a gentlemen's club. The original lots were one- to two-plus acres along just two blocks between Inglewood Land Company, Williams Ferry Road (later McGavock Pike), and the Williamses' farm. Interestingly, Stratford Avenue in the golf club subdivision was originally called Alice Avenue. The plat shows no Riverside Drive, and Kennedy Avenue was originally called Greenfield Avenue. In 1933, the clubhouse moved to the corner of Stratford and Shelton Avenues, where it still stands today. According to locals interviewed for this book, the club was moved when Ivy Hall was built for Dr. Cleo Miller on Shelton Avenue. (MNA.)

EAST NASHVILLE GOLF AND COUNTRY CLUB HOMES FROM THE 1920S. The golf club homes reflect a variety of English-inspired architecture. In the early part of the 20th century, it was popular for the newly rich to connect themselves with the English aristocracy through the architectural style of their homes. Tudor Revival and English cottage homes became very popular. Having a home overlooking a golf course was as prized as it is today. These homes each had spacious porches with an inspiring view of the golf course.

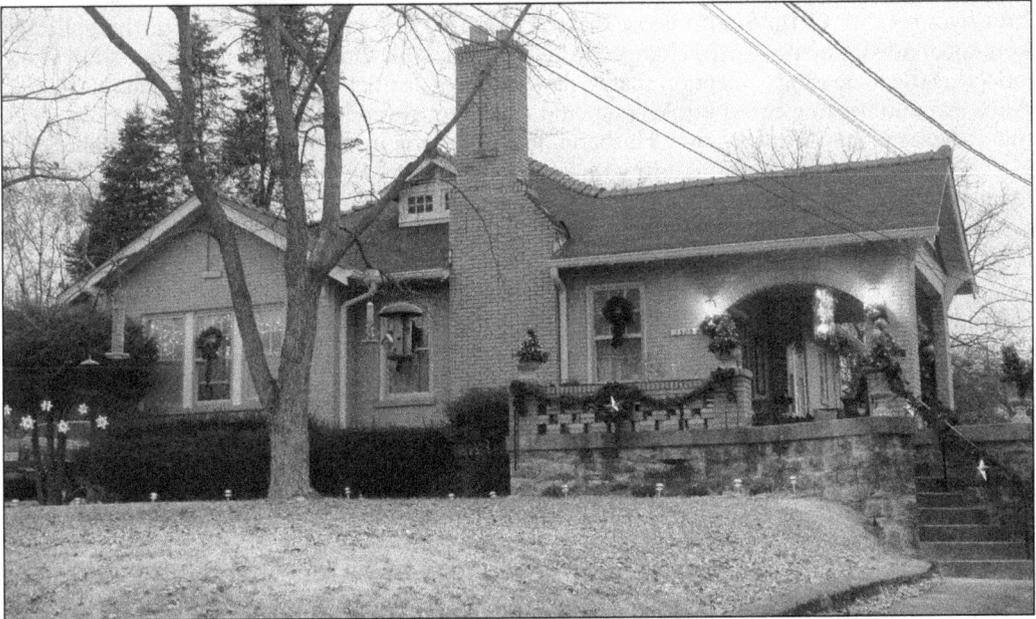

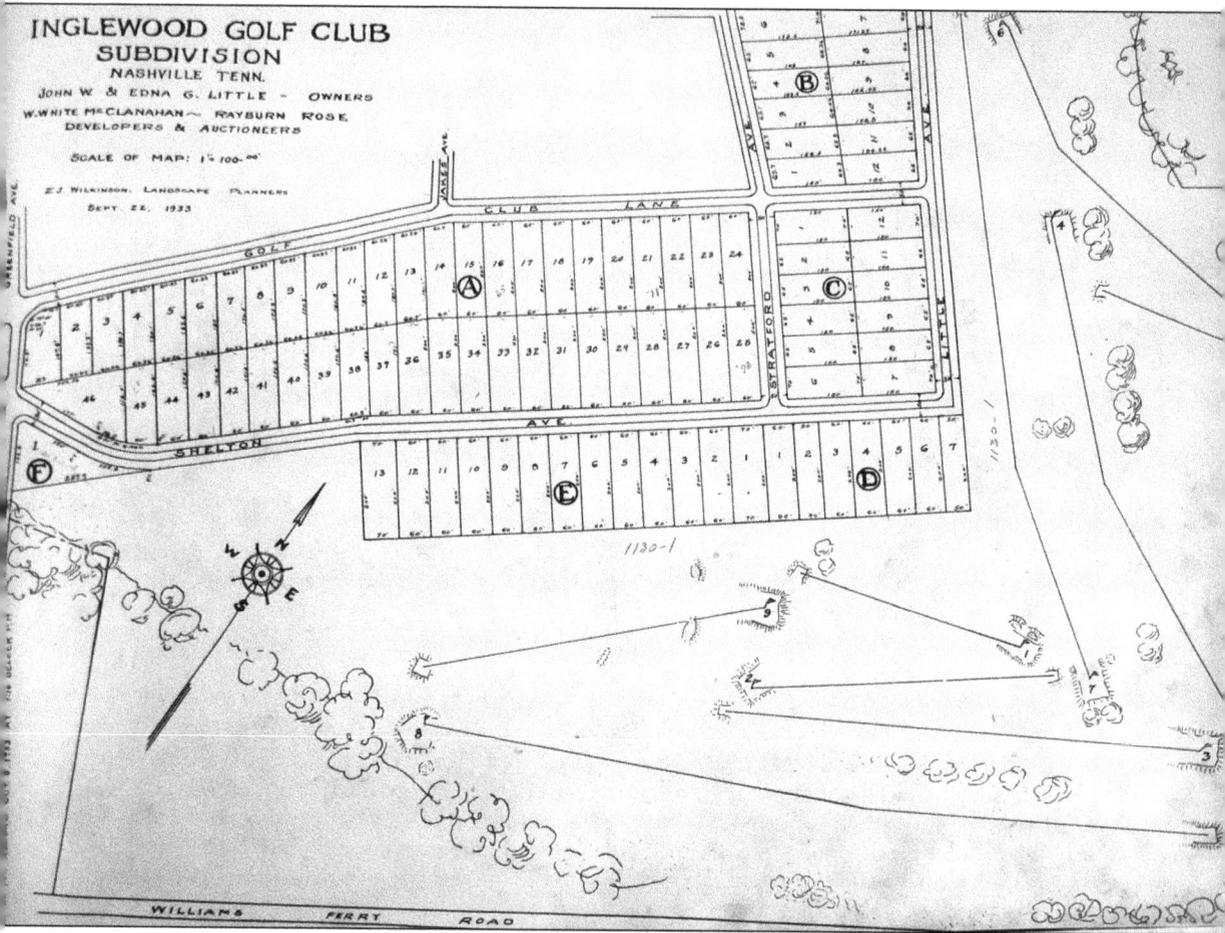

INGLEWOOD GOLF CLUB SUBDIVISION PLAT, 1933. In 1933, additional lots from the golf club were subdivided. The name had changed from East Nashville Golf Club to Inglewood Golf Club, reflecting the increasing perception that Inglewood was a distinct community from East Nashville. Alice Avenue became Stratford Avenue, and the street extended to Shelton Avenue. In 1935, the club was rechartered by Harry Husband, John W. King Jr., Earnest Parker, C. E. Baker, and H. C. Cunningham for the establishment "of a club for social enjoyment and not for profit, with reading rooms" and for the "promotion of social feeling and intercourse; the establishment of a gymnastic and gymnasium club, golf, tennis, polo, baseball, cricket and gun club." (MNA.)

Choice Homesites in

INGLEWOOD
GOLF CLUB ADDITION
NASHVILLE, TENNESSEE

East Nashville's Unequalled and Finest Residential Section, Fronting on Riverside Drive; Golf Club Lane; Greenfield, Stratford and Shelton Avenues.

AT AUCTION!

beginning WEDNESDAY **OCTOBER 4th** 2 at O'CLOCK

EVERY LOT OFFERED WILL BE SOLD REGARDLESS OF PRICE!

Choose Your Lot Attend This Sale

The Question of Price will be Settled by You

PLYMOUTH Two Door SEDAN **FREE** No Obligation to Buy or Bid **$300 in CASH FREE**

Once in every generation you have an opportunity to buy land at such low prices as now prevail. Your dollars in bank or pocket are worth a dollar each, but put in land now they will do double duty.

"Buy Real Estate wisely . . . keep it . . . and it will keep you."—Roger Babson.

JOHN W. AND EDNA GUNN LITTLE, OWNERS

W. White McClanahan — Rayburn Rose

Home Office: Springfield, Tenn. DEVELOPERS AND AUCTIONEERS Nashville Office: Noel Hotel

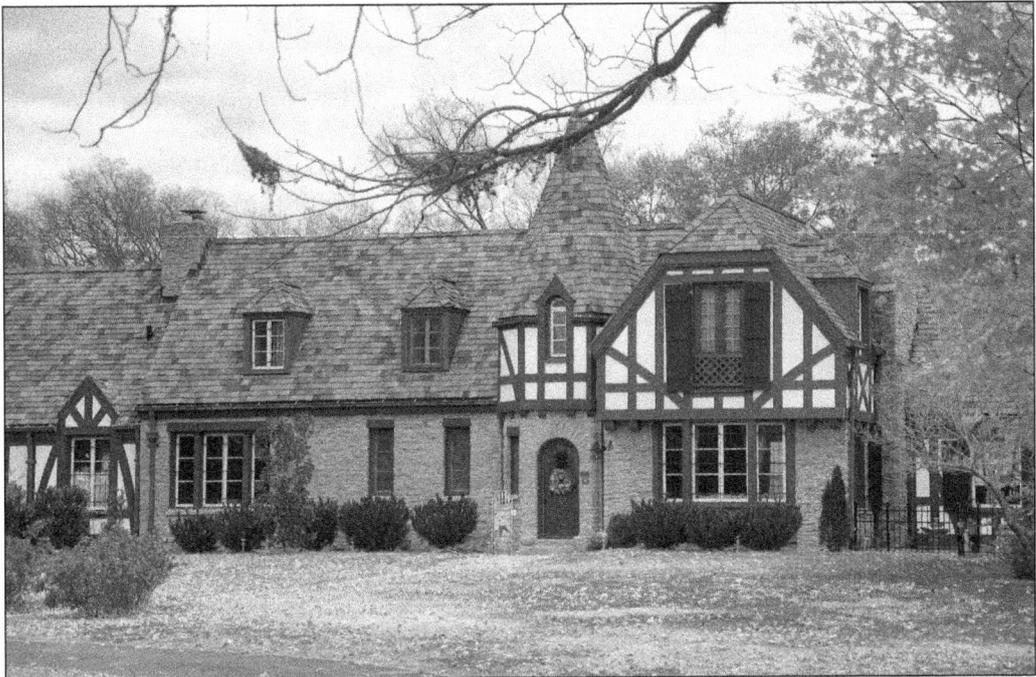

INGLEWOOD EXPANDS IN THE 1930S. To sell the remainder of the golf club lots, W. White McClanahan and Rayburn Rose held an auction on September 29 and October 4. Unfortunately, the flyer doesn't name the year, but it must have been shortly after the land was subdivided in 1933. The flyer mentions that the original Inglewood Golf Club Association had recently been reorganized and that "the remainder of the original 18-hole course has been subdivided into most attractive and desirable home sites, overlooking the new golf course and will be offered for sale as the Inglewood Golf Club Addition." Since the new plat only shows nine holes, the original 18-hole course may have been converted into a nine-hole course. Ivy Hall, pictured below, was built in this new subdivision in 1936 for Dr. Cleo Miller, founder of Miller's Clinic. (Right, Lana Sigg.)

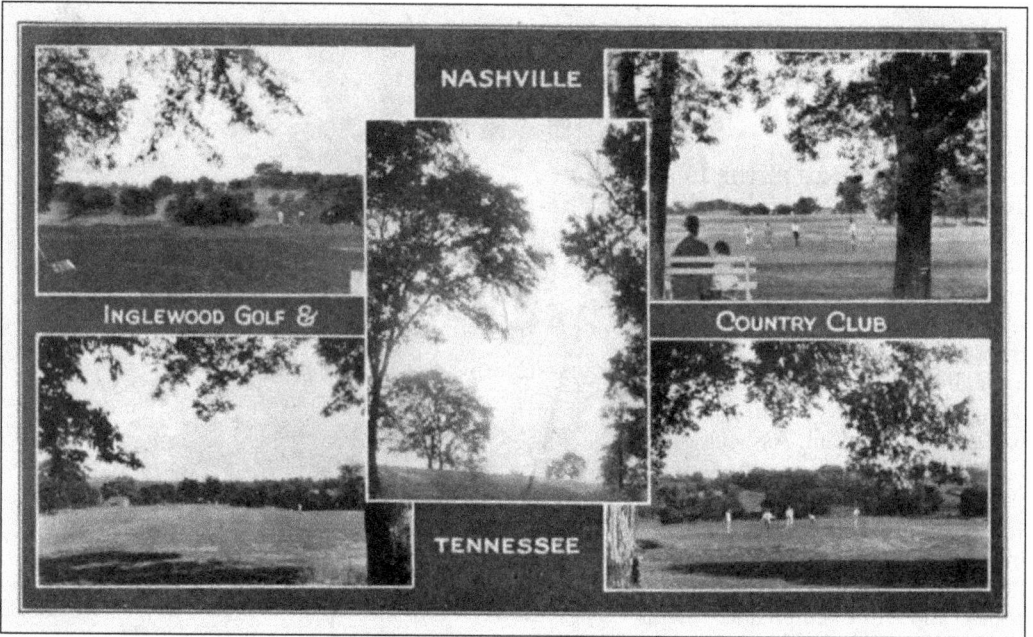

INGLEWOOD COUNTRY CLUB AND POSTCARD AND CLUBHOUSE AS IT IS TODAY. Most locals remember the country club as mainly being a drinking club, since liquor was not allowed outside of the city but could be bought at private clubs like this one. Boys in the neighborhood earned extra change by collecting golf balls and selling them to the golfers who lost theirs on the course. Many locals remember the golfers using wet sand to tee off of instead of the usual wooden golf tee. There was a fence along Riverside Drive that separated the course from the street. Along the fence, the club built walkways so that people could easily come to the course from their homes. (Above, MNA.)

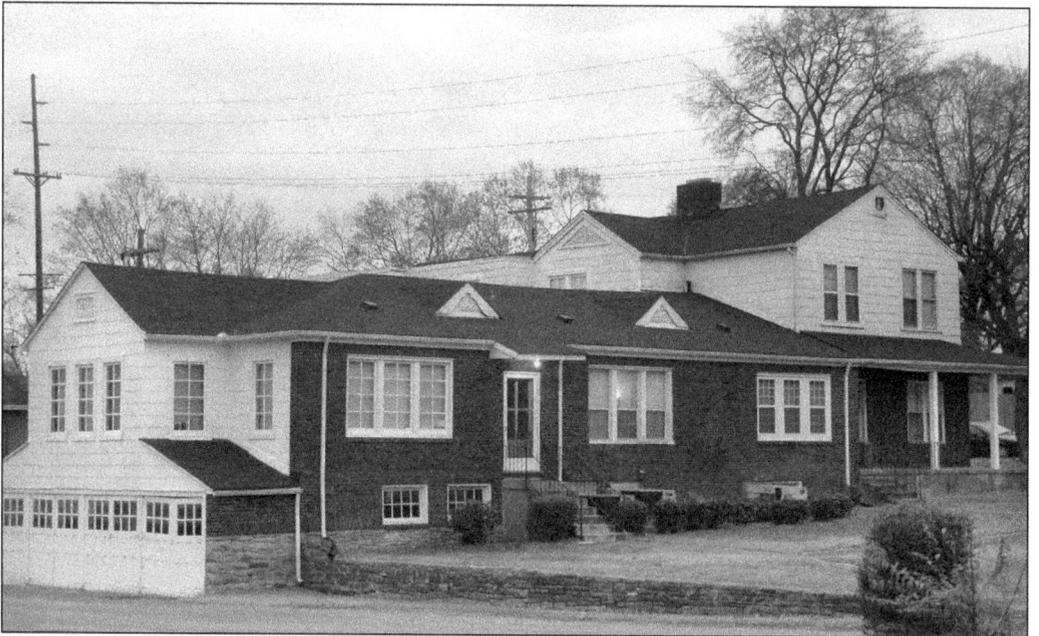

RIVERSIDE DRIVE MEMORIALIZES FALLEN SOLDIERS. Riverside Drive, known as "Double Drive" to many locals, is probably the only community road dedicated as a living memorial to fallen soldiers from three wars—World Wars I and II and the Korean War. It was first created in 1933 as a memorial to World War I soldiers. Poppies, the emblem of the war, were planted along the middle greenway, and irises, the Tennessee state flower, lined the border. The memorial was started by Mrs. Louise Fort, who was the first to give a generous donation of irises. Inglewood children were taught early that this was sacred ground, and they were forbidden to walk down its center. The greenway down Riverside Drive has been replanted and rededicated several times by Inglewood clubs; in 1959, over 500 trees and shrubs and hundreds of tulips were planted. (Below, Jack McMahan.)

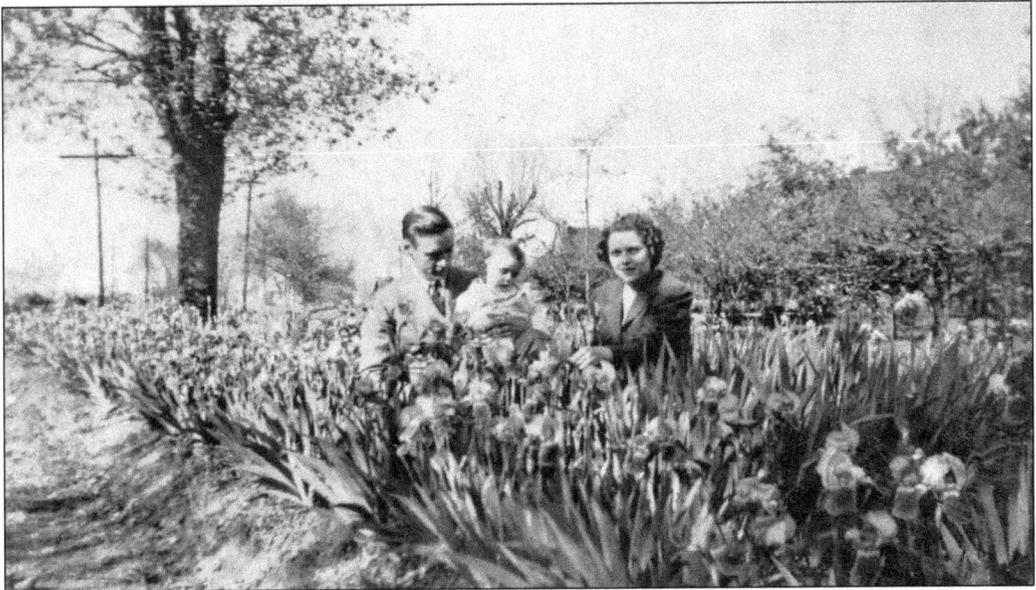

TANGLEWOOD HISTORIC DISTRICT. Tanglewood Historic District is just upstream on Love's Branch from the site where historians believe the original 1700s Haysborough township was located. This unique collection of cottages typifies the Arts and Crafts architectural movement, which is known to harmonize with the landscape. According to the Historical Commission of Metropolitan Nashville and Davidson County, Tanglewood Historic District was developed from the 1920s to 1940s by Robert M. Condra, a prominent Nashville builder.

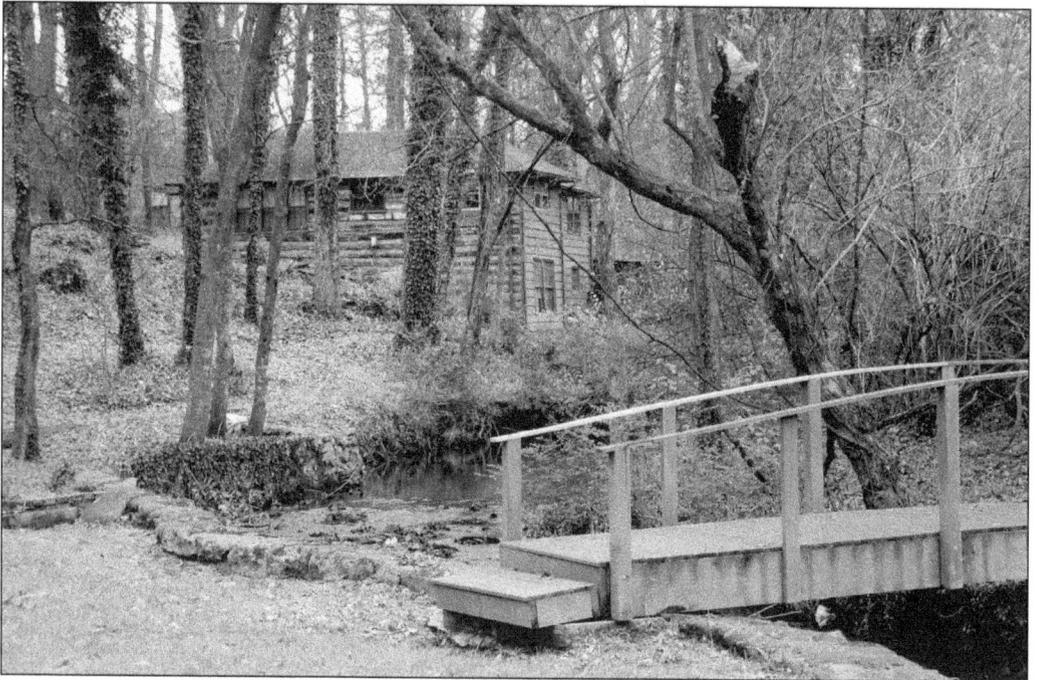

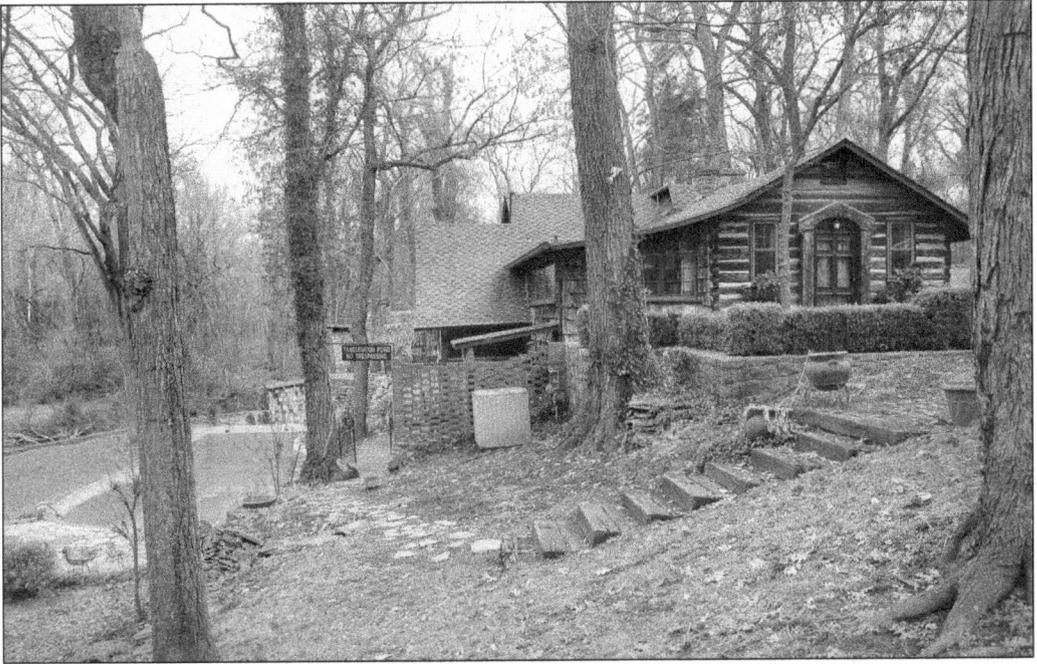

Tanglewood Pool House and Cabins. The Tanglewood cabins feature natural materials, and many of the beams in the cabins are thought to have been taken from the original Haysborough cabins. In the 1920s, Love's Branch was diverted to fill this pool, and the constant current from the creek kept the pool clean. Dr. Henry and Kathy Romersa have lovingly restored Tanglewood and have rented the pool house to notables such as Hugh Heffner, Waylon Jennings, and the Pointer Sisters. Charlie Daniels recorded several songs in the main cabin at Tanglewood because of its unique acoustics.

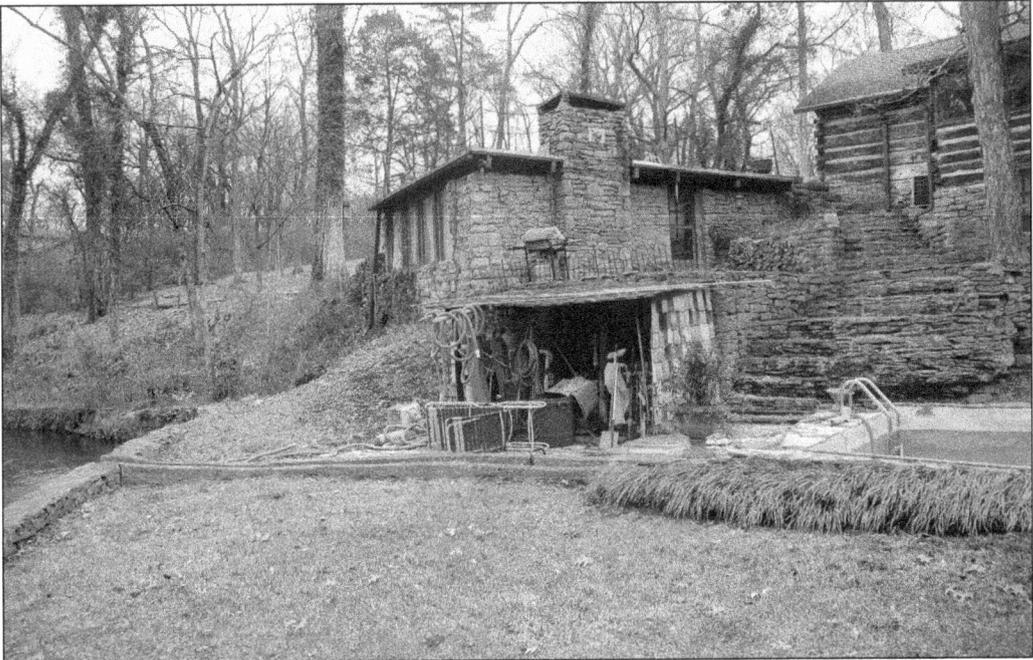

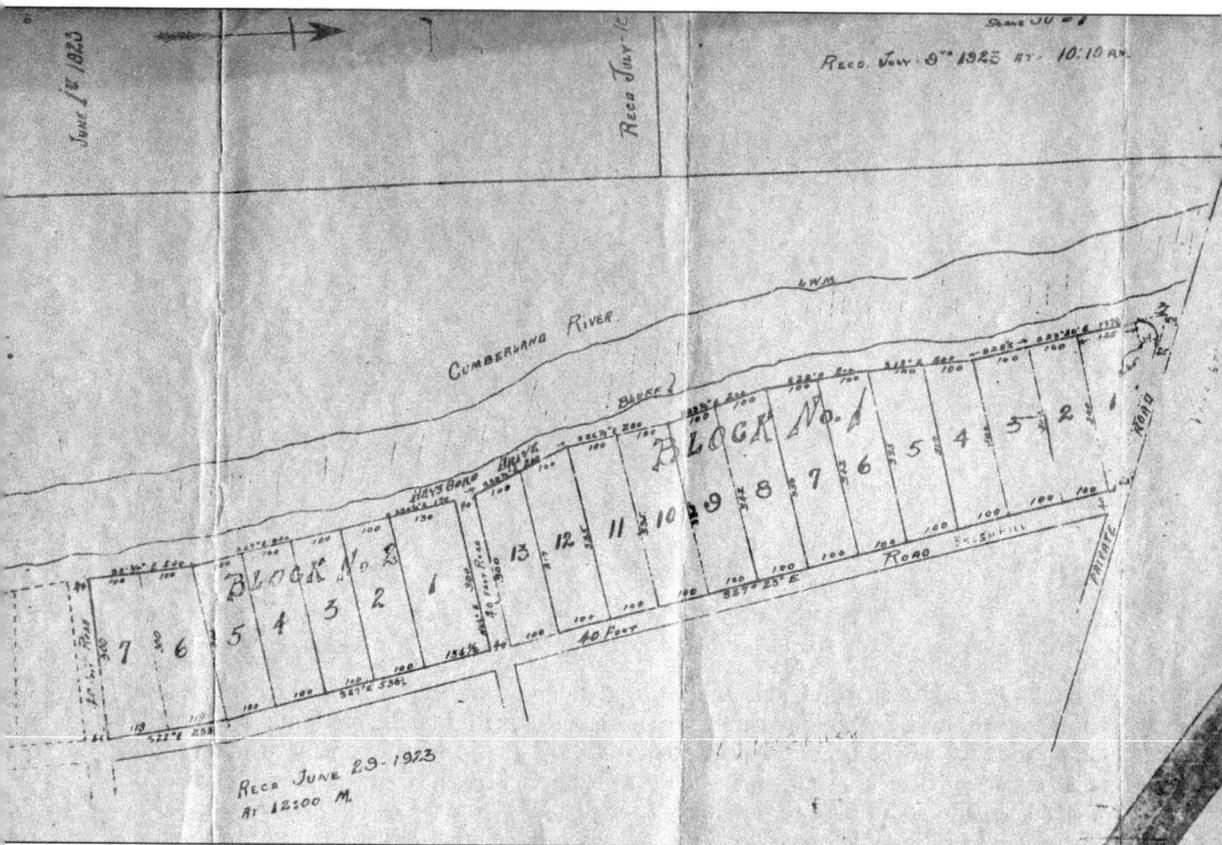

HAYSBORO-ON-THE-CUMBERLAND PLAT. In 1923, A. J. and Marina McGaughey subdivided a large tract of the land on the banks of the Cumberland River that they had inherited from their great uncle, Jim T. Love. In tribute to the old town of Haysborough, which lay several hundred feet to the north, they named it Haysboro-on-the-Cumberland. This community was made up of cottages for city dwellers to enjoy during the heat of the summer. Notice that these lots ran from Haysboro Avenue to Brush Hill Road; most of the homes faced Haysboro towards the river. Haysboro Avenue was either never completed or stopped being used so long ago that the remains cannot be found except on road maps. Many of the cottages that remain still face Haysboro Avenue and the river and show their backs to Brush Hill Road. (Peter King.)

Haysboro-on-the-Cumberland Summer Retreats. After a short drive, Nashvillians could quickly escape the city pollution and heat during the summer in Haysboro. Many prominent Nashvillians had their summer homes here, including railroad executives who built their cabins out of old railcars. The railcar numbers or the railroad names are still visible on the wood used in the framing of many of the homes. Several politicians had summer cottages here as well. Hillary Ewing Howse, known for championing causes for the poor, was mayor of Nashville from 1923 until his death in 1938. He is pictured above with his wife at their summer cottage in Haysboro. Below, a modern photograph from the river bluff shows a view of Pennington Bend not too different from the 1920s. (Right, TSLA.)

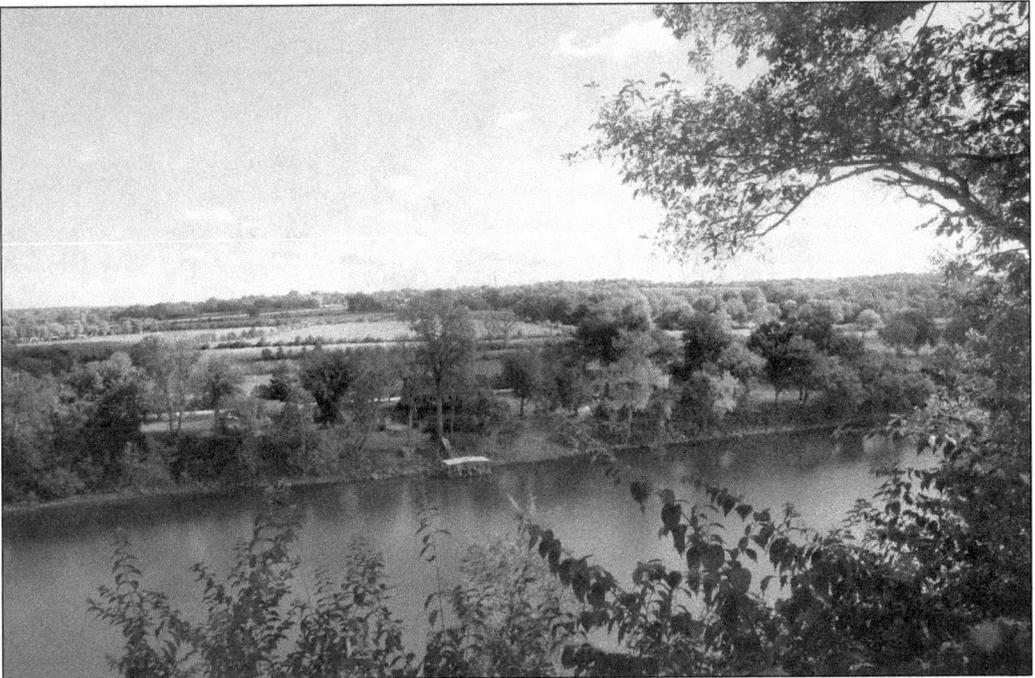

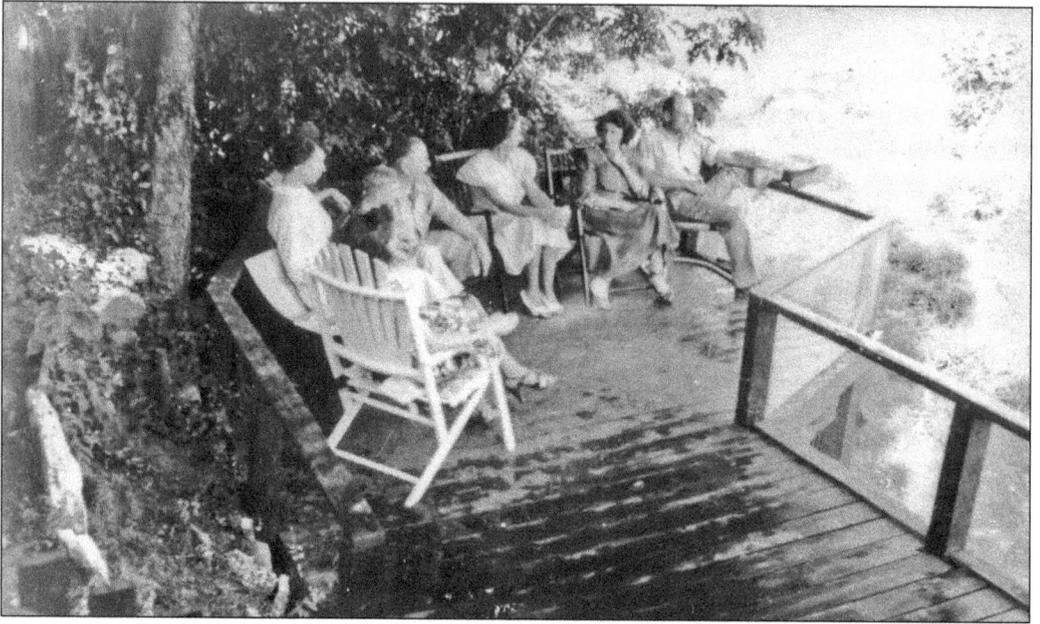

THE RIVER BLUFF ON BRUSH HILL ROAD. The cool air off the river and the high ground make the temperature cooler here even in the middle of summer. According to several residents, the river was much higher before the dams were installed in the 1950s. Most people could not imagine being able to walk down to the river today. Here a family enjoys the view from the bluff in the 1940s. Some houses had cranes that dropped boats down to the river and lifted them back up. The stairs at this house wind down the bluff to the river. (Courtesy of Ann Brush.)

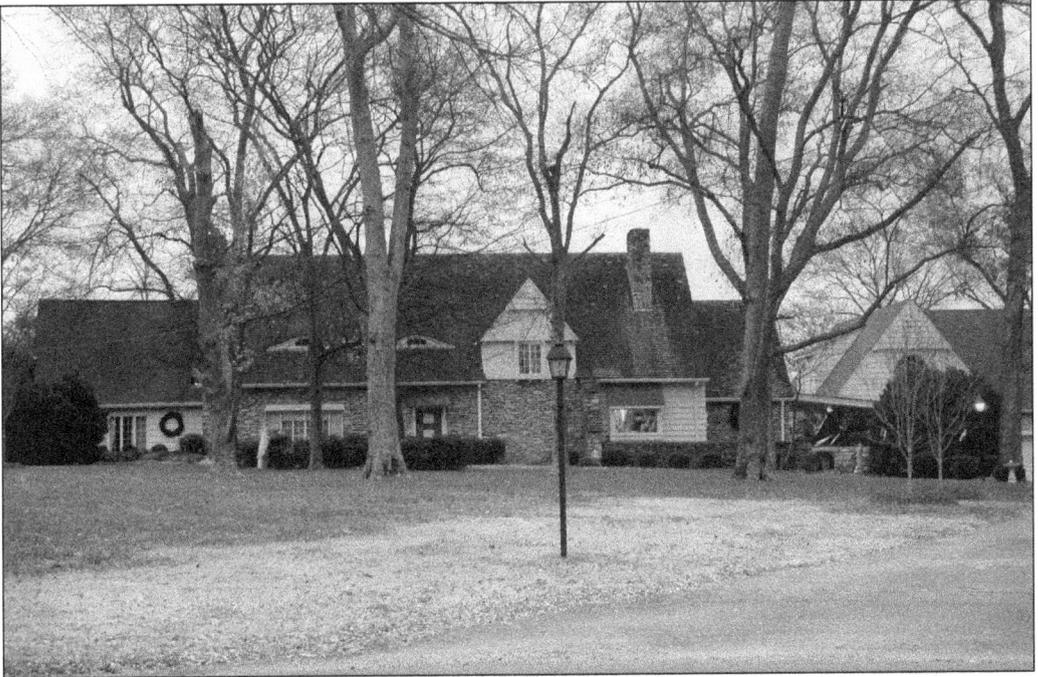

NASHVILLE BUSINESS EXECUTIVES SETTLE ON THE RIVER BLUFF. As city services became more available in Inglewood in the mid-1930s, it wasn't long before lots were bought by local business executives who wanted an estate home on the bluff overlooking the Cumberland River. Many of these people either bought empty lots that had never been developed or tore down existing cabins to build their dream homes; some of the homes were built as part of the Riverwood subdivision. The Tudor-style home above was once the residence of Owen Howell Jr., president of Genesco Shoes. The Brush Hill Road home below belonged to Allied Sound chief executive officer Jim Howell and his family. (Below, JH.)

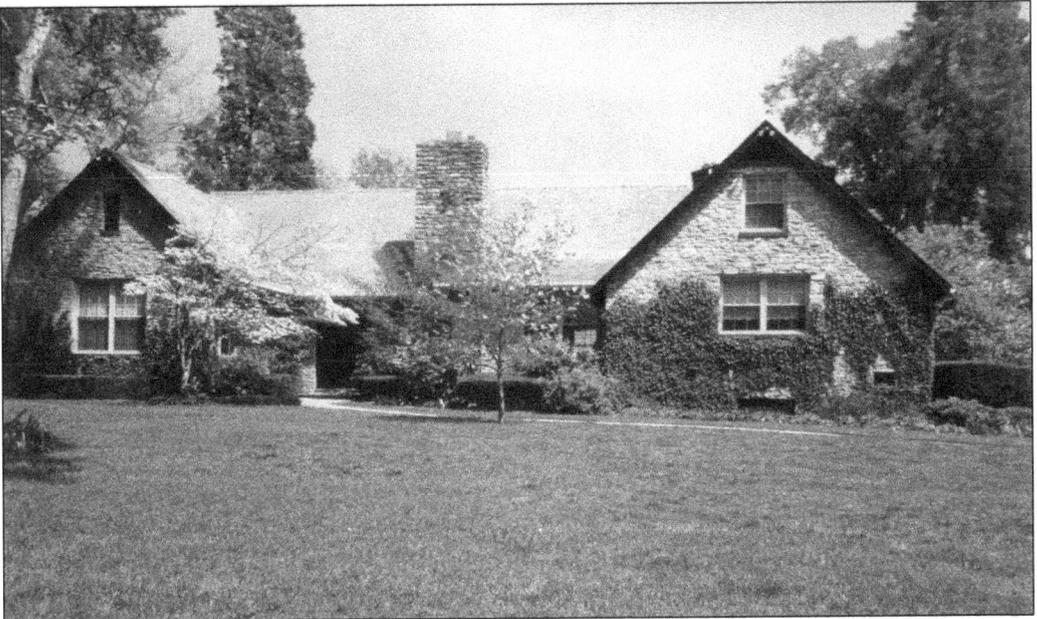

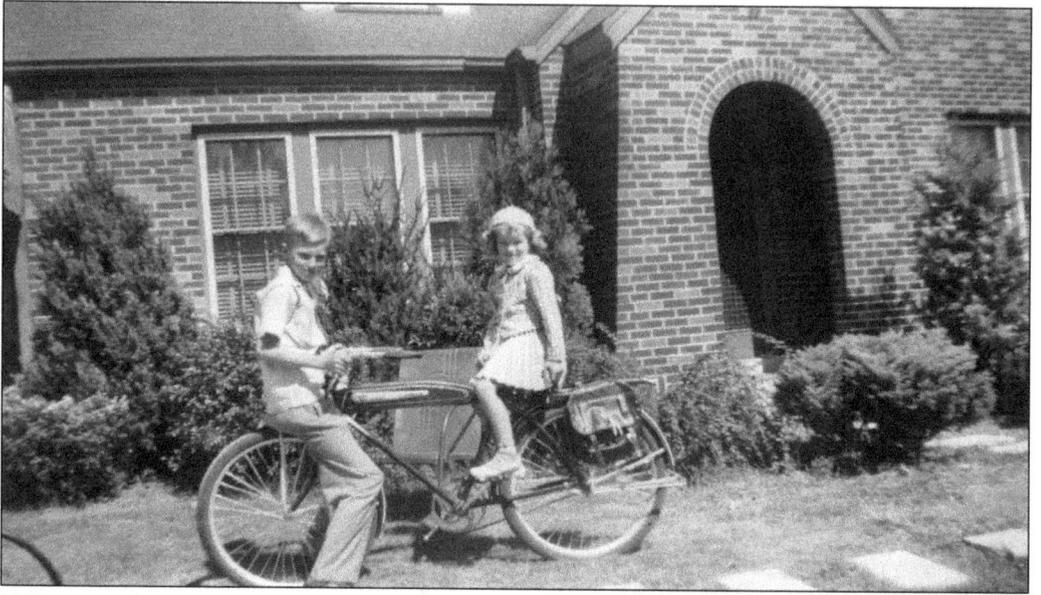

RIVERWOOD DRIVE AND MOSS ROSE HOMES. The Riverwood area of Inglewood was subdivided in the late 1920s. It was apparently named for the Riverwood mansion and farm. Several architectural styles are found in Riverwood reflecting what was popular during the time, including Craftsman, Cape Code, English cottage and, of course, Tudor. Bill Hunt and his sister Betty are shown sitting on a bike in front of their Tudor-style home on Riverwood Drive. The cabin below is an example of the cottage style from the Waddey's River Bluff subdivision on Moss Rose Drive. Today Riverwood remains a well-organized community. The Riverwood Neighborhood Alliance, Inc., was established in 1996 and has been expanded and renamed the Inglewood Neighborhood Association. (Both BH.)

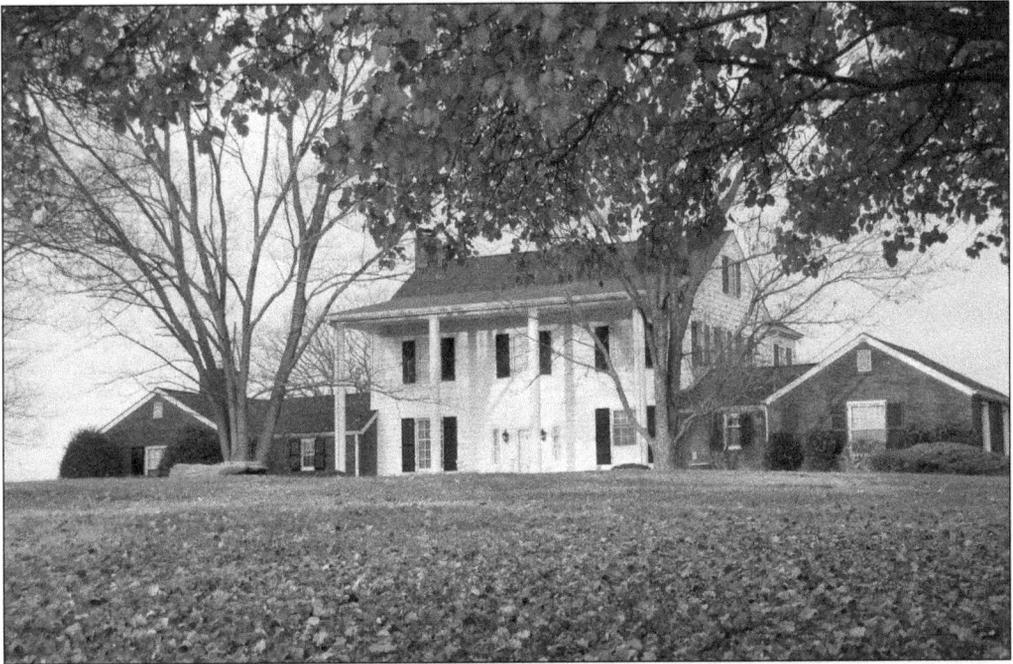

Roy Acuff's Home and the View from the River Bluff at Moss Rose Drive. Roy Acuff, the "King of Country Music," is perhaps the best-known Inglewood resident. Acuff emerged as a country star in the 1940s and shaped much of Nashville's music industry, becoming the personification of the Grand Ole Opry. In addition to his performing talents, Acuff was a powerhouse in the music business, partnering with Fred Rose to form the hugely successful Acuff-Rose music publishing venture. He had an abiding love for log cabins and built several of them in the area. His most memorable Inglewood residence is the large white Colonial home on Moss Rose Drive shown above, where he looked out over the river bluff and watched Opryland being built. The photograph below shows the Hunt family, who lived next door to Acuff, and the view from the bluff before Opryland USA was built. (Below, BH.)

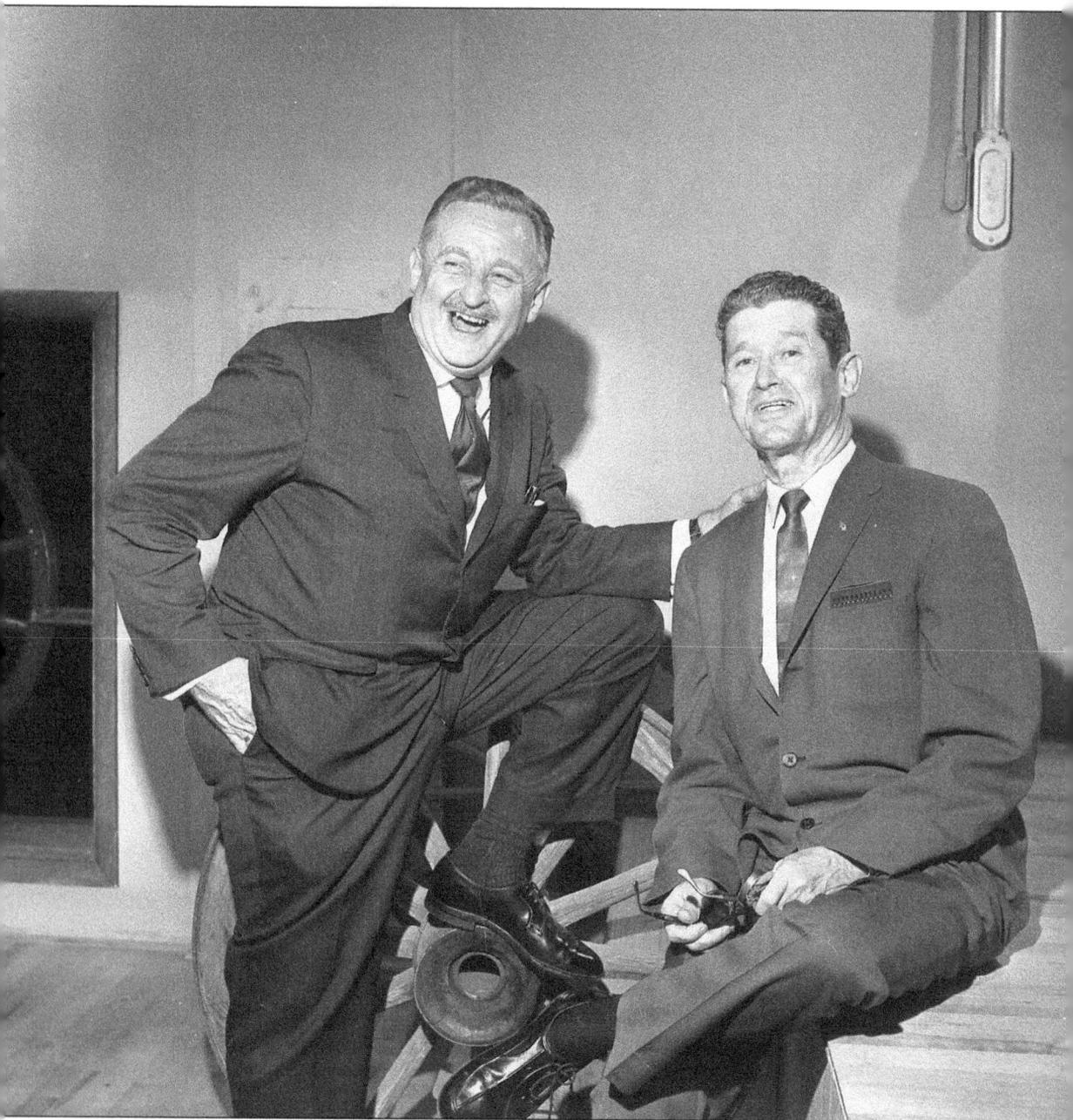

ROY ACUFF WITH MAYOR BEVERLY BRILEY. Acuff is fondly remembered in Inglewood, where neighbors recall him shopping at the local grocery (always tipping his bag boy) and dropping in at Riverside Pharmacy for his favorite—a butter pecan ice cream cone. In this photograph, Acuff is pictured with his neighbor, Nashville mayor Beverly Briley (left). The Briley home on Winding Way in Jackson Park was just a few miles from Roy's home on Moss Rose Drive. Acuff had his own brief affair with politics. He ran for governor as a protest candidate in 1944 after then-governor Prentice Cooper said that country music was "disgracing the state." In 1948, he was the Republican nominee for governor, with a platform based on the Golden Rule and Ten Commandments. He was defeated by a 2-1 margin. (TSLA.)

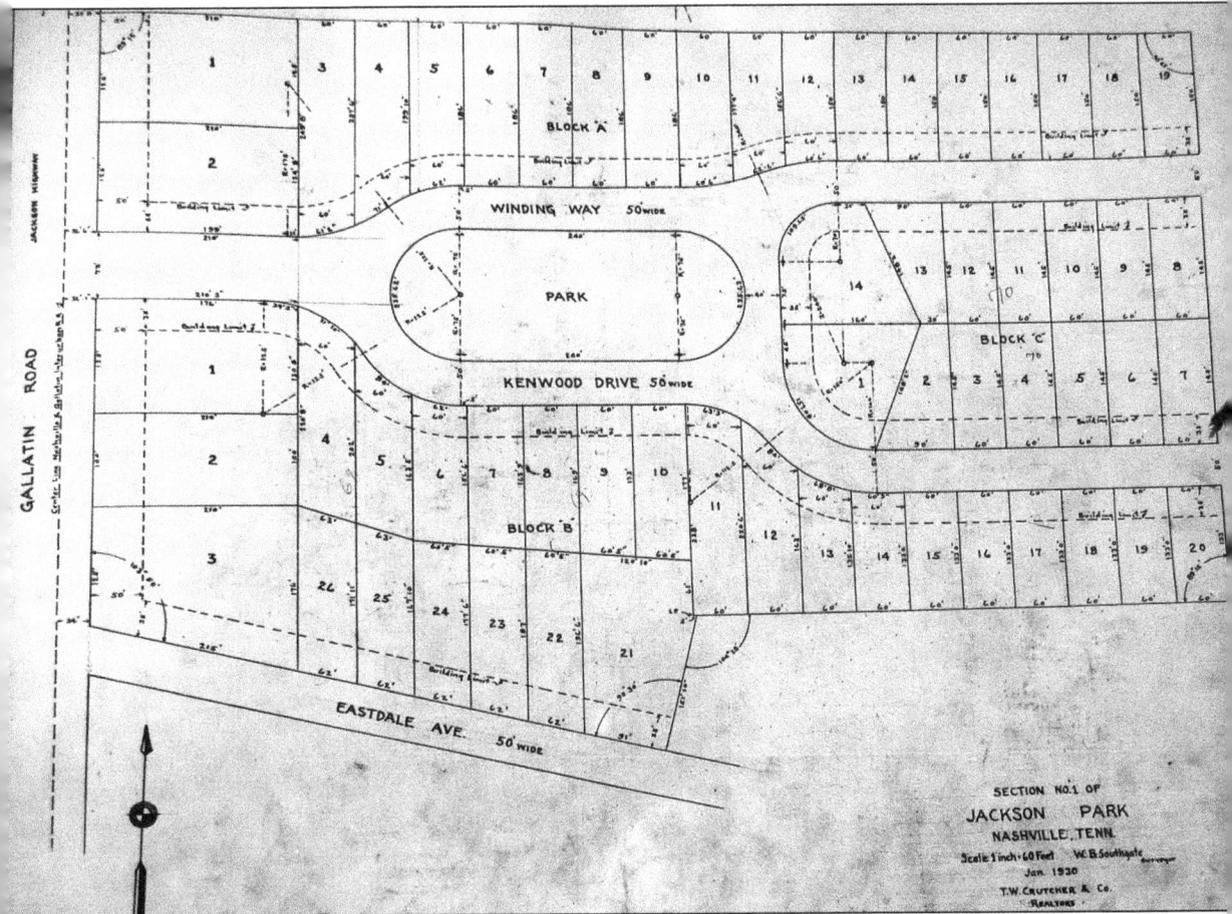

JACKSON PARK PLAT. In 1930, a new subdivision was created and dubbed the "Bellemeade of East Nashville"—Jackson Park. It extended from Gallatin Road at the Jere Baxter Masonic Lodge to Brush Hill Road. This subdivision reflected the change in lifestyles of the newly rich—sidewalks were deemed passé for families with multiple cars. Lots were oversized to incorporate much larger and wider homes that were beginning to add two and sometime three-car garages; the automobile suburb had arrived in Inglewood. The entrance to Jackson remains very much like it was in 1930s; the park at the entrance was bought by Jackson Park residents to maintain and to prevent development. The stone house at the entrance, built by the Nichols family, was one of the first homes constructed in the subdivision. (MNA.)

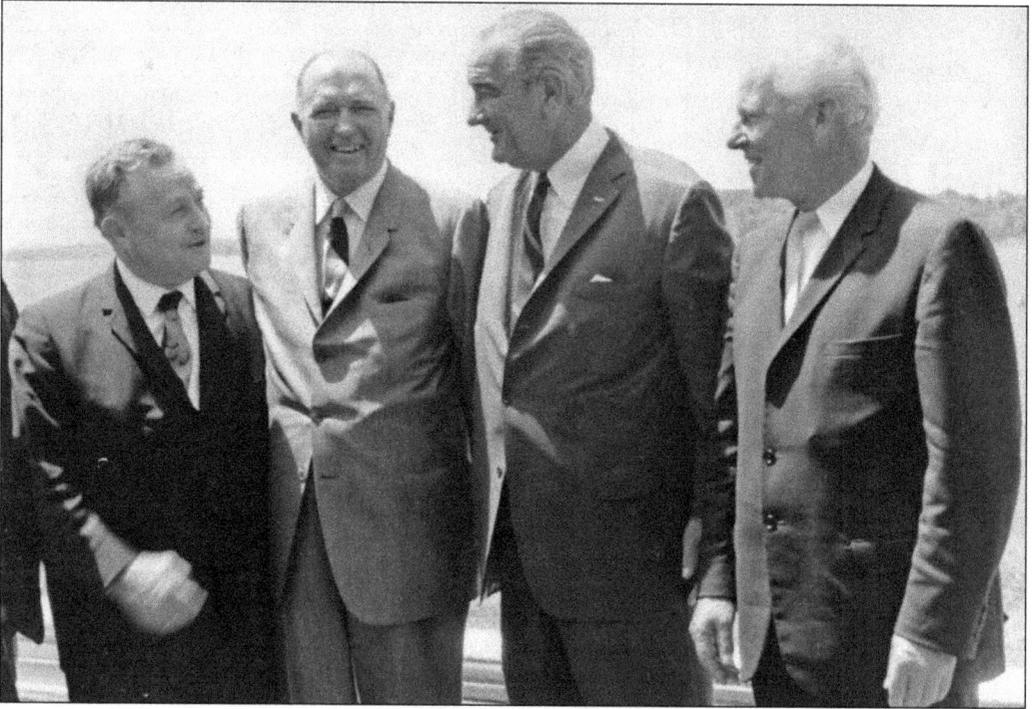

NASHVILLE MAYOR AND INGLEWOOD RESIDENT BEVERLY BRILEY. Inglewood resident Clifton Beverly Briley (1914–1980) was the first mayor of both metropolitan Nashville and Davidson County, serving from 1963 to 1975. He was active in city politics for more than 30 years, serving as chief judge executive of Davidson County before becoming mayor. His mayoral term passed during a time of significant change in Nashville and all Southern cities. Racial tensions were high, but Mayor Briley's cooperative approach to the city's black leaders is credited for easing Nashville's transition to desegregation. From left to right, Briley is pictured here with Tennessee governor Buford Ellington, Pres. Lyndon Johnson, and U.S. Sen. Albert Gore Sr. when the men were on a visit to Nashville during Johnson's administration. The Briley family lived in this Jackson Park home on Winding Way while Mayor Briley was in office. Briley Parkway, the expressway named in honor of the former mayor, passes over the Cumberland River nearby. (Above, Diane Briley Easterling.)

POST-WAR BUILDING BOOM. The automobile suburbs that had begun prior to World War II exploded after the war. A booming economy allowed more of the middle class to own cars, and the advent of Federal Housing Authority and, after the war, Veterans Administration loans permitted more people to enjoy home ownership with less down. As prices for land increased, area farms were enticed to subdivide. By the 1960s, all of the area farms were gone with the exception of the Jay Evans Riverwood Riding Academy. The Rosebank Dairy, Wild Acres, Fortland, Oakland, Dale, Williams, and Riverwood farms, and many more, were all subdivided into various home tracts including Rosebank, Burchwood Gardens, Porter Heights, Henderson Gardens, and Fortland. (Above, Ida May Infanti; below, Russ Thompson and the Pendergrass family.)

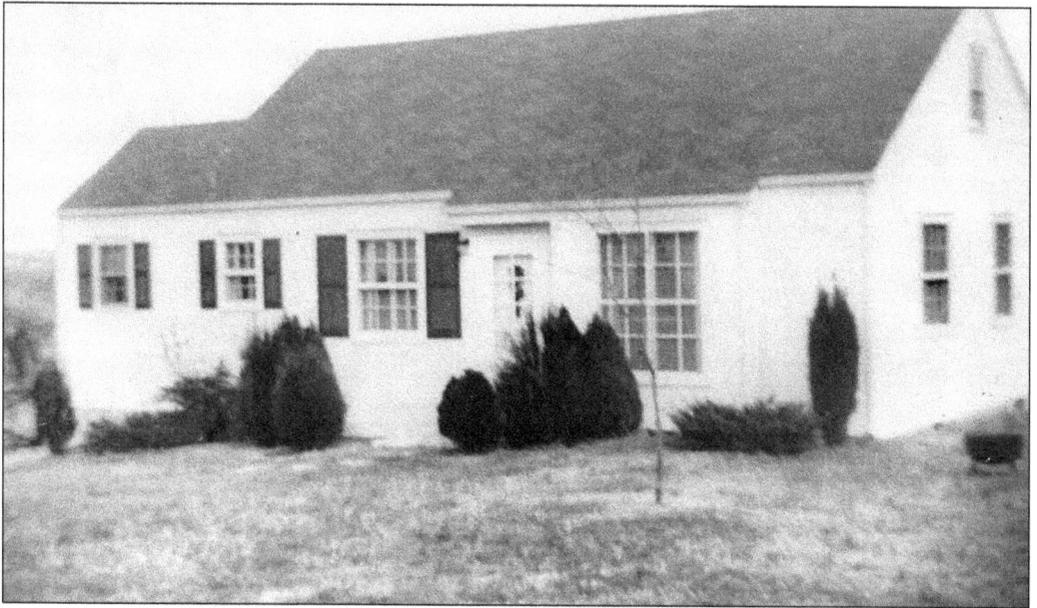

POST–WORLD WAR II HOMES REFLECT DEMOGRAPHIC SHIFTS. In the post–World War II Inglewood subdivisions, sidewalks became a thing of the past, yards got bigger, and kids had more room to play. Home tracts were built by single real estate companies or contractors, so the homes begin to look more alike, and the demographics for each area began to look alike as well. Businesses no longer had to be within walking distance, and the homes did not have to be within walking distance of the streetcars, forming a clearer divide between commercial and residential zones. All of these shifts are reflected in Inglewood's structures. It wasn't until the 1980s that many of the streets in Inglewood got sidewalks. (Above, Joyce R. Patton. Below, LC.)

CROSSING THE CUMBERLAND BY FERRY. As more and more people moved into Inglewood, congestion grew on Gallatin Pike, and waiting for the ferry to cross the Cumberland River became a daily activity. Even after the old Edgefield that only held three cars was replaced with the new Judge Hickman ferry that could carry up to five, many locals described having to wait over an hour to cross the river to get to their jobs at Dupont in Old Hickory. Drivers on Gallatin Road, Riverside Drive, and McGavock Pike began to experience bumper-to-bumper traffic. In order to alleviate this congestion, the city installed two new expressways, Ellington Parkway and Briley Parkway, the latter featuring a bridge that crossed over Love's Branch. In 1965, ferries stopped running at the end of McGavock Pike for the first time in more than 100 years. (Both MNA.)

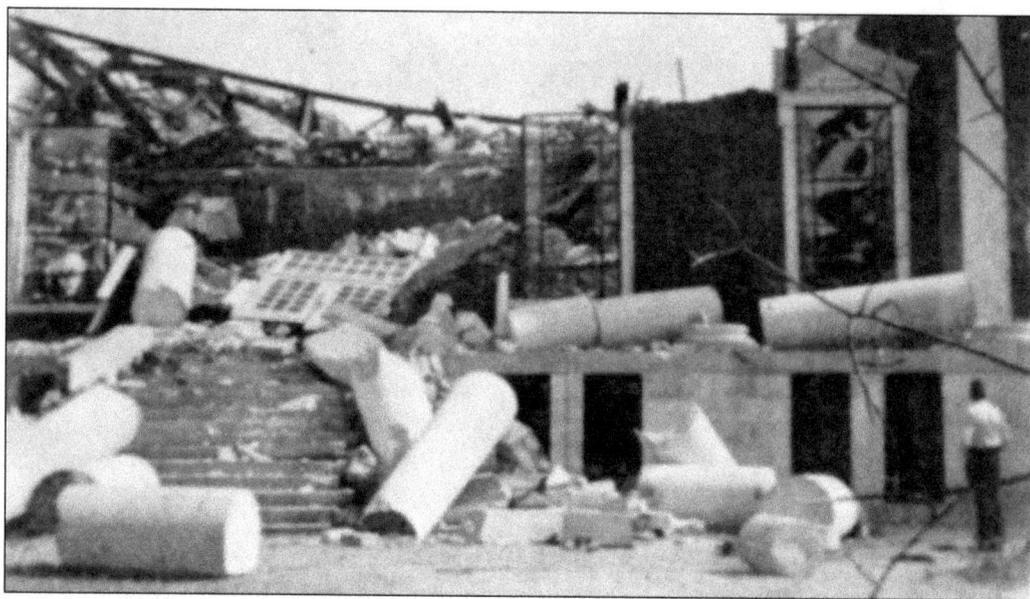

THE TORNADO OF 1933 TORE THROUGH EAST NASHVILLE AND INGLEWOOD. On March 14, 1933, at 7:30 in the evening, a tornado tore through downtown Nashville, leaving a path of destruction very similar to the path taken by the tornado that would go through Nashville in 1998. Ripping through East Nashville down Main Street, it cut across at Porter Road and into the Inglewood area. Many residents living at the time can remember it as if it were only yesterday. The tornado killed 11 people in Nashville, and 1,400 homes were damaged. Inez McFarland Garner, who was 13 at the time, remembers how her mother was almost pulled out of their basement on Riverside Drive by the storm when the basement door was ripped off its hinges. As she clung to the stairs, the wind ripped her dress over her head, and all of the windows blew out. When the wind died down, they learned that two of their neighbors had died in the houses directly in front of them and right behind them. (Both Nashville Public Library.)

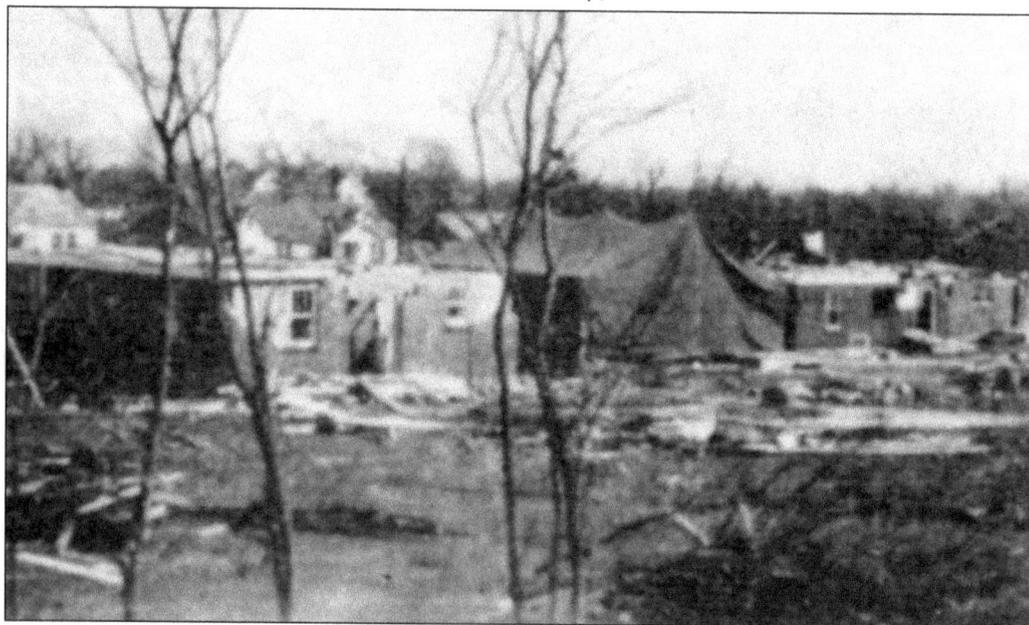

Three

COMMUNITY LIFE

Neighborhoods are more than a collection of buildings located close together. Rather, a neighborhood is a group of people living in close proximity who share a common history, practice similar beliefs and habits, and commit to protect and encourage the welfare of all members. These traits lead to the development of institutions to support civic life: businesses, churches, schools, and social and charitable organizations.

Long before the suburb of Inglewood was founded, Rev. Thomas B. Craighead built the Spring Hill Meeting House near the Cumberland River. The building served as both the first church and the first school. Community life had begun. Traders brought provisions to sell to the families living along the Cumberland River, and trading posts opened to serve residents as well as people traveling along the busy road between Nashville and Gallatin. Social and civic organizations sprang up to meet the needs of residents and to provide relaxation and recreation.

After the Inglewood Land Company began offering lots for sale, a new style of neighborhood began—suburbia. Within its boundaries were institutions to meet many of the needs of residents. Schools were opened to serve the children, and churches were formed to offer worship for families closer to home. The Inglewood Madison Police Patrol was incorporated in 1941 to promote public safety; the Inglewood Madison Fire Department formed to protect the community from fires. Businesses, restaurants, and recreational facilities began to thrive; doctors, dentists, and other professionals also brought their offices to Inglewood.

A mother raising her children in the suburb would be able to send them to school, visit a doctor, purchase medicines from one of several pharmacists, buy groceries, send a funeral wreath to the family visitation at the neighborhood funeral home, find bug repellant at the hardware store, and become aware of the latest household hints at the Inglewood Home Demonstration Club. All the elements were in place to permit the neighborhood to prosper, allowing the families of Inglewood to bond together for the benefit of all.

JERE BAXTER SCHOOL CLASS. Jere Baxter School was opened in 1888 on land donated to the school district by Jere Baxter and his wife, Mattie. The one-room frame structure housed 12 students who traveled to and from school with their teacher, Carrie Sharpe, in her horse-drawn wagon. Fire destroyed the first building. The photograph above shows a class seated in front of the building erected in 1915 and expanded in 1920. (Diane Hood.)

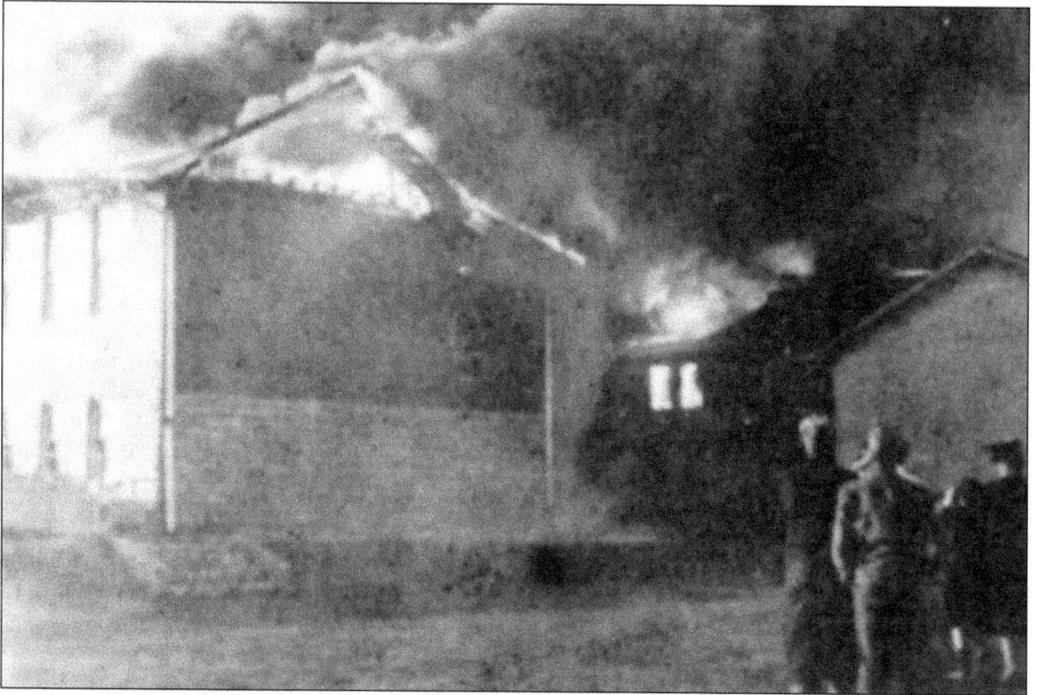

JERE BAXTER SCHOOL BURNS. The small brick school was razed in 1941, and a new building was finished and occupied in early December. Fire destroyed the school on the evening of December 6. Classes were moved across the street to the Inglewood Methodist Church, where they would remain until the new building was completed in October 1942. (EF.)

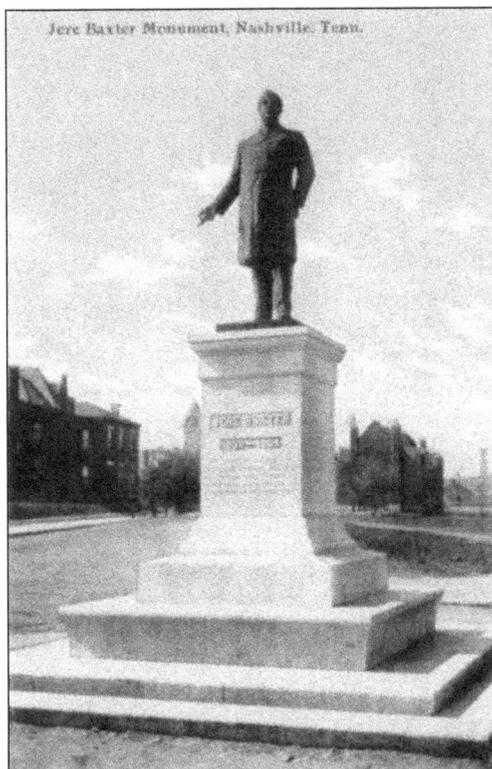

JERE BAXTER MONUMENT. Originally located at the intersection of Sixteenth Avenue South and Broadway in downtown Nashville, this monument was moved to the school named for Baxter during the 1945–1946 school year. When the school moved to a new building in 1997, the statue was also relocated. (MNA.)

Jere Baxter Monument, Nashville. Tenn.

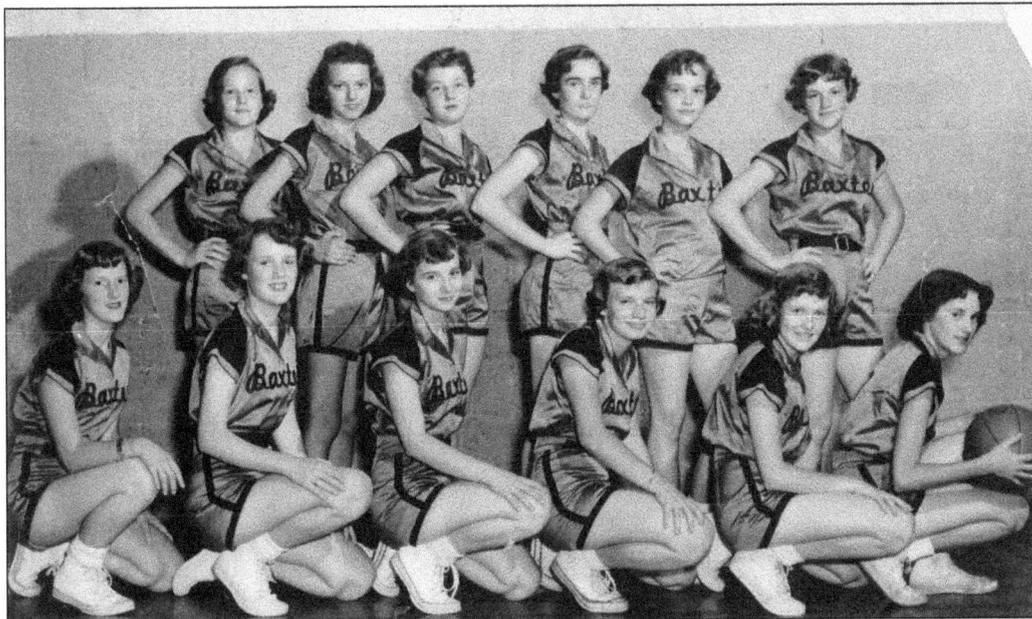

JERE BAXTER GIRLS BASKETBALL TEAM, 1953. Team members pose in the gymnasium. From left to right are (first row) Linda Fergus, Judy Hamblen, Carlyn Holly, Nancy Lucas, Patsy Borum, and Bobbie Graham; (second row) Pat Akin, Norma Sullivan, Martha West, Mary Wherry, Pat Clark, and Judy Jennings. Wherry became the assistant director of recreation for Metro Parks and mentored countless young men and women during her 42-year career. (Patsy McCullough.)

ROCK CITY ELEMENTARY, INTERIOR VIEW. This school for African American children was built entirely with funding from the families of Rock City and the Men's Social Club of the First Baptist Church South Inglewood. At this dinner, founding families of Rock City are gathered inside the school building: Bridgewaters, Sweeneys, Buchanans, Pitts, Browns, Whites, and the Boleyjacks. (JBB.)

ZULA SMITH RICE'S KINDERGARTEN. One of the first kindergartens in Nashville was opened in the 1920s by Zula Smith Rice on Scott Avenue. She was highly respected as an educator. On the far left are the Robinson twins, Muriel (hands on hips) and Maude (looking over Muriel's shoulder). Muriel is a judge for the general sessions court, and Maude operates the family business, Phillips and Robinson Funeral Home. (MRH.)

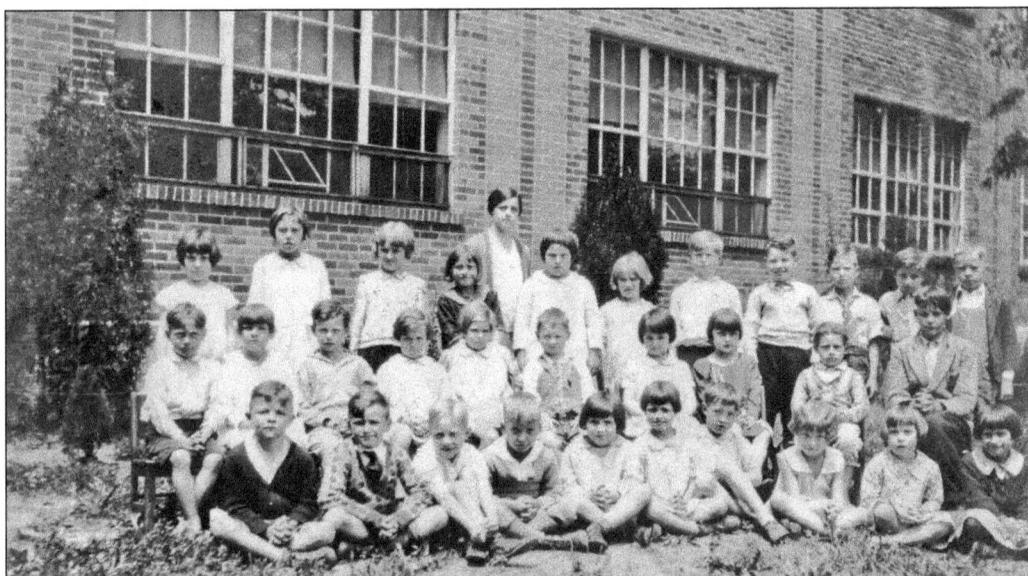

Miss Ida's Class, 1930. Miss Ida, in the center of the back row, assembled her students on the lawn in front of the new Inglewood Grammar School. Classes were first held in a tent on the grounds in September and October 1929 while the building was being completed. Older boys sat around the tent's outer edges to hold onto the tent poles when the wind was strong. (Beatrice Rader Jones.)

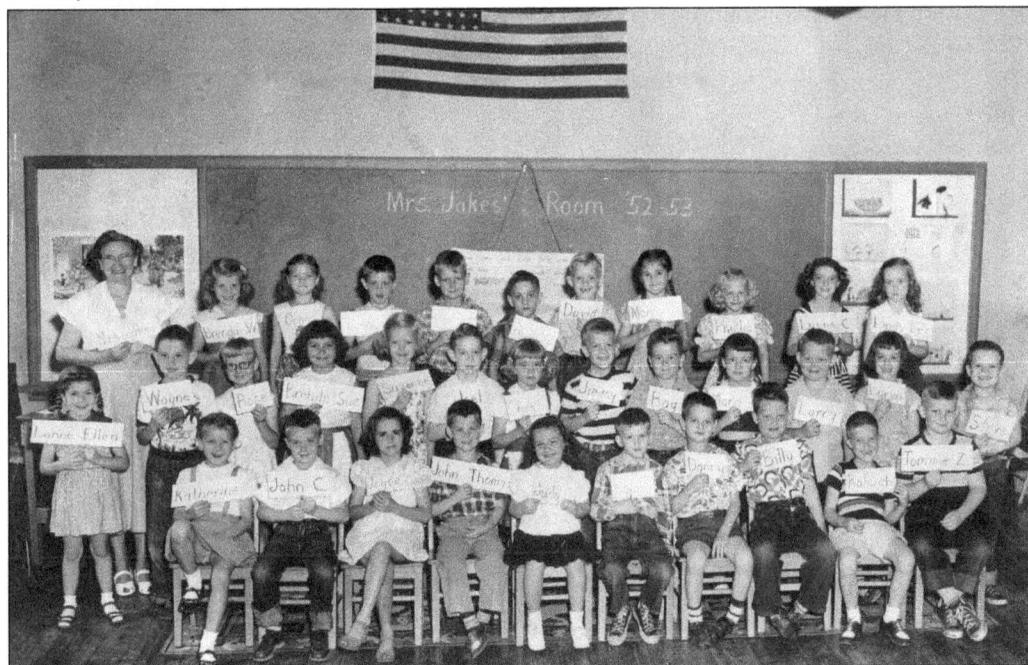

Mrs. Jake's Second-Grade Students. A new wing was added to the school in 1948 to handle the increased enrollment. The first hard-surface court in the school system was installed on the grounds, and Inglewood still served first through eighth grades. This photograph was taken in the 1952–1953 school year, before Alaska and Hawaii had entered the Union, so the flag has 48 stars. (Ida May Infanti.)

DAN MILLS SCHOOL. Dan Mills School was named for a man who served many years on the board of education and was a champion of teachers. It opened on September 1, 1937, with four teachers and 110 students in grades one through seven. The photograph shows the 1952–1953 first grade class. The growing Inglewood population required additions to the school in 1941, 1950, and 1953. (Ruth Hewgley Wayman.)

GRADUATING CLASS OF DAN MILLS SCHOOL. Students at Dan Mills enjoyed a vibrant learning environment that included team teaching, high-level reading programs, and an active assortment of special-interest clubs. The school was known for its well-maintained grounds and was a frequent recipient of the Metro Beautiful Award. The graduating students looked forward to moving on to Isaac Litton High School. (Ruth Hewgley Wayman.)

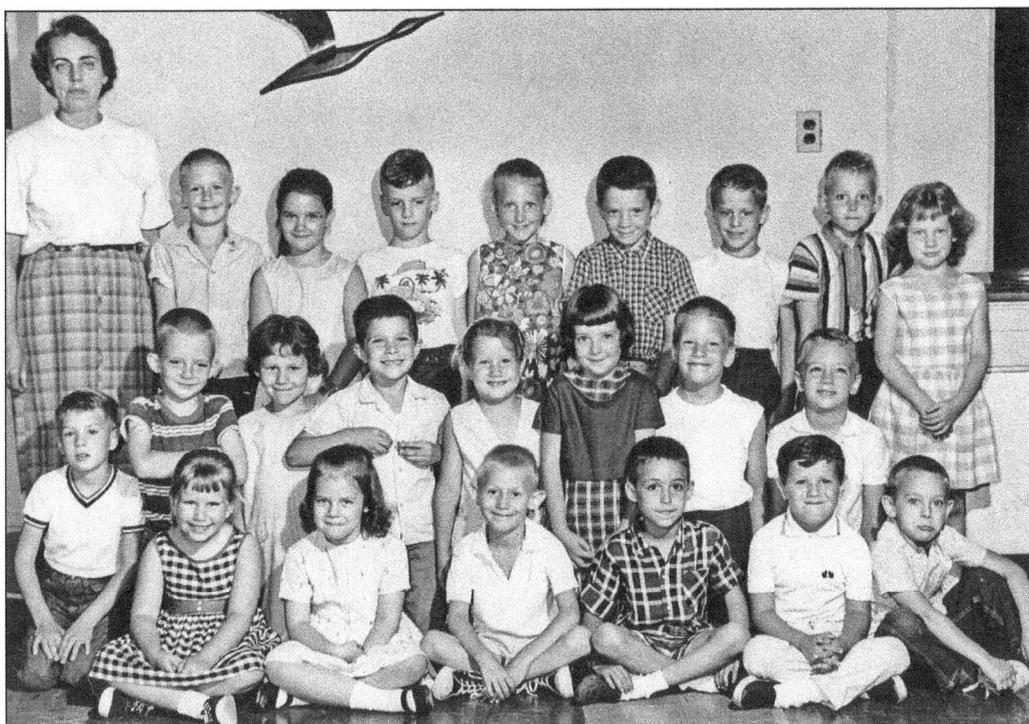

DALEWOOD ELEMENTARY. Dalewood Elementary School was built at the corner of McGavock Pike and Stratford Avenue to handle the increase in school-age children in Inglewood. The boy seated second from the right on the first row is Lloyd Warren Jr. His father, Chief Lloyd "Buddo" Warren, operated the Inglewood Madison Fire Department. (LWF.)

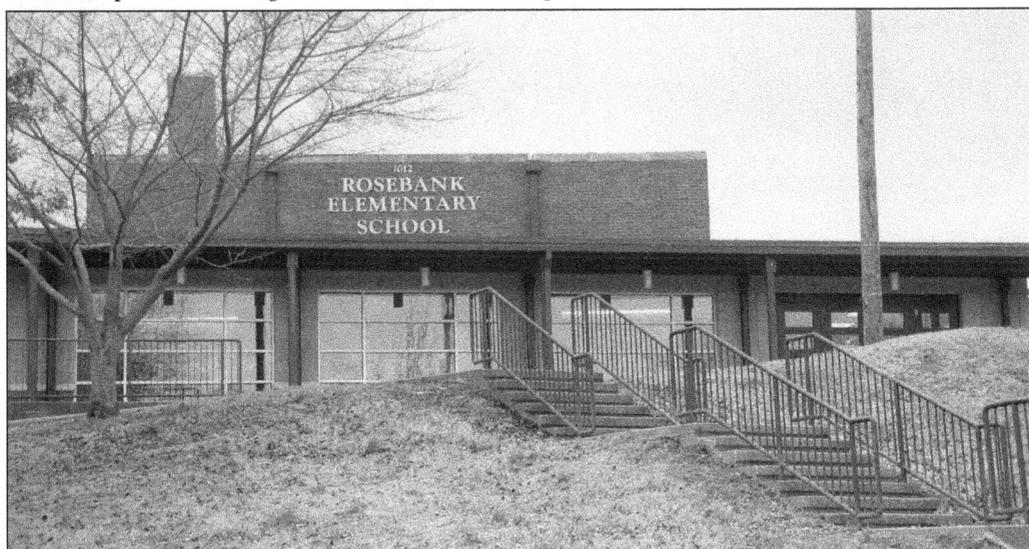

ROSEBANK ELEMENTARY SCHOOL. Inglewood parents anxiously awaited the completion of the new school they saw taking shape on the Rosebank Dairy land. They had purchased homes in the community knowing their children would be educated nearby. Their dreams were realized when the school opened in 1954 with grades one through six, a faculty of six teachers, and Principal Forest Marker.

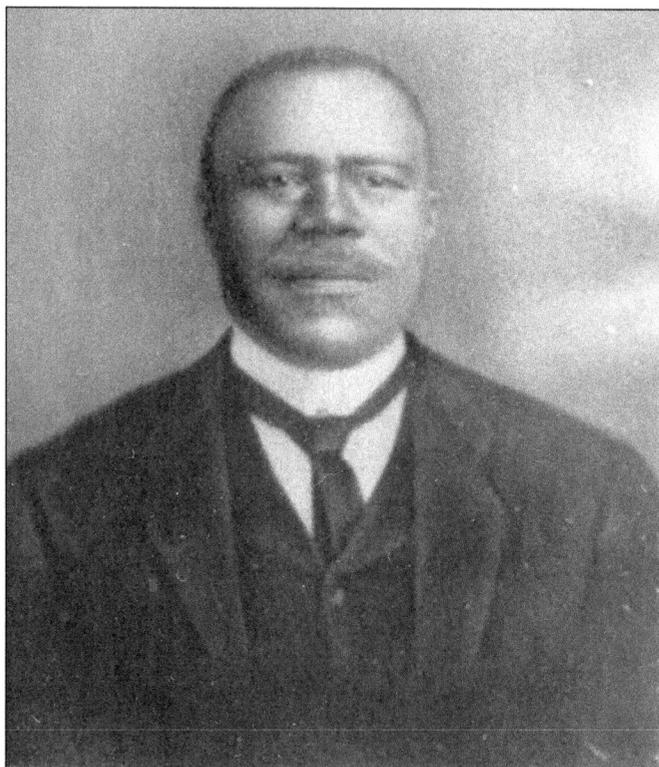

Rev. A. W. Wilson. Reverend Wilson founded the First Baptist Church Rock City in his kitchen in December 1881. The community of Rock City had sprung up around a quarry northwest of Porter Road. The African American families who settled in Rock City formed a tight-knit community where neighbors supported one another. (JBB.)

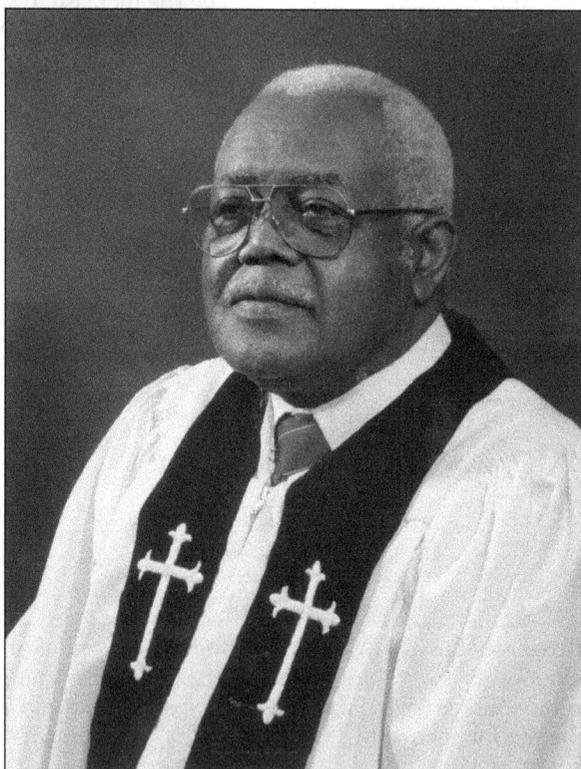

Rev. Thomas E. Sweeney Sr. Reverend Sweeney was called to lead the congregation in 1960 and brought new energy to the church. His leadership and diplomacy in the 1960s led to the inclusion of Rock City into the white community of Inglewood. He suggested the church would be more aptly named if it was called First Baptist Church South Inglewood. Under his guidance, members formed auxiliaries to offer aid and comfort to the community. (JBB.)

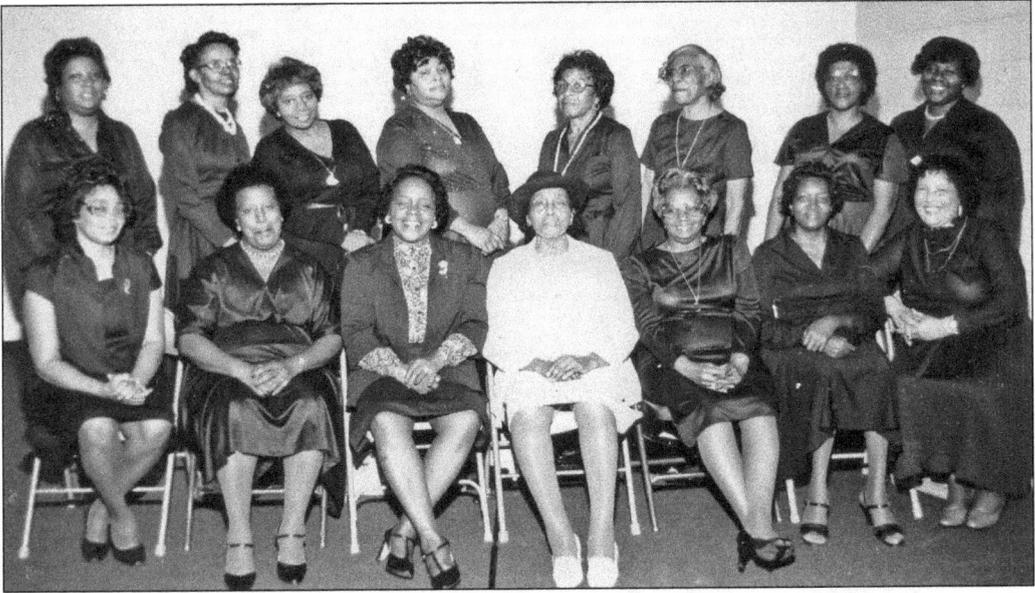

BEAUTIFYING CLUB. The church was a source of great pride in the community. The women of the Beautifying Club worked to maintain the appearance of the grounds and interior of the church building. One of their efforts was a pew drive, which provided pews for the sanctuary purchased by members. (JBB.)

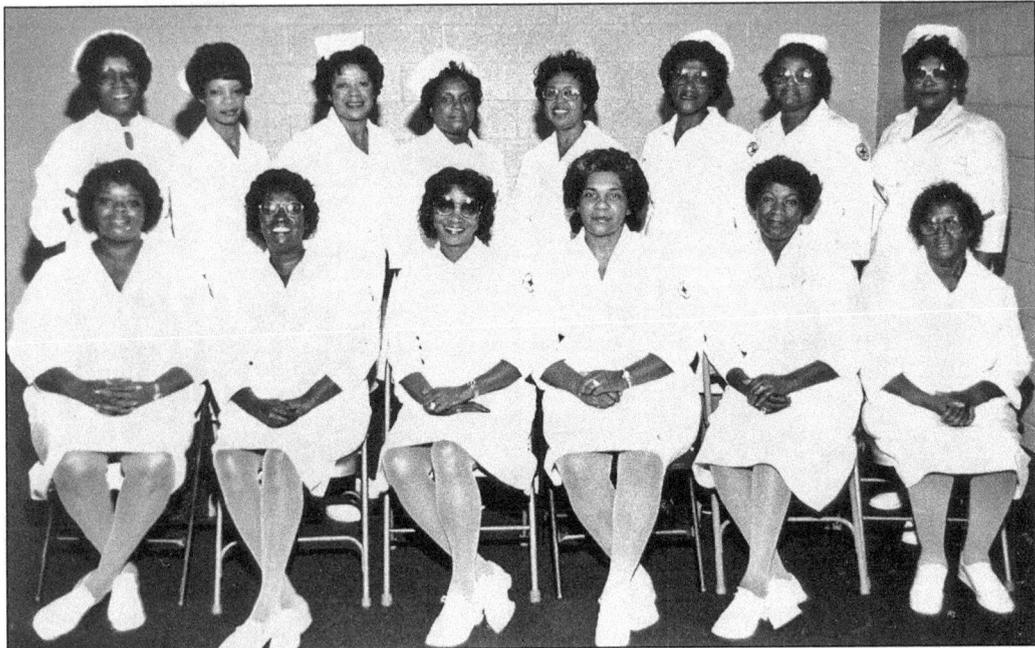

THE HEALTH MINISTRY TEAM. "Church nurses" are unique to African American churches. Dressed in white uniforms, white stockings, and starched nurses' caps, they sit in designated places during church services to provide aid to members. At First Baptist Church South Inglewood, three nurses are on duty at each service, and a nurse always attends each funeral. (JBB.)

SUNDAY SCHOOL ORGANIZED. This handwritten note marks the organization of the Inglewood Baptist Church Sunday school at the home of Mr. Robert J. and Mrs. Margaret Overall on November 11, 1923. The missionary society was organized on November 16 with Mrs. Overall as president; H. M. Estes was chosen as the first pastor. (IBC.)

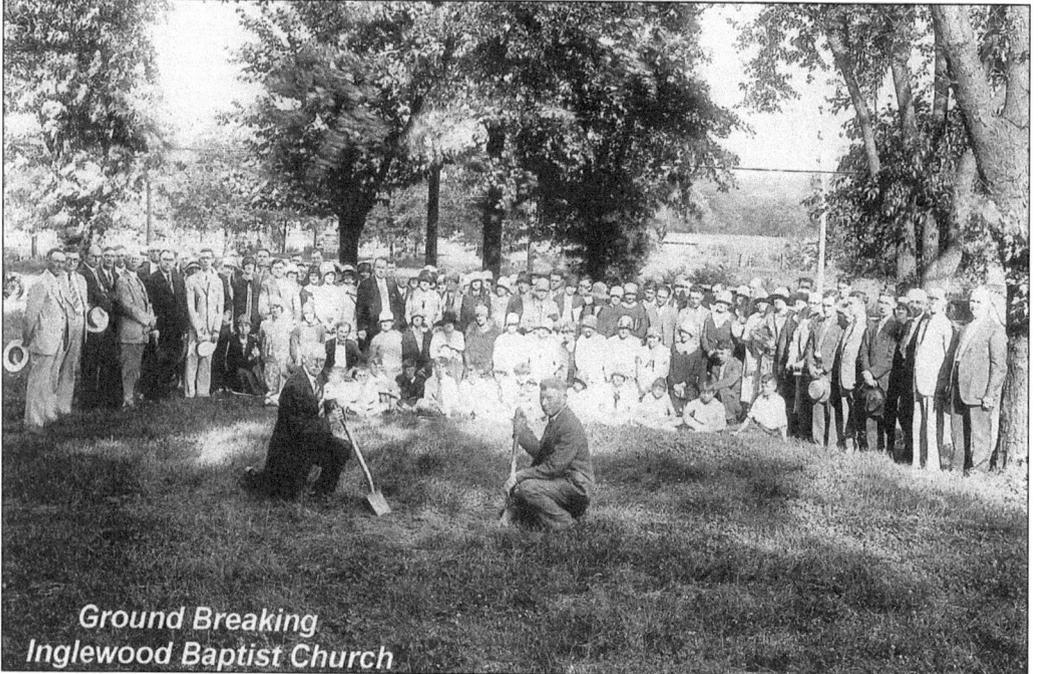

INGLEWOOD BAPTIST CONGREGATION, 1924. After meeting at members' homes, the congregation purchased a lot on Gallatin Road for a church building in March 1924. A temporary meeting space was quickly erected so the newly formed church could hold a revival service. In this photograph, members are gathered to break ground for the first construction on the lot. (IBC.)

WORSHIPPING IN THE BASEMENT. Construction of the basement auditorium began in August 1927. Services were held in the basement until a new auditorium was opened in 1948. In this photograph, the church choir is seated on the stage to the right of the pastor. The growing membership roll of Inglewood Baptist has led to standing room only during services. (IBC.)

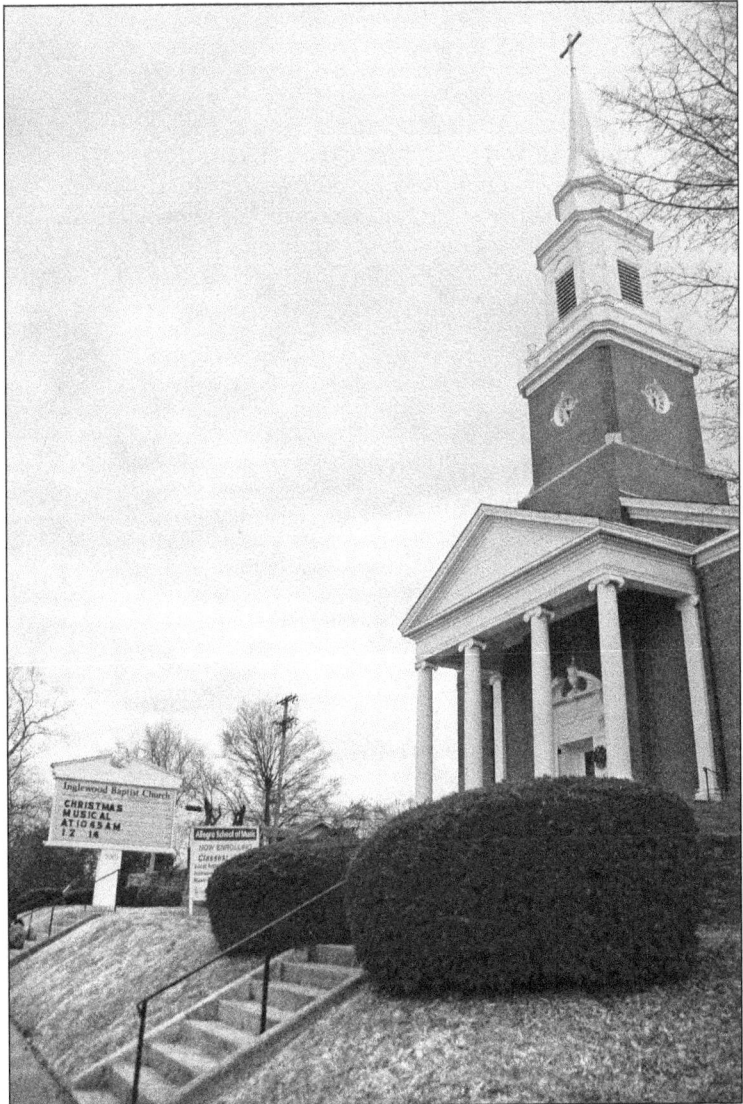

INGLEWOOD BAPTIST CHURCH EXTERIOR. Inglewood Baptist Church has grown from 32 members in 1923 to become a leading church for the neighborhood. Over its history, the church has sponsored other congregations, sent missionaries abroad, and developed ministries for all age groups. The building is a local landmark, with the steeple topped with a spiral reaching skyward.

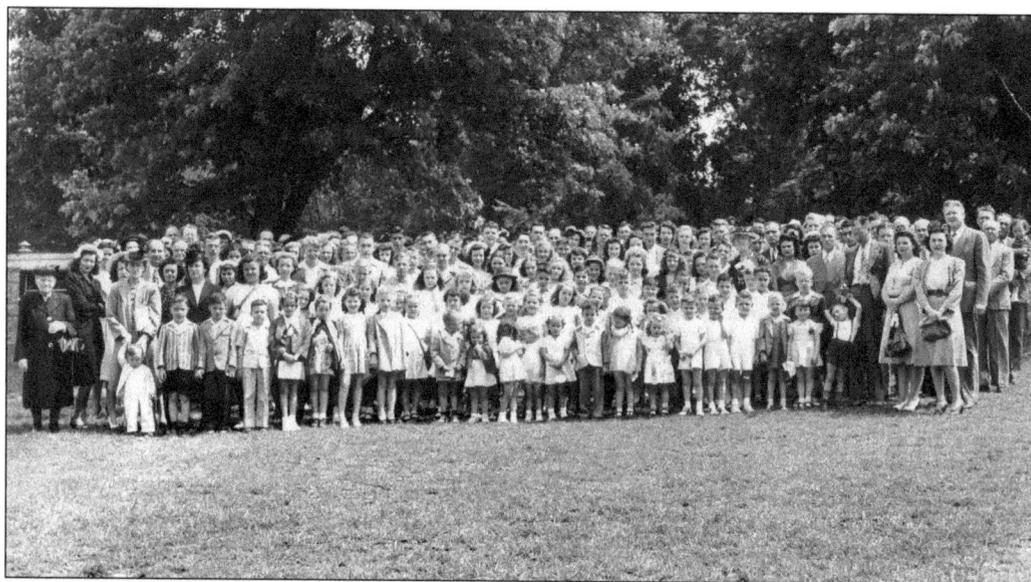

JACKSON PARK CHURCH OF CHRIST CONGREGATION, 1947. The church was started in 1932 with members meeting in a private home. Land with a house was purchased in 1933, and the church moved to Gallatin Road at Virginia Avenue. A basement auditorium was built in 1946 that would serve as the foundation for the new auditorium, built in 1950. (JPCC.)

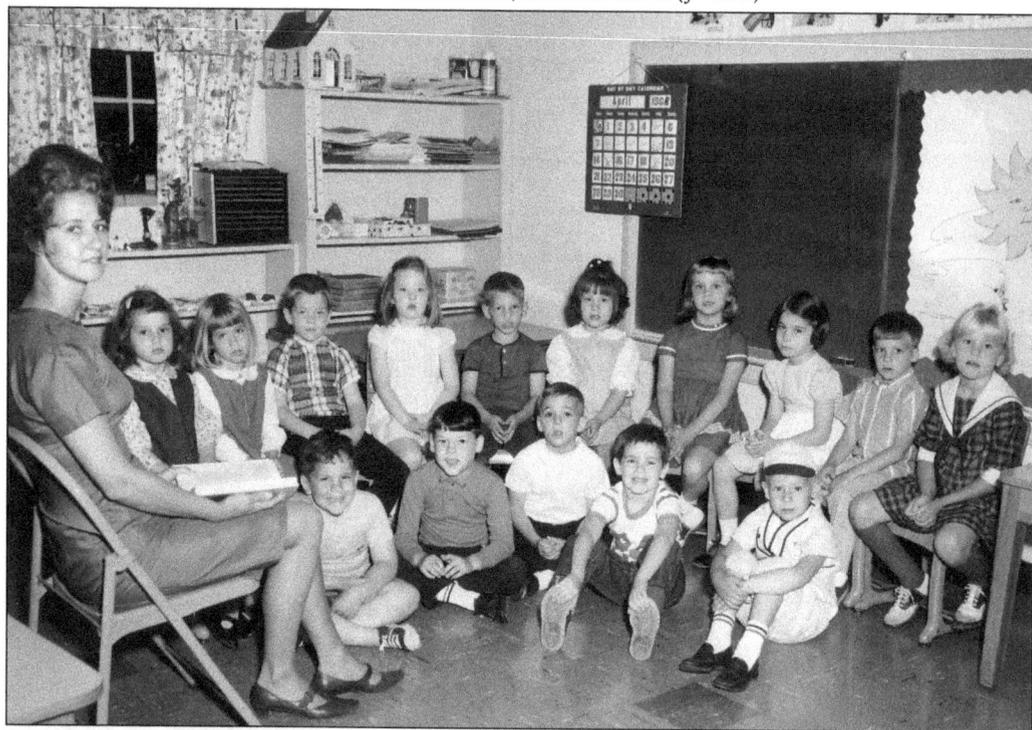

NANCY MCDOUGAL'S KINDERGARTEN CLASS, APRIL 1968. The church provided an invaluable service to the community by establishing a kindergarten program, since it was not offered in public schools. Hundreds of children passed through this program to prepare for an elementary school education. (JPCC.)

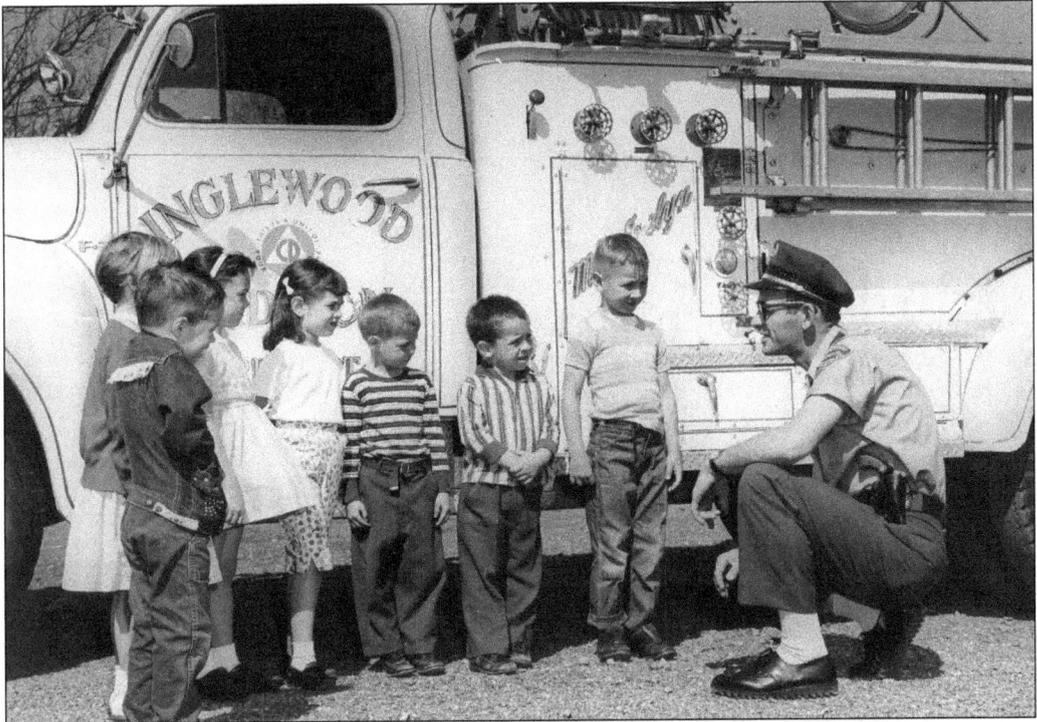

LEARNING FIRE SAFETY. A firefighter from the Inglewood Madison Fire Department talks with kindergarten students at Jackson Park Church of Christ about his fire engine and fire safety during a visit. The fire hall and police station were located across the street near the church. (JPCC.)

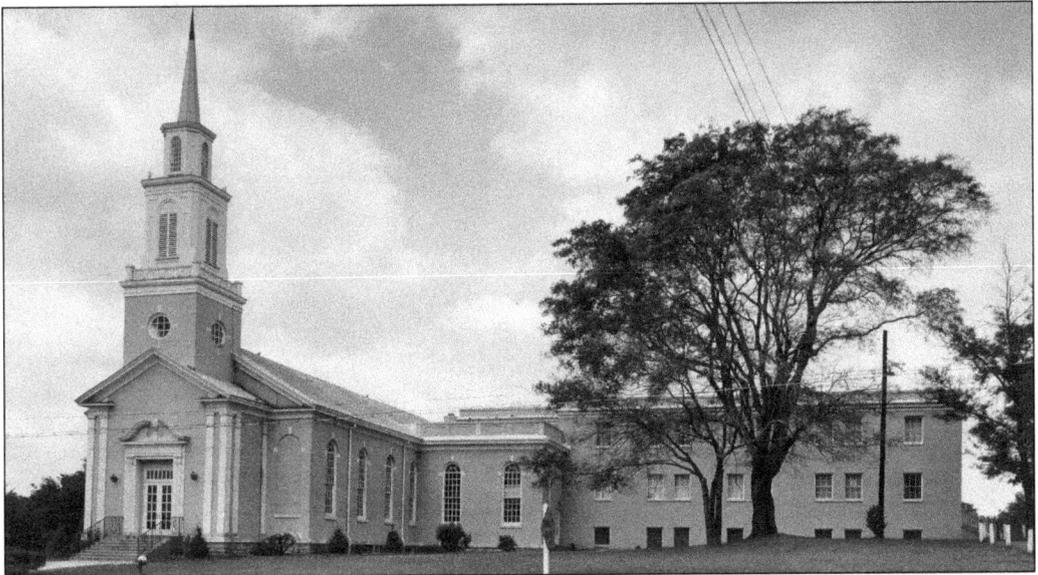

JACKSON PARK CHURCH OF CHRIST CAMPUS. This photograph shows the church in the late 1950s. There were now two services on Sunday morning to accommodate the membership. Mission and benevolent works also increased as the church sought to help fulfill the needs of families and children in the area. In 1969, the Jackson Park Christian Home opened to provide care and companionship for the elderly in need of living assistance. (JPCC.)

INGLEWOOD UNITED METHODIST CHURCH. Located across the street from Jere Baxter School, this church gave space for classrooms when Jere Baxter School burned and again when the Isaac Litton High School building was under construction. Inglewood is home to churches from many faiths: Presbyterian, Lutheran, Nazarene, Primitive Baptist, and others. (Ann Brush.)

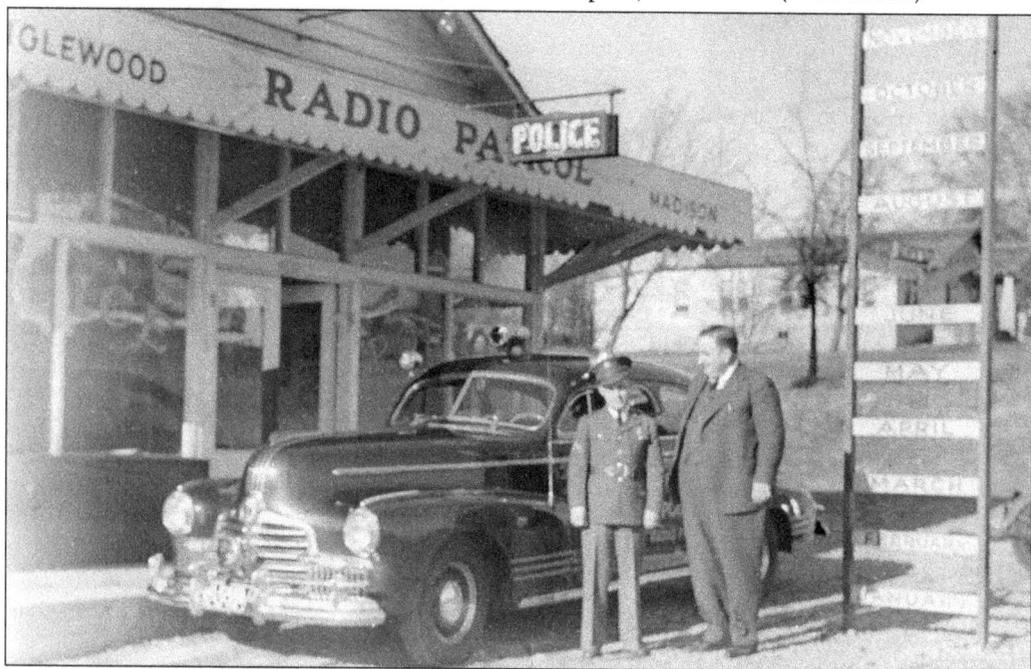

INGLEWOOD-MADISON POLICE PATROL. The police patrol was chartered in 1941 to protect life and property. Chief Raymond Cannon was a strong presence in the neighborhood, partly from the authority of the law and partly from his tall, 400-pound stature. The police and fire services shared this building at 4011 Gallatin Road. (RCF.)

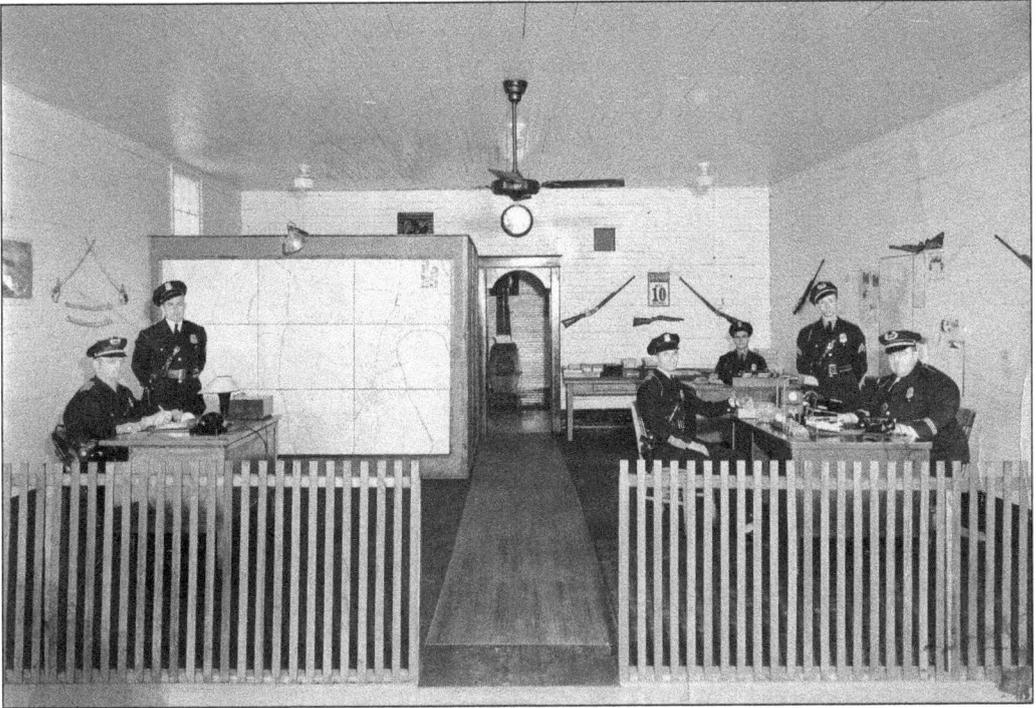

INTERIOR SHOT OF POLICE STATION. Chief Cannon is seated at the desk on the right side of the station. The department was funded by subscription: citizens paid an annual fee for the patrol. The original fee was set at $1 per year. Calls for assistance were received and cars dispatched by radio from this office. (RCF.)

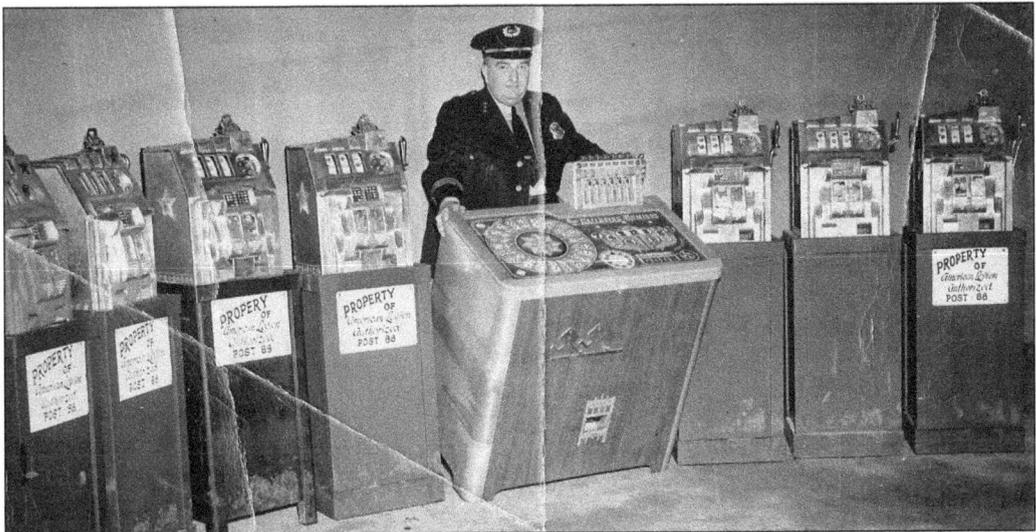

ILLEGAL SLOT MACHINES SEIZED BY POLICE. Fraternal clubs often kept illegal gambling machines for their members' use, and police departments across the country often seized the machines. The family tells of Chief Cannon visiting a private club after a call from a young wife and mother seeking help because her husband spent his evenings gambling his earnings. Cannon raided the club and seized the machines, told the young man to go home, and had groceries carried to the house for the mother and children. (RCF.)

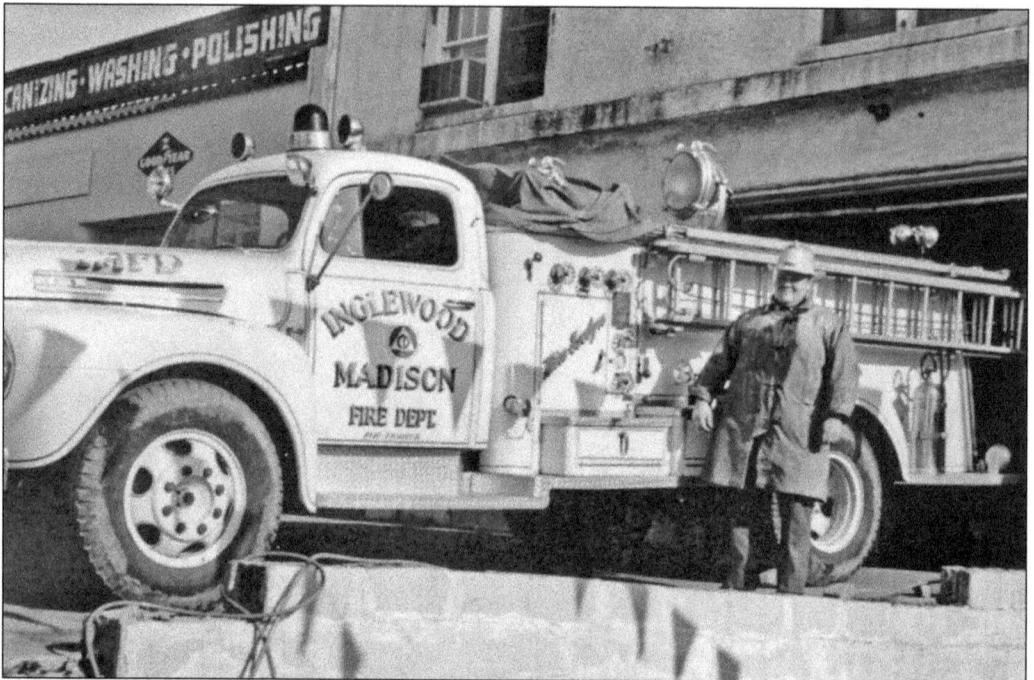

FIRE CHIEF LLOYD "BUDDO" WARREN SR. AND "MISS EVELYN." Chief Cannon named the new fire engine for his daughter, Evelyn. The family remembered one day when the men and the engine left for a call. As they drove away with lights flashing and siren sounding, Evelyn's mother realized that Evelyn had been playing on the back of the engine and was now on her way to the fire. (LWF.)

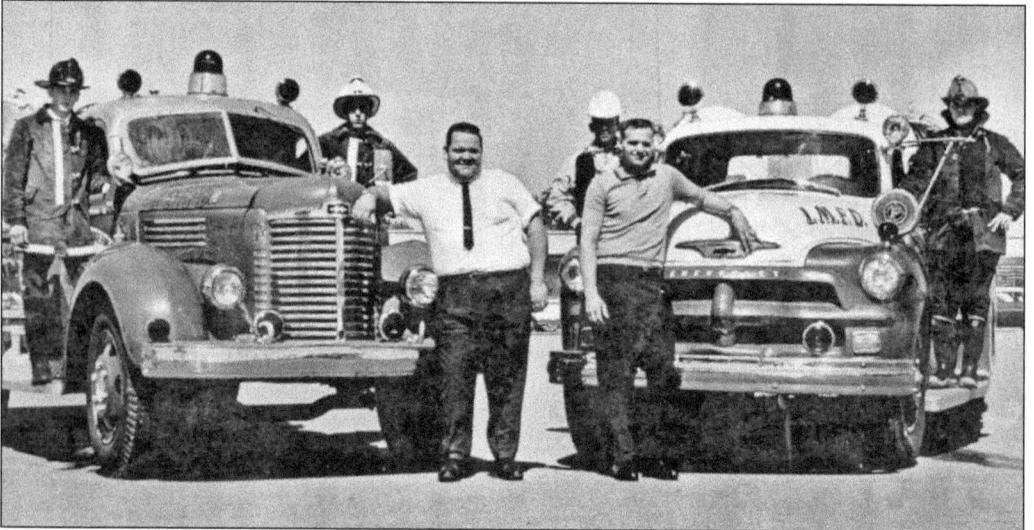

INGLEWOOD MADISON FIRE DEPARTMENT. Firefighters and Chief Warren are posed with their engines for a calendar given to members. The subscriptions paid by residents supported the department. Chief Warren was dedicated to his men and his neighborhood. When the department was dismantled and fire protection was assumed by the Metro Nashville Fire Department, he refused to sign the agreement until he was assured that each of his firefighters would become full-time city employees. (LWF.)

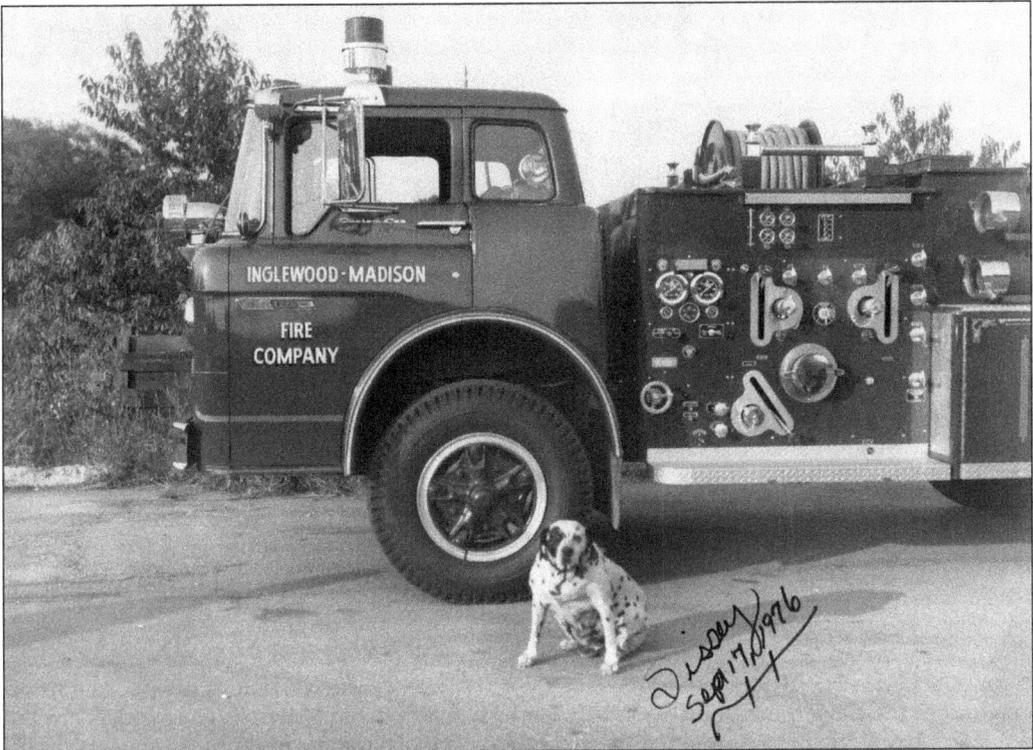

SISSY THE FIRE DOG. Sissy poses in front of the new fire engine. The station had relocated from Gallatin Road to a site 2 miles north. Sissy had 13 puppies in her first litter, and the firefighters helped the mother by bottle-feeding some of the pups. Fire halls are prohibited from having dalmatians as pets or mascots today in Nashville. (LWF.)

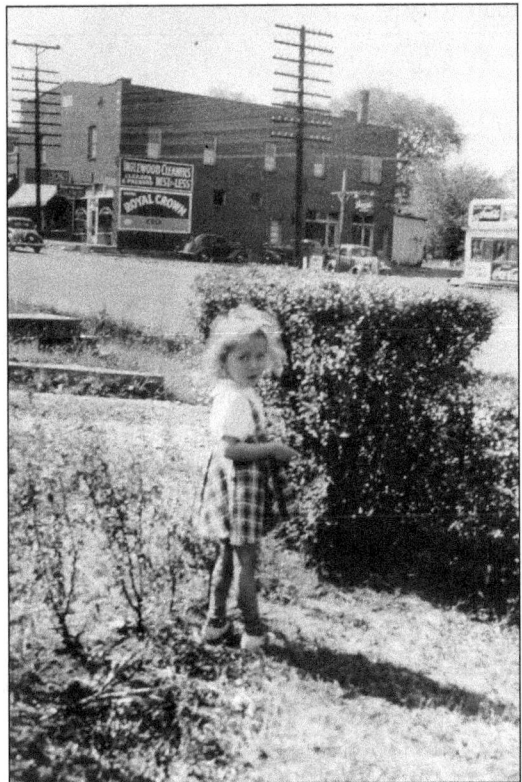

PAULA SOFGE IN HER FRONT YARD AT 3612 GALLATIN ROAD. Young Paula Sofge Pelham knew that stepping past the hedge was forbidden. The background shows the two-story building that housed Inglewood Cleaners on the ground floor and the Masonic hall meeting space on the second floor. That building is gone, but the white building on the right remains. Paula Sofge's sister Carolyn grew up to marry Chief Lloyd Warren Sr. (LWF.)

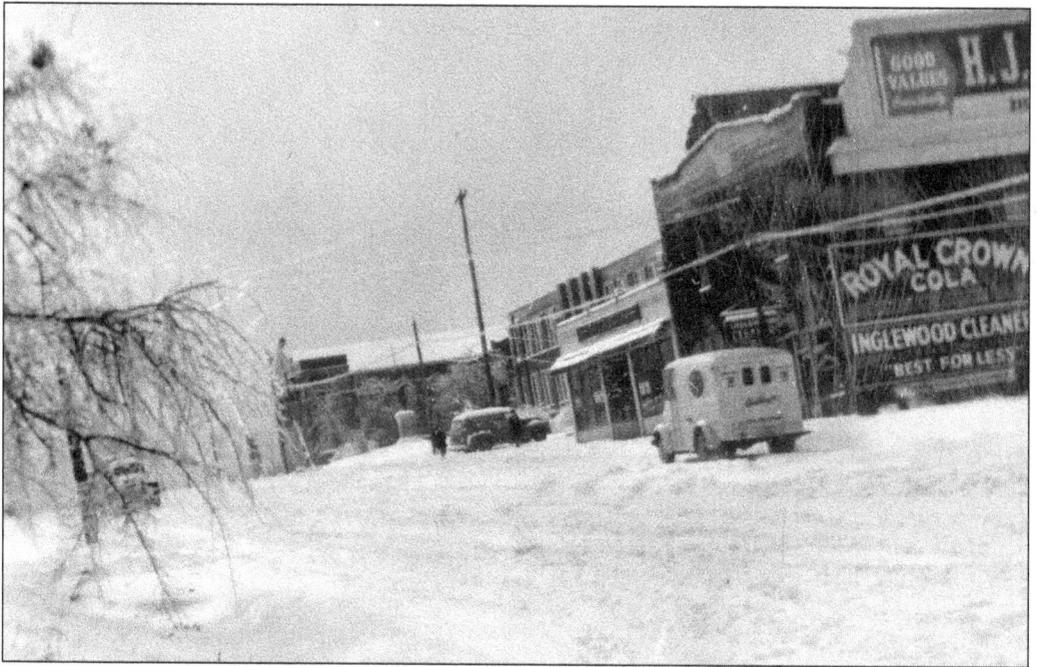

SNOW ON GALLATIN ROAD. Snow seemed to bring Inglewood to a halt. This photograph is taken from the Sofge yard looking south toward the intersection of Ben Allen Road. Snow did not keep the milkman from making deliveries, but he did not have to dodge many cars on his route. (LWF.)

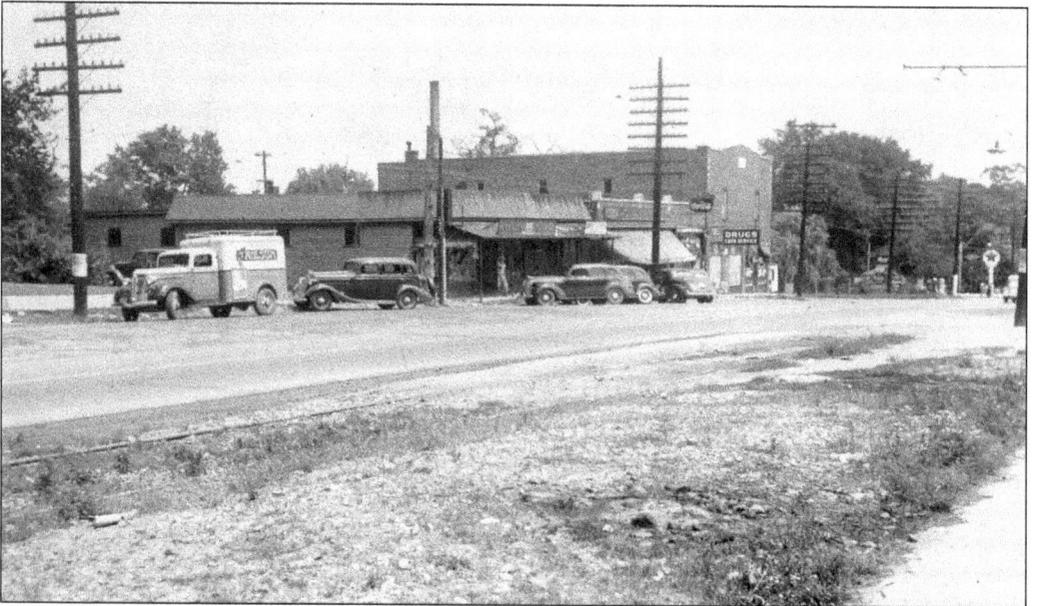

INGLEWOOD BUSINESSES, 1938. This view looks north on Gallatin Road and shows a delivery truck and customer cars at the businesses. Note the streetcar rails in the foreground. The streetcar line was a major impetus spurring life in the suburbs: travel to and from town for work was affordable and convenient. The interurban trolley service offered a ride north to Gallatin, Tennessee, at nearly 65 miles per hour. (HB.)

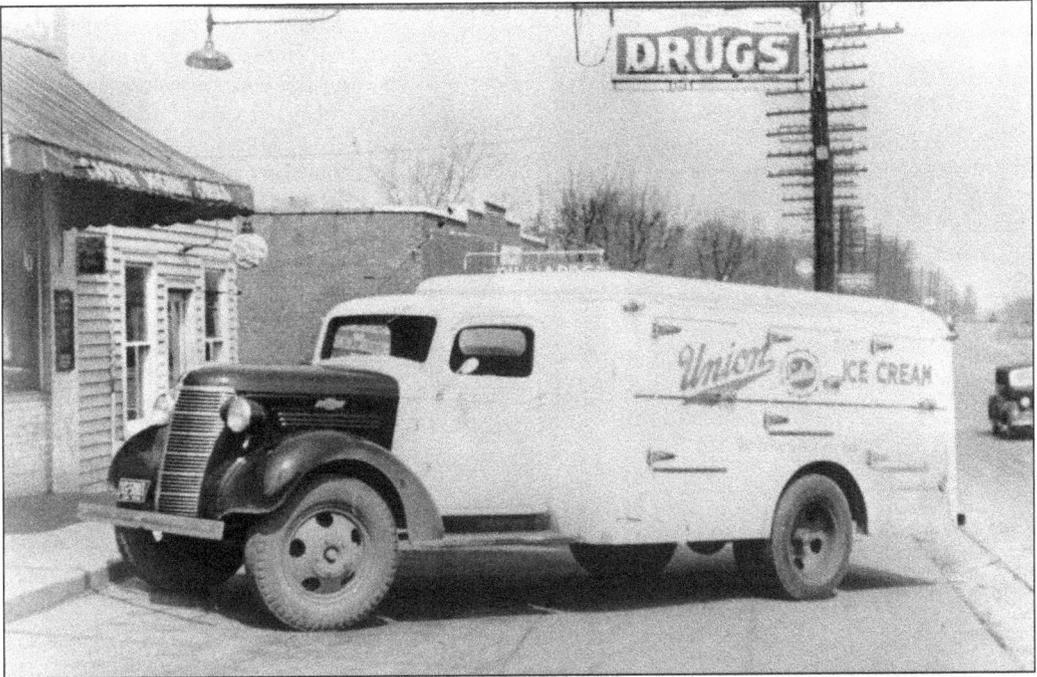

ICE CREAM DELIVERY TRUCK. Ice cream was as popular in the 1900s as it is today. Here the Union Ice Cream truck makes deliveries to local shops along Gallatin Road. The emblem on the hood indicates this is a Chevrolet model. (TSLA.)

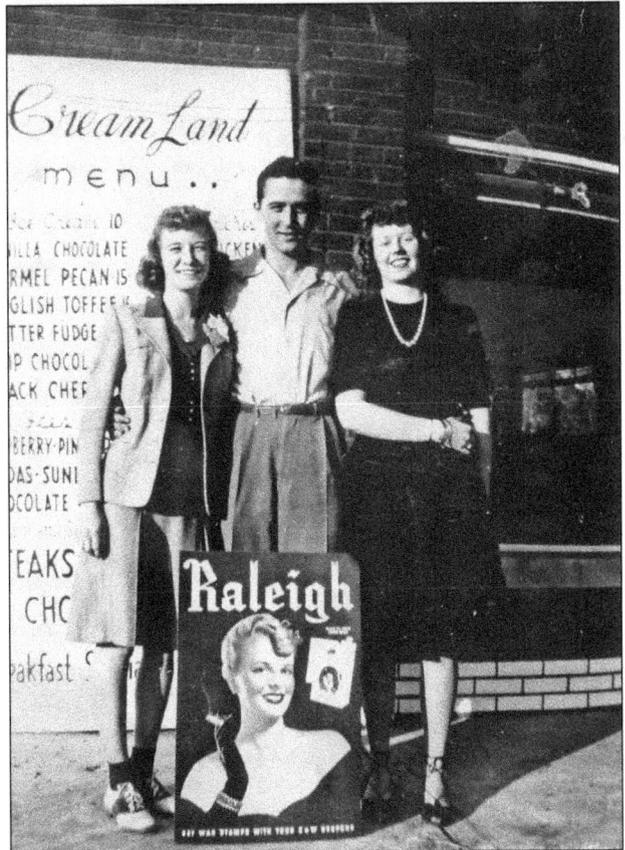

SQUEAKY, NED, AND JEAN AT CREAMLAND. Creamland, owned by Gus "Papa" Geese and his wife "Mama," was a popular teen hangout on Gallatin Road in the 1940s. The menu featured ice cream, sundaes, homemade candy, and sodas, as well as steaks, dinners, and the promise of breakfast served anytime. Local teenagers enjoyed the food as well as dancing to the latest tunes on the jukebox. (Diane Hood.)

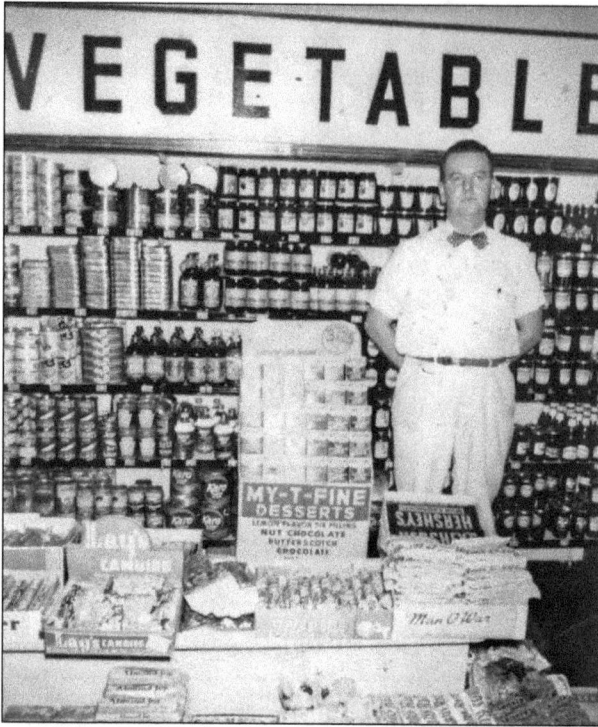

RED MALONE'S GROCERY BUSINESS. Hudson (Red) Malone stands behind the counter in the early years of his grocery. Located at the corner of Gallatin Road and Ardee Avenue, the market operated for more than 30 years and served four generations of families. Red Malone passed the market to his son, Mike, and his employee, Lyell Hunter, when he retired. (MM.)

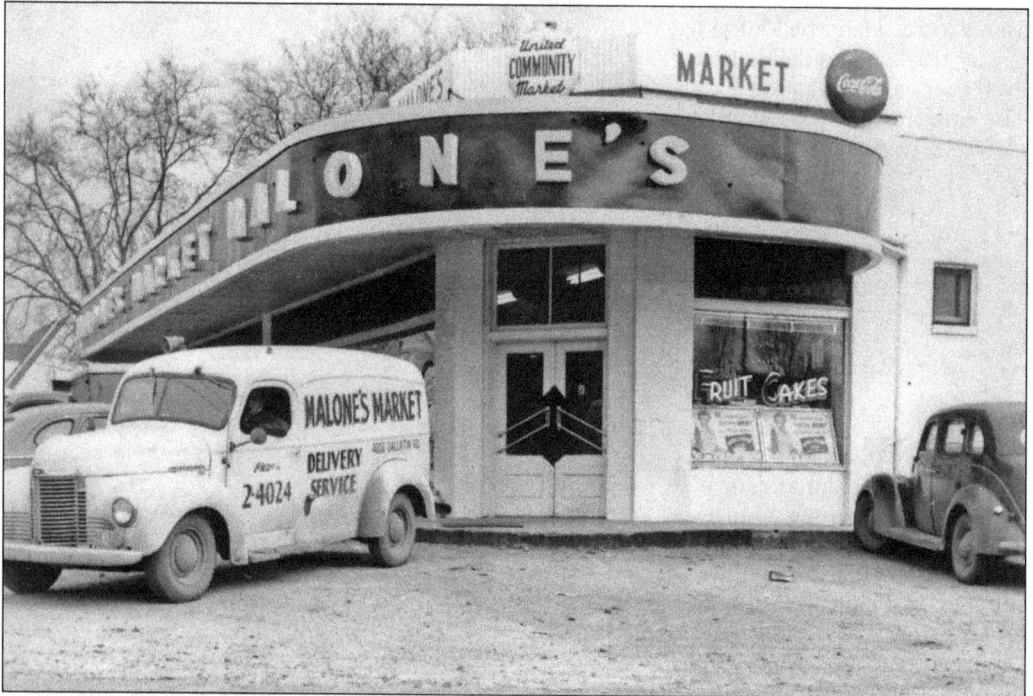

MALONE'S MARKET ENTRANCE. Malone's Market offered delivery service for the convenience of customers. Here the truck is parked at the entrance ready to be loaded with delivery orders. Malone's was known for friendly service, fresh produce, and a superior meat department. The butcher was always ready to make special cuts for customers. (MM.)

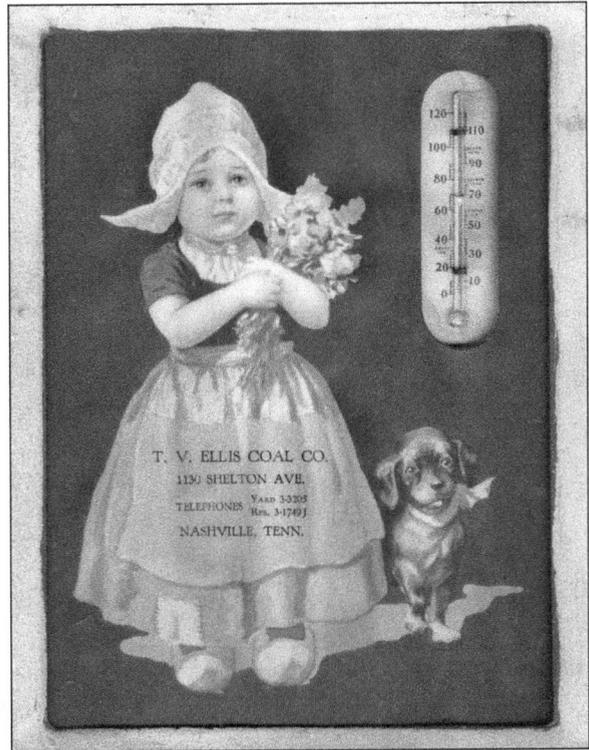

PROMOTIONAL ITEM FROM ELLIS COAL COMPANY. This attractive thermometer card was distributed by the T. V. Ellis Coal Company as an advertisement. Ellis operated from Shelton Avenue in Inglewood for decades. Coal was used for home heating, and some of the larger mansions in the neighborhood would use many tons of coal during the winter. (MM.)

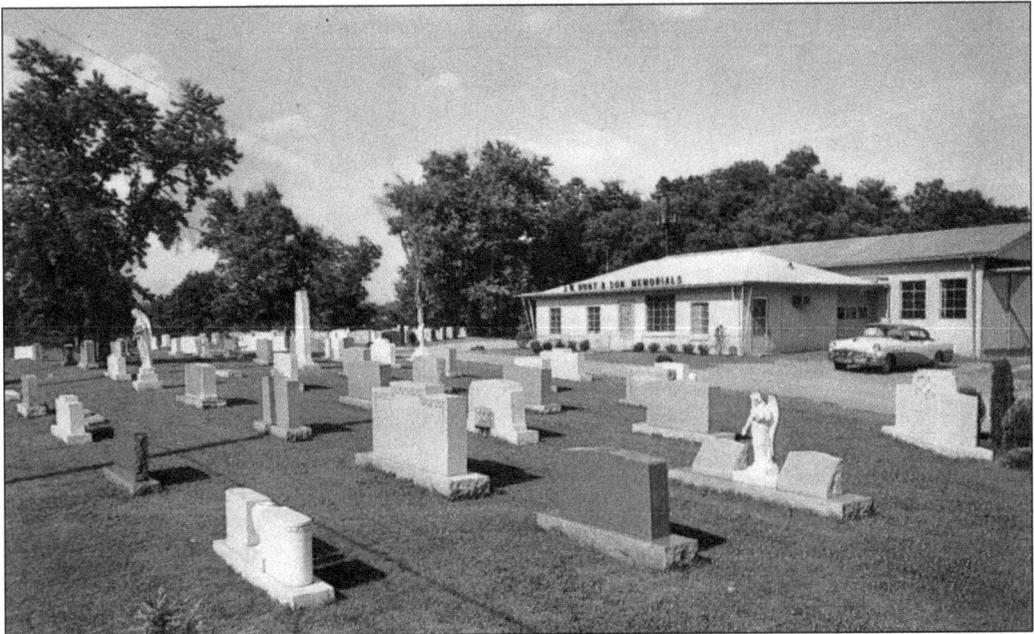

J. B. HUNT AND SONS MEMORIALS. The Hunt family has served the community since 1928 through three generations. This postcard shows the original building on Gallatin Road near Spring Hill Cemetery. Known for its craftsmanship, the company has received numerous awards and was honored to create a granite monument to World War II soldiers that was installed in a memorial building on Normandy Beach in France. (BH.)

MOBLEY VETERINARY CLINIC. This animal hospital has been the scene of many joyous and many heart-breaking moments in the lives of Inglewood residents. Dr. Summerfield Q. Mobley opened the hospital in 1951. His son, also S. Q. Mobley, carries on the tradition of caring and competent service to animals of all shapes and sizes. Many young adults have worked with the veterinarians as they decide whether animal care is their future. (Dr. Summerfield Mobley.)

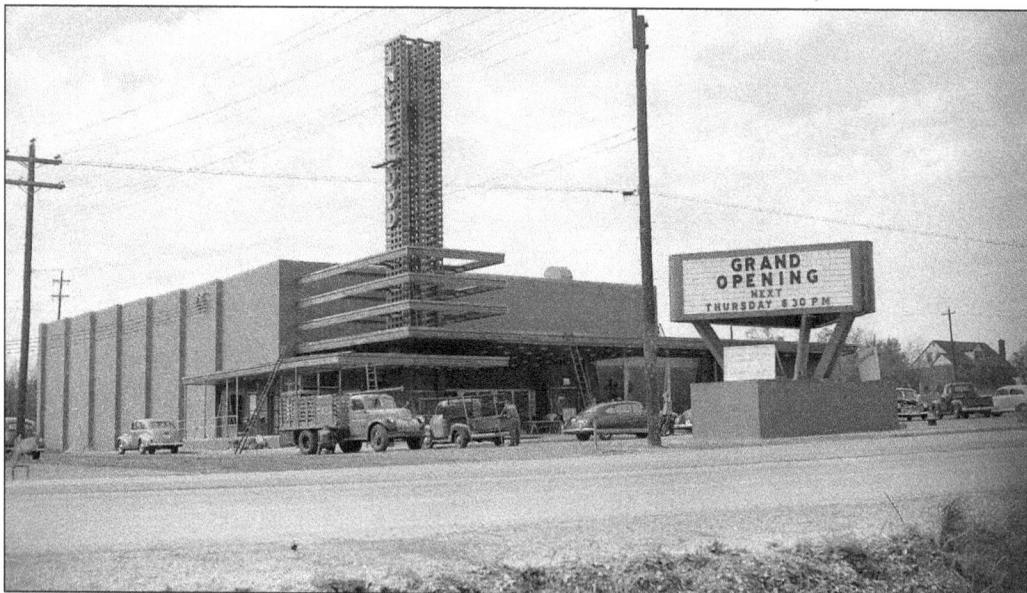

INGLEWOOD THEATER OPENING. Inglewood Theater opened on a Thursday night in 1950 and brought the finest in entertainment to the neighborhood. The 1,000-seat theater was built by Crescent Entertainment. In later years, the building became the home of Joywood Salvage. Items for sale were displayed on the gently sloping floor, which lent an uncanny air to shopping. The building was demolished for the construction of a drugstore. (MNA.)

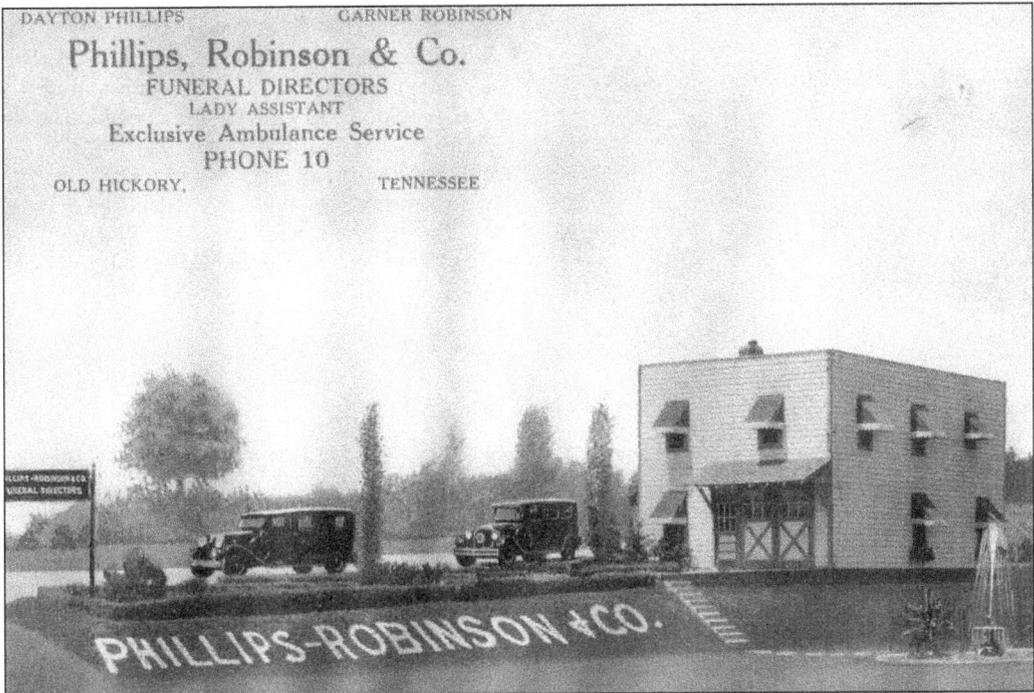

PHILLIPS-ROBINSON AND COMPANY ADVERTISEMENT. The building pictured in this advertisement is located in Old Hickory, but the company also offered services at a Gallatin Road location in Inglewood. Note the mention of a "lady assistant." Women have shared equally as business partners and funeral directors since the beginning of this company. The company operated the ambulance service for many years until the service was offered by the city. (MRH.)

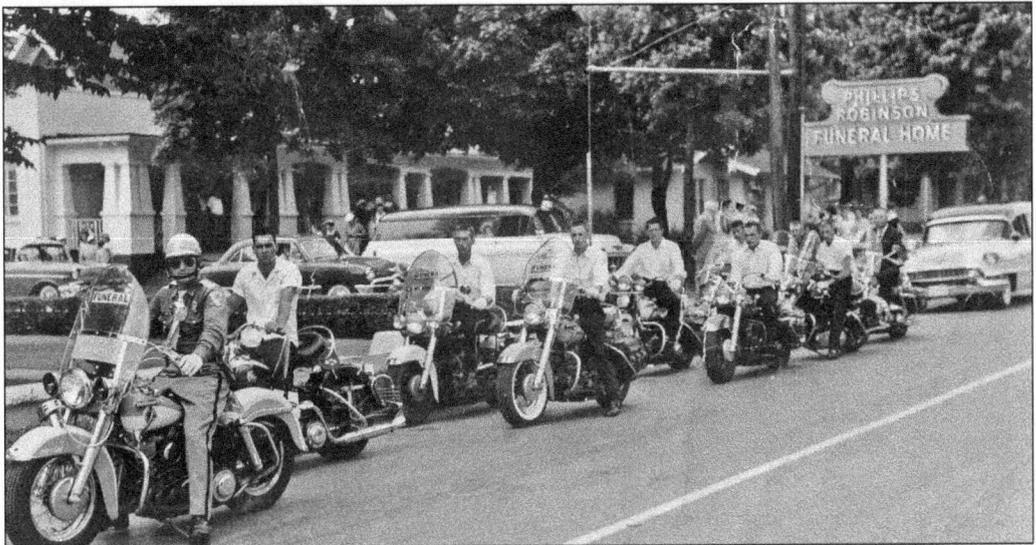

PHILLIPS-ROBINSON FUNERAL HOME. This photograph shows a funeral procession lined up in front of the Gallatin Road funeral home. Inglewood residents have chosen Phillips Robinson to handle arrangements for loved ones for several generations. The company still abides by its policy of providing complimentary services to families of firefighters and police officers killed on duty. (MRH.)

BURRUS FILLING STATION
LESLIE C. BURRUS

"The Home of Toasty Barbecue"

PAN-AM GAS AND OILS
FIRESTONE TIRES
SANDWICHES OF ALL KINDS
SODAS AND CIGARS

MUSIC BY VITO AND HIS ORCHESTRA

Curb Service Road Service

3409 Gallatin Road Nashville, Tennessee

Telephones 3-9107

BURRUS FILLING STATION. This advertisement was printed in 1933. Mr. Leslie C. Burrus offered full service at his station and provided road service when needed. After buying gasoline, customers could enjoy the music of Vito and his orchestra while munching on a toasty barbecue sandwich. The station was on Gallatin Road near Jere Baxter School. (EF.)

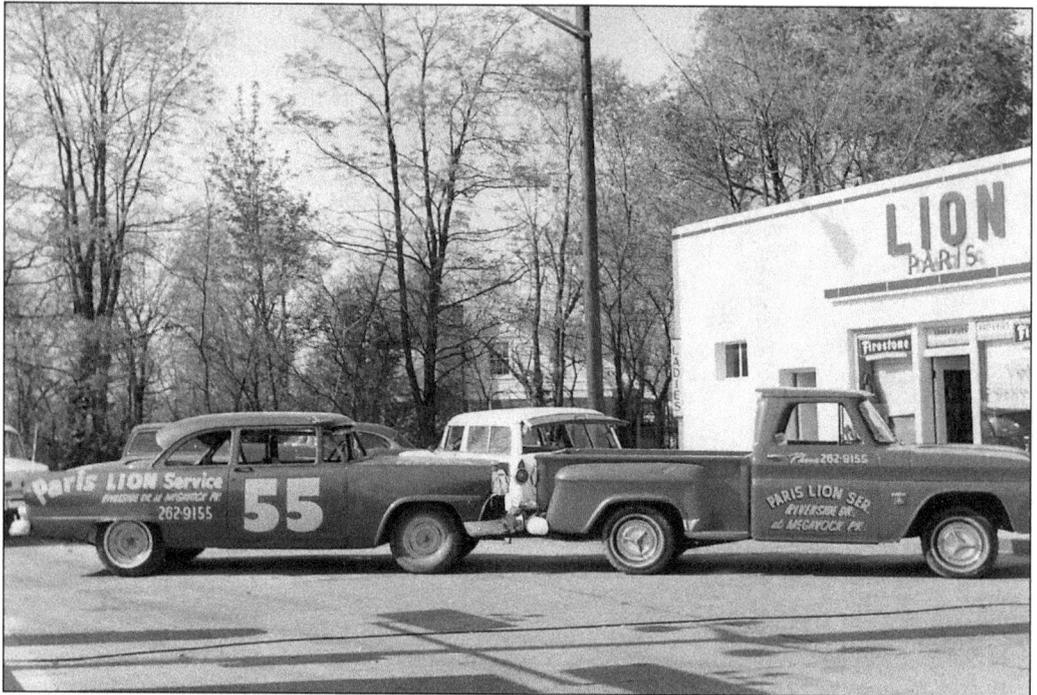

WALTER PARIS LION STATION. Walter Paris operated his station at the northeast corner of McGavock Pike and Riverside Drive. The No. 55 race car was a frequent competitor at the Saturday races at Nashville Speedway, located at the fairgrounds near downtown. The driver was a city police officer: John Behaylo. (Russ Thompson.)

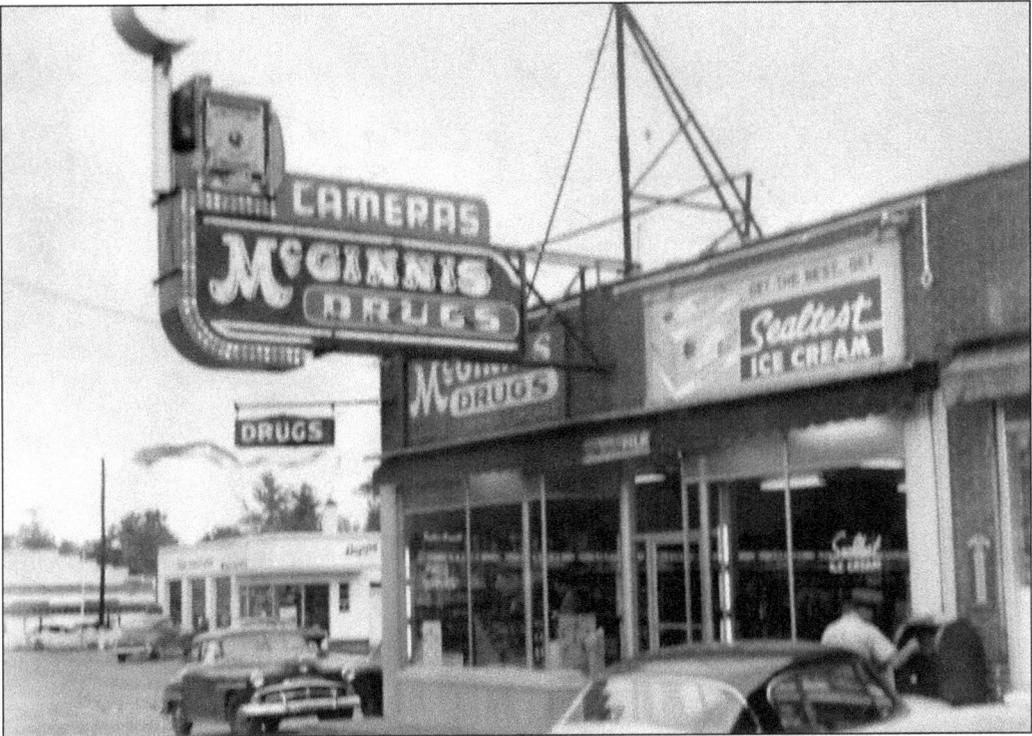

McGinnis Drug Store and Camera Shop. McGinnis Drug Store stood on Gallatin Road at the intersection where Trinity Lane stopped. The adjacent building held the camera shop. Developing of film and printing of photographs were offered on site. The business was closed after a fire in the late 1970s destroyed the buildings. The service station in the background is Wallace's Esso. (McGinnis family.)

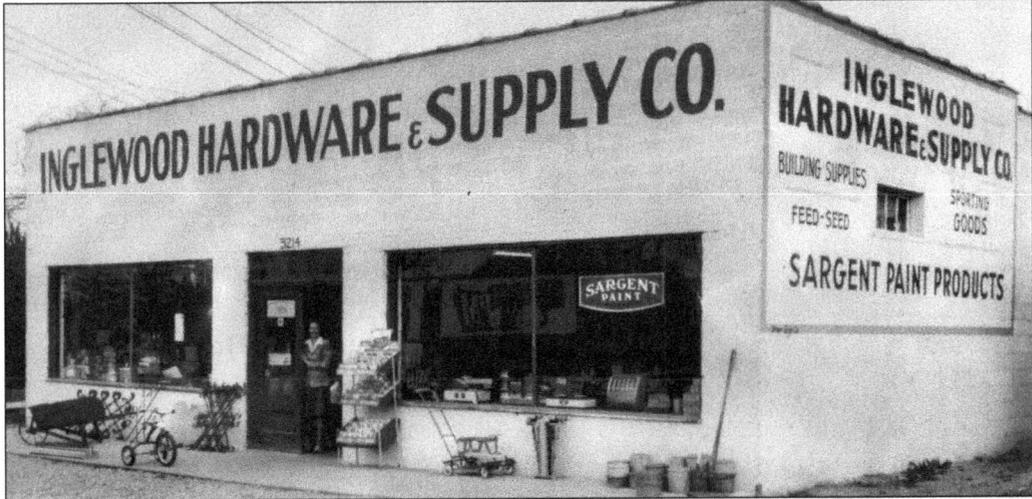

Inglewood Hardware and Supply Company. Sarah Hayes greeted customers at the Inglewood Hardware at 3214 Gallatin Road. The hardware opened in 1946 and has been in continuous operation since. The store is known for friendly, competent service and has always been able to supply neighbors' needs, whether it is one small bolt for a repair or supplies to add a room to a house. (Betty Harbaugh and Joe Herndon.)

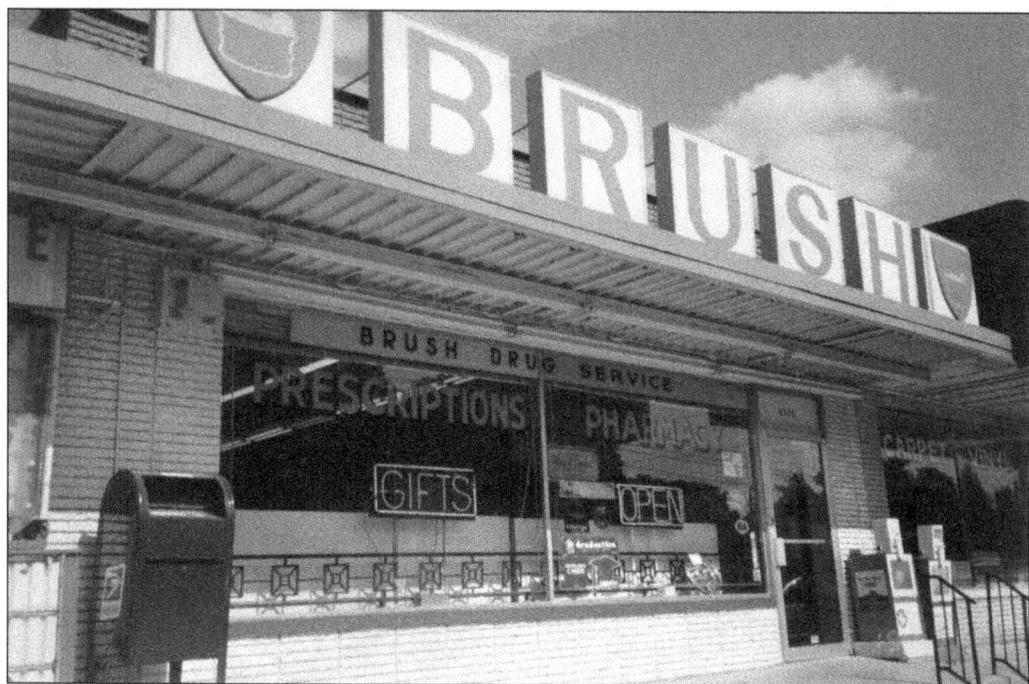

BRUSH DRUG SERVICE. Brush Drugs was the northernmost pharmacy in Inglewood. Located in a small strip mall on Gallatin Road, Brush Drugs was convenient to both Inglewood and Madison. Other businesses in the mall included a pizza restaurant and a carpet outlet. (HBF.)

HASSELL BRUSH HEADS TO WORK. Hassell Brush was the pharmacist who owned and managed Brush Drugs. He also chose to raise his family in Inglewood, as did many other business people. Inglewood families tended to remain with a single pharmacist throughout their lives. The following generations usually traded at the same store as their parents and grandparents. (HBF.)

LUNCHING WITH THE BRUSHES. An unidentified customer enjoys a break at the lunch counter at Brush Drugs in June 1955. Perhaps she was waiting for a prescription to be ready or meeting a neighbor for a sandwich and a cup of coffee. Brush Drugs was located beside Isaac Litton High School and was visited by students thirsty for a malt or a cherry coke after school. (HBF.)

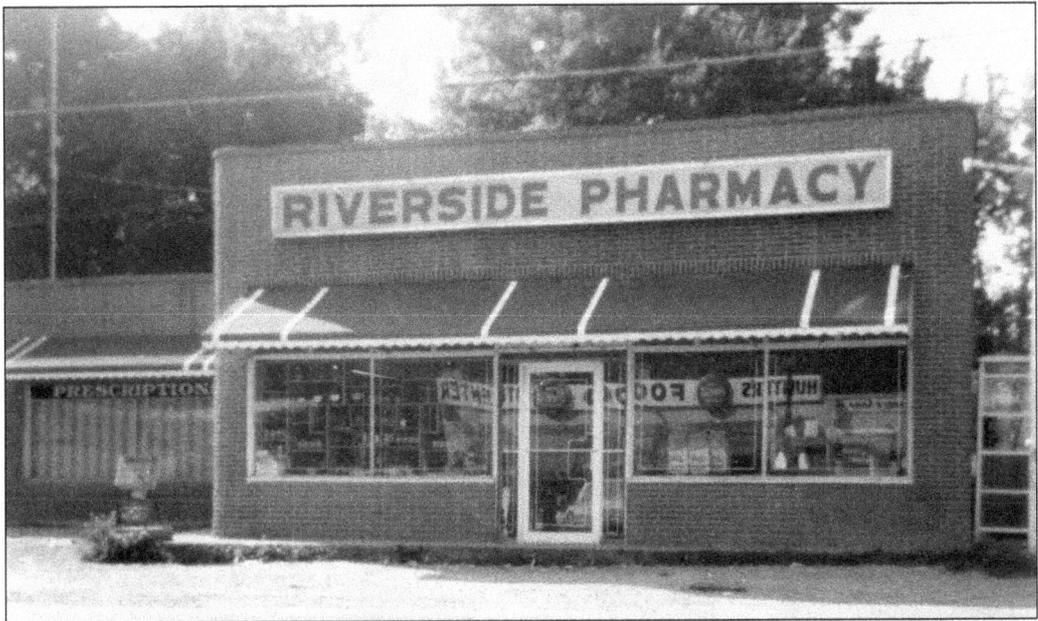

RIVERSIDE PHARMACY. Riverside Pharmacy was owned by Dr. Charles Jones. This photograph, taken in 1964, shows the first home of the business at the northwest corner of McGavock Pike and Riverside Drive. Notice the reflection in the window of the Hunter's Foods Store across the street. Dr. Jones would later build a small strip mall across the street diagonally from the first pharmacy. Both buildings still stand and have been rehabbed for new businesses. (CJF.)

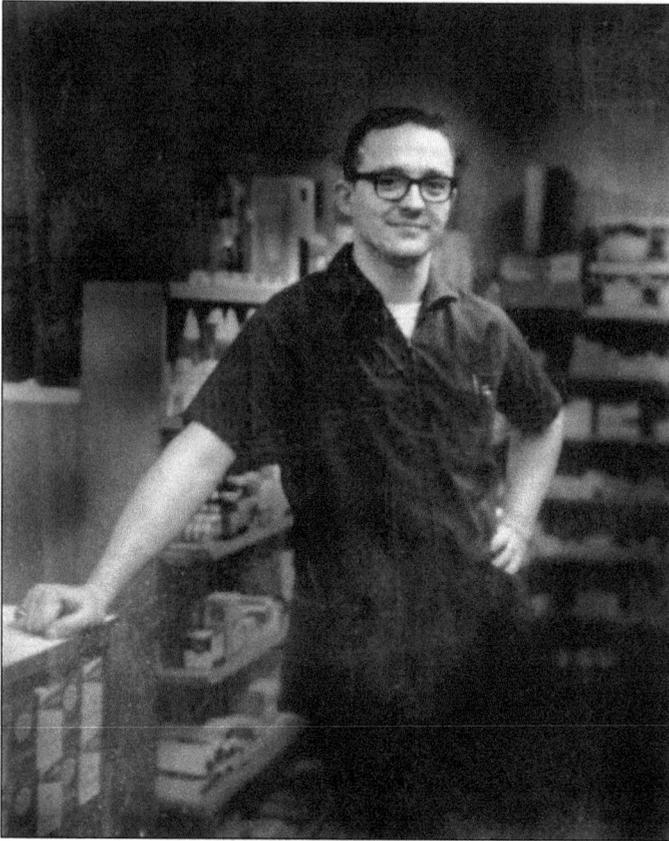

RIVERSIDE PHARMACY. Dr. Charles Jones, known as "Doc Jones" to his neighbors and patrons, owned and operated Riverside Pharmacy for more than 20 years and is fondly remembered for his sense of humor and generosity. Many locals remember the pharmacy fountain where they enjoyed Mrs. Eddie Jones's (Charles's mother) pies and Miss Hilda Levan's egg salad sandwiches. To this day, mere mention of the pies make mouths water. (CJF.)

CREECH'S FIVE AND DIME. Looking to the west on McGavock Pike, Creech's dime store is seen on the right. Lost forever to the big box stores, the dime store was an important fixture in the 1900s. At Creech's, the family could find ordinary household supplies, small tools, toys, cosmetics, and much more. The Ford Galaxie in the foreground is parked in front of Riverside Pharmacy. (CJF.)

Four

Isaac Litton High School

Prior to 1930, if Inglewood students wanted to go to high school, they had to commute by trolley to Central High or Hume Fogg. As Inglewood grew into a middle class suburb, it became more important to have its own senior high school. In 1929, the county purchased 11 acres on Gallatin Pike to build what would become by 1954 the largest high school in Middle Tennessee. The first classes met at the Jere Baxter School but quickly outgrew this space and began meeting in the basement of the Inglewood Methodist Church as well. On October 25, 1930, Isaac Litton opened its doors for the first time. Within a few years, Isaac Litton's reputation as a school of excellence was well established throughout Middle Tennessee. Everyone wanted to attend. Even the children from Inglewood's wealthiest families, who were destined for one of the prominent private schools, begged their parents to send them to Isaac Litton.

Sharp focus on excellence in everything and strong community support made Litton great. The community's support assured that resources were available for new textbooks, school trips, band uniforms and instruments, and one of the best school newspapers in the state, the *Litton Blast*. Because of this school, citywide traditions were established, such as the Miss Nashville High School competition (the brainchild of the *Litton Blast* and Littonian staffs and teacher sponsors). The Clinic Bowl, a football game whose proceeds to this day benefit the Vanderbilt Children's Hospital, is another city tradition that began with Litton. Excellence was expected from every student who attended the "Red and Blue." Litton's great band director, Sammy Swor, personified this value. It was this drive for greatness coupled with the financial support from the community that made Isaac Litton's band, the Marching 100, nationally known. Isaac Litton was not only a reflection of the professional care of its administration and teaching staff, it was also a reflection of this community and what can be achieved when it works brilliantly together.

AERIAL VIEW OF ISAAC LITTON HIGH SCHOOL. Before Litton, Inglewood's students attended Jere Baxter "Junior High," which offered classes through 10th grade. After 10th grade, students had to ride the streetcar to another county school such as Central High or to a city school such as Hume Fogg to finish. In 1929, Alvin Davidson County bought 11 acres of land from the Spotswood family to build Inglewood's first high school. The history of Isaac Litton begins with the purchase of land that is said to have been at one time owned by Isaac Litton. Isaac Litton High School's namesake was a successful businessman in lumber and insurance who died 36 years before the school was opened. At the time of his death, he owned a large farm on Gallatin Road near where the East YMCA is today. His grandson, Judge Litton Hickman, was a Davidson County judge at the time and grew up on the farm on Gallatin Road. He requested that the school be named Isaac Litton. (LC.)

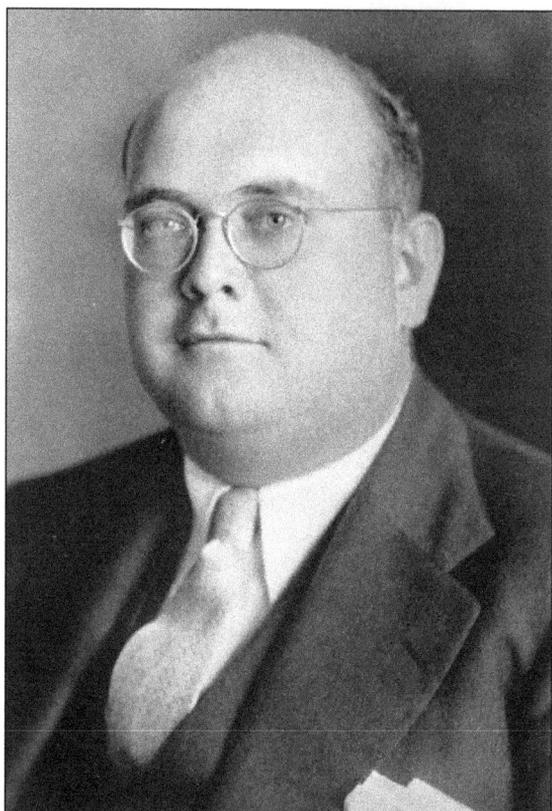

ISAAC LITTON HIGH SCHOOL: FIRST
PRINCIPAL AND FIRST BUILDING. A
Sewanee graduate, Principal James
Dean Brandon got Isaac Litton off to
a prosperous start as its first principal.
The first senior class dedicated their
annual to James Dean Brandon: "With
hearts full of love and appreciation for
all that he has meant to us during our
high school career, we thoughtfully and
sincerely dedicate this, our first annual,
to our principal." Those first three years
as Isaac Litton was being built must
have been difficult. During that time,
he managed over 300 students, hired 12
faculty members, found extra class space
at Jere Baxter Elementary and later at the
Inglewood United Methodist Church,
and oversaw the construction of the new
building. The school building is pictured
below as it appeared in 1932. (Both EF.)

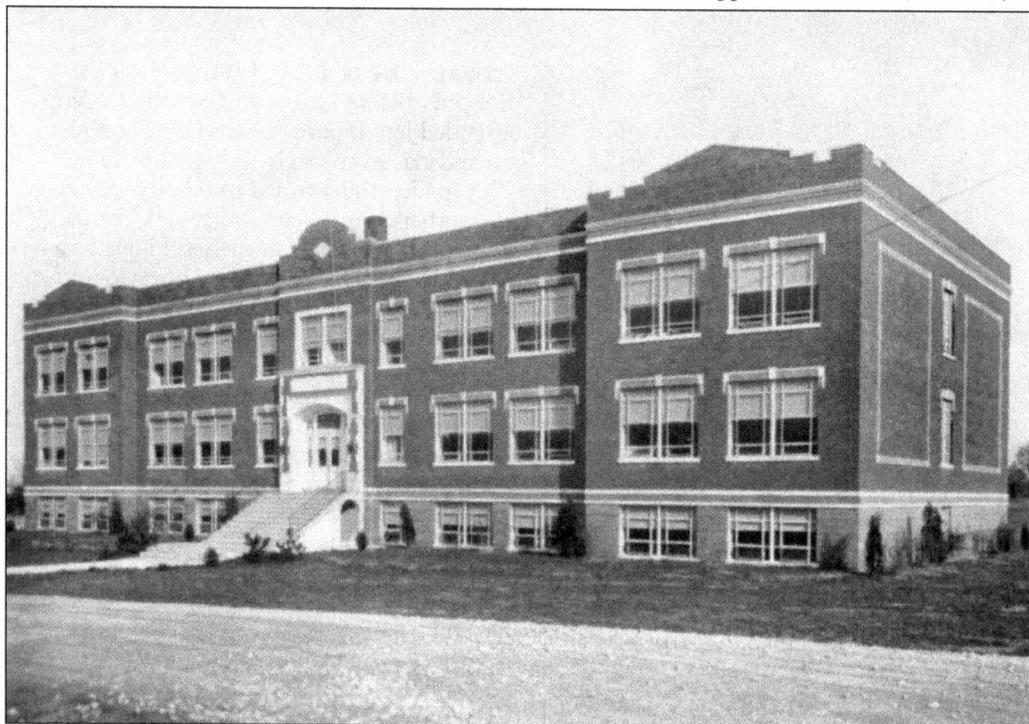

MARY VIRGINIA KING GEE, ONE OF LITTON'S ORIGINAL FACULTY MEMBERS. Mary Virginia King (Gee) taught English at Litton from the school's beginning until her retirement. She graduated cum laude from Vanderbilt University and later earned her master's degree from Peabody College. She was a favorite at Isaac Litton reunions, where she was known for her famous and entertaining poems. She was one of many well-credentialed original faculty members; many of them graduated from Vanderbilt, University of Tennessee, or Peabody and held advanced degrees. Their resumes reflect how seriously academics and scholarship were taken at Isaac Litton from the beginning. Some of the general courses taught that first year were history, science, English, Latin, Spanish, biology, and algebra. According to report cards at the time, students were evaluated not only on scholarship but also on conduct and effort per subject. They were also given a rank in class for each course in order to foster competition. (EF.)

Seniors

ANNA MARGARET DORRIS

Girl Reserve, '29, '30, '31, '32; Lindbergh Society, '30; Glee Club, '31; Dramatic, '32; Science, '32.

VERNA ELLIS

Girl Reserve, '29, '30, '31, President, '32; Athletic Association, '29; Lindbergh Society, '30; Basketball, '29, Captain, '30, Alternate Captain, '31, '32; Sportsmanship, '32; Class Vice-President, '30; "L" Club President, '31, '32; Home Ec. '31, Vice-President, '32; Tennis Secretary and Treasurer, '31; Dramatic, '32; Science, Vice-President, '32; LITTONIAN Editor.

ETHELYN FAITH

Springfield High, '29, '30, '31; Girl Reserve, '32; Home Ec, '32; Dramatic, '32.

JANE FLETCHER

Ward-Belmont, '29, '30; Girl Reserve, '31, '32; Home Ec, '31, '32; Glee Club, '31.

THE FIRST GRADUATING CLASS OF ISAAC LITTON AND THE FIRST CAFETERIA. There were 58 graduates in the first graduating class of Isaac Litton, all of whom began as freshmen at the Jere Baxter School. By the time these students were juniors, the size of the student body required that the seniors be moved to the Inglewood Methodist Church next door. It wasn't until they moved to their new home on Gallatin Road in October 1930 that their school officially became Isaac Litton High School. For some in this community, the plate lunch served at Litton was their biggest meal of the day. The plate lunch of a meat and two vegetables cost 6¢. (EF.)

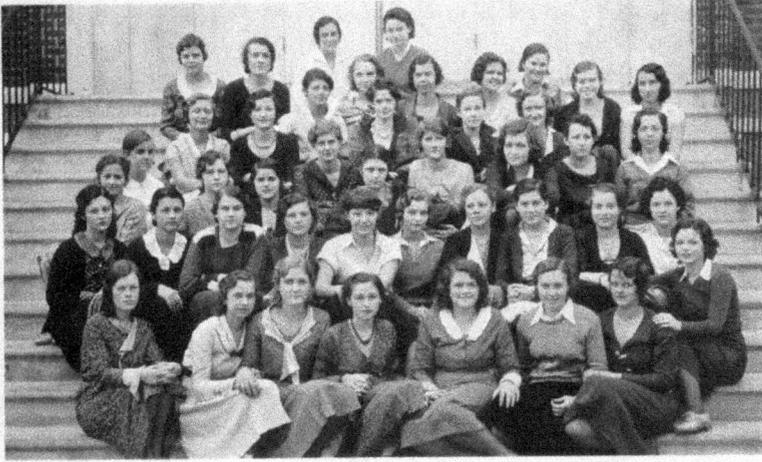

H. H. M. Club

THE H. H. M. CLUB AND THE DEBATING AND DECLAMATION CLUB IN 1932. Litton had some unusual clubs, including the Royal Order of the Purple Shaft, the Old Maids' Club, and the Bachelors' Club. The H. H. M. Club's motto was "We study not for school but for life," which is a good motto for Litton as well. Due to the demand for membership, Litton had separate science and Latin clubs per teacher or year. Started by Litton's first mathematics teacher, Otto Prater, the Debating and Declamation Club had already won its first debating medal that first year. Under Prater's leadership, the Litton Debating and Declamation Club would win four district debate titles and go to two national tournaments. (EF.)

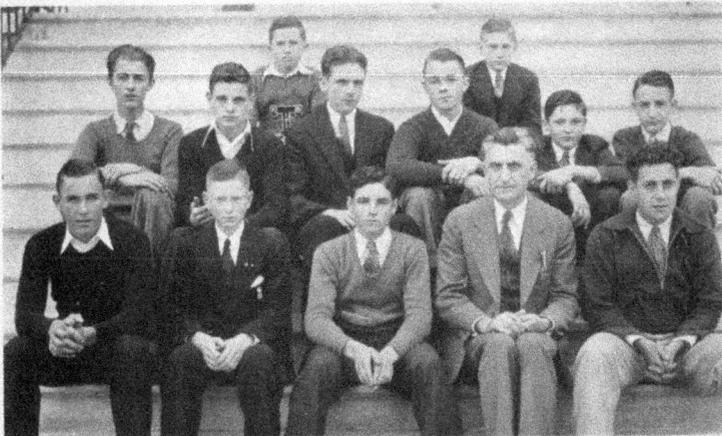

Debating and Declamation Club

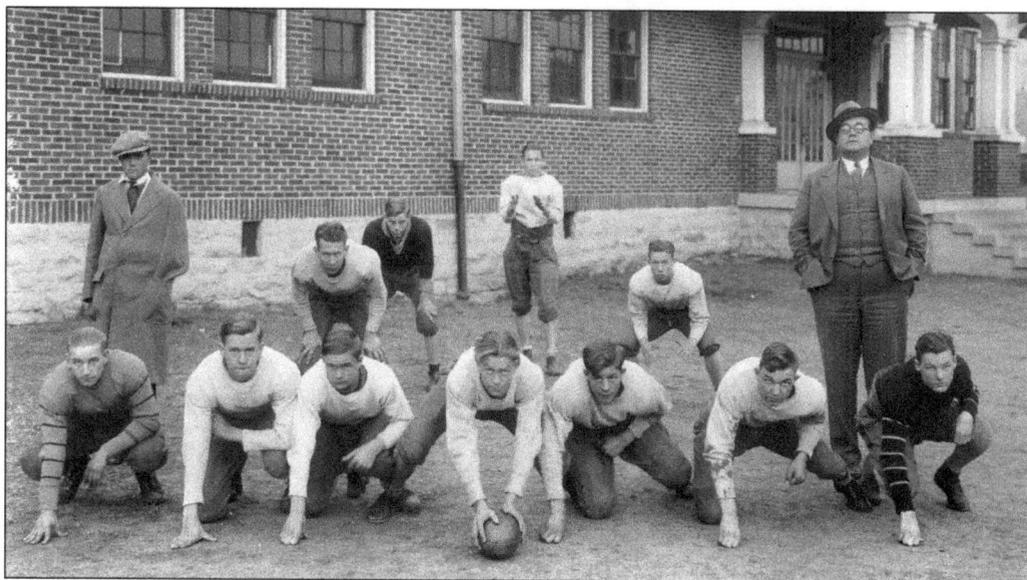

THE ISAAC LITTON FOOTBALL TRADITION. Even before Isaac Litton had a school building or a school name, it had a football team that was destined for greatness. By the 1950s, the Litton Lions dominated the Nashville Interscholastic League, winning 5 of the 10 championships. Here the first Isaac Litton football team is practicing in front of the Jere Baxter School with Principal Brandon, who was also the football coach. The first season in 1932 ended with an overall winning season for the Litton Lions. The annual warns its fans to "Watch out . . . ! The Lions are beginning to Roar!" The boys and girls basketball teams were crowd-pleasers as well. The girls only lost two games that season. (Above, JH; below, GBF.)

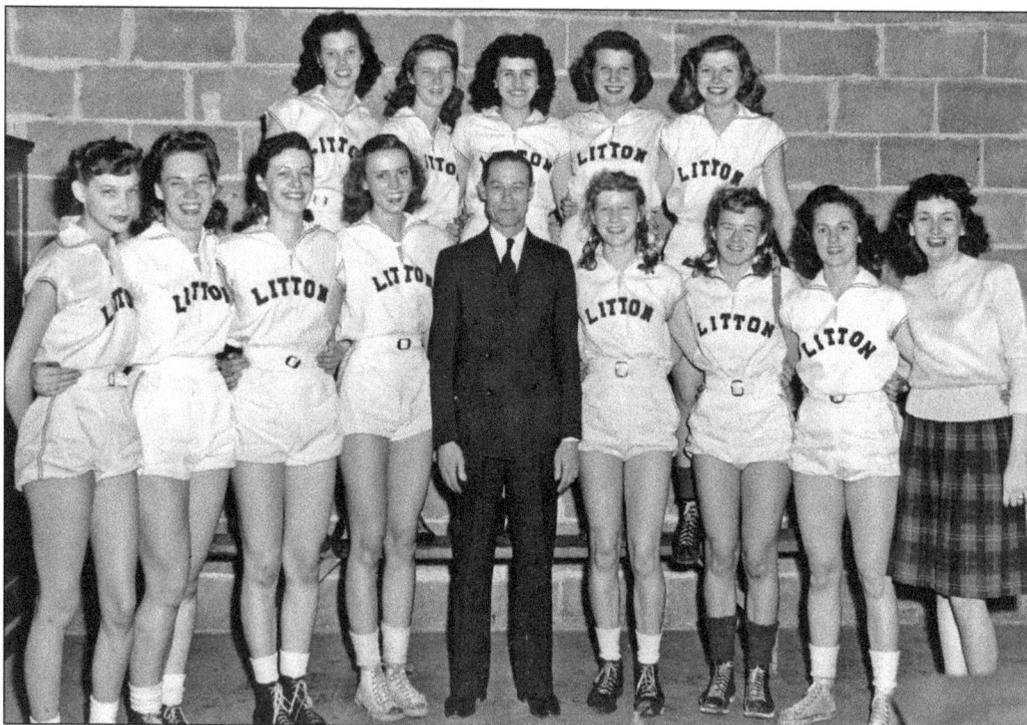

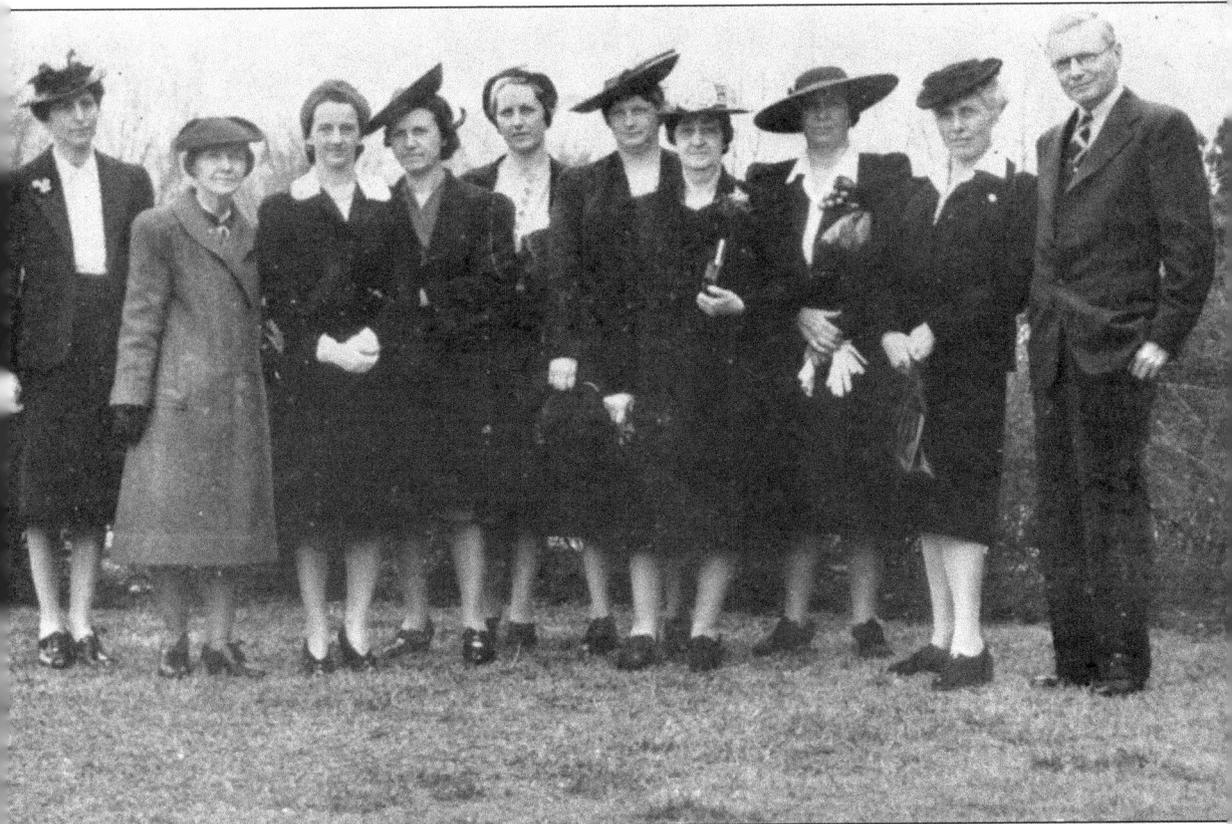

THE ISAAC LITTON PARENT TEACHER ASSOCIATION IN 1941. A key ingredient in the success of this school was community support. The PTA formed quickly in 1930 and remained a dominant friend to the school to assure its prosperity. According to the 1932 annual, the mission of the PTA was to cooperate "with the teachers and students to promote the welfare of the school." That year, the PTA had already financed a new hospital room for the school, the installation of a new bell, a new trophy case, and landscaping for the school surrounds—not bad for its first year. (EF.)

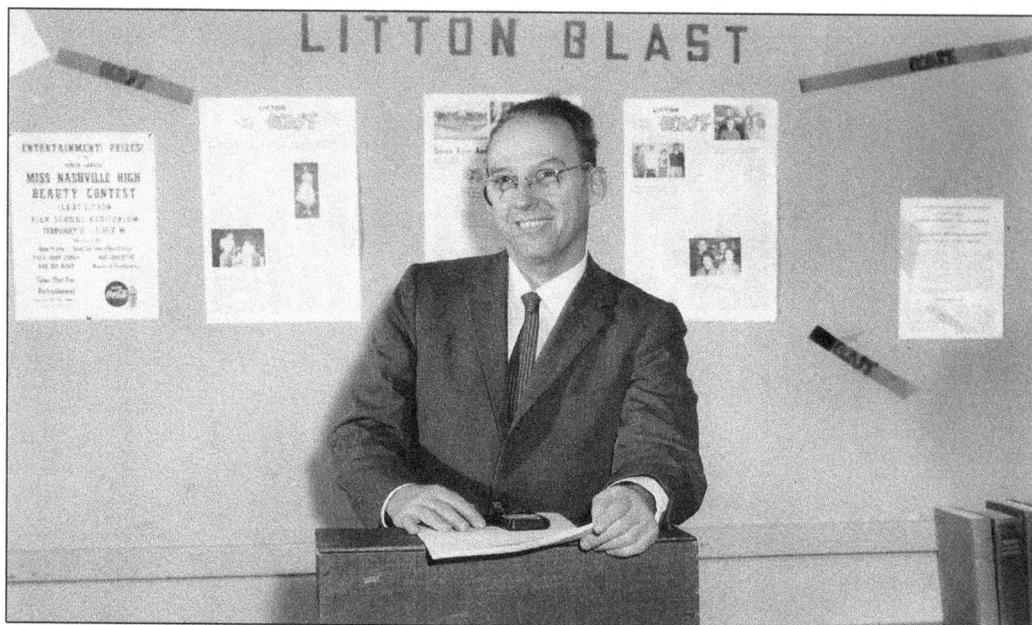

ISAAC LITTON'S NEWSPAPER, THE BLAST. Within a few years, Isaac Litton established its newspaper, and the *Blast* was an incredible student paper for its time. The monthly *Blast* started publishing in the 1930s and was first sponsored by Virginia Gee. By 1940, it boasted a staff that many commercial newspapers would envy, including a business manager, advertising manager, editor-in-chief, sports editors, photographers, columnists, and even poets. In 1958, it even began publishing in color, when every major paper in the United States was still in black and white. Isham Byrom, pictured above at the lectern and below with his journalism class, sponsored the *Blast* in the 1950s. Byrom taught English and journalism at Litton until the school closed. (Stuart Byrom.)

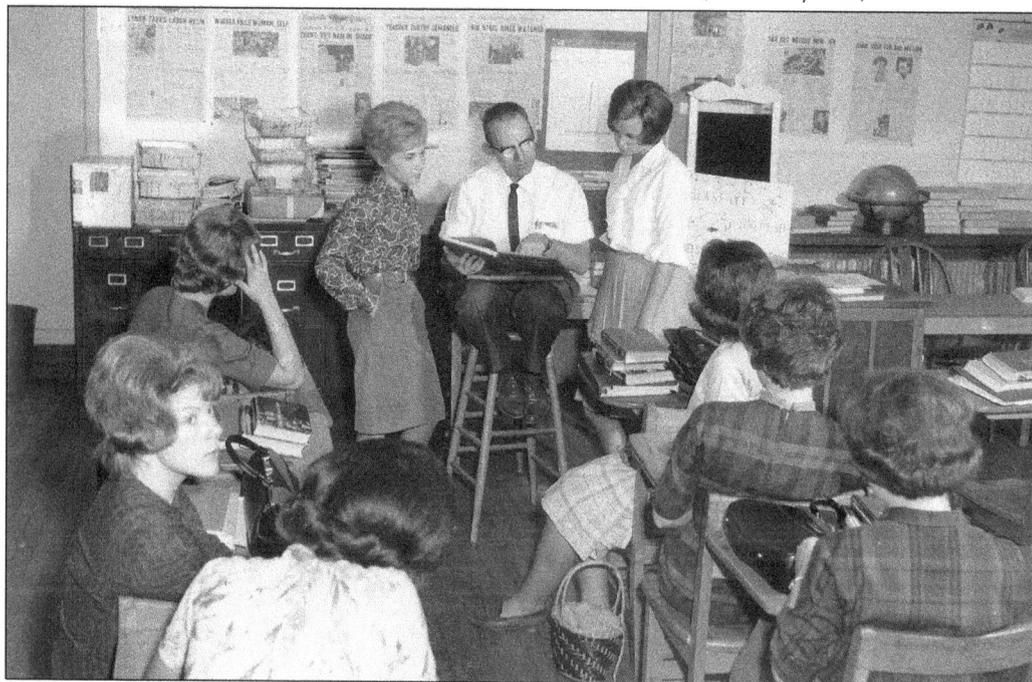

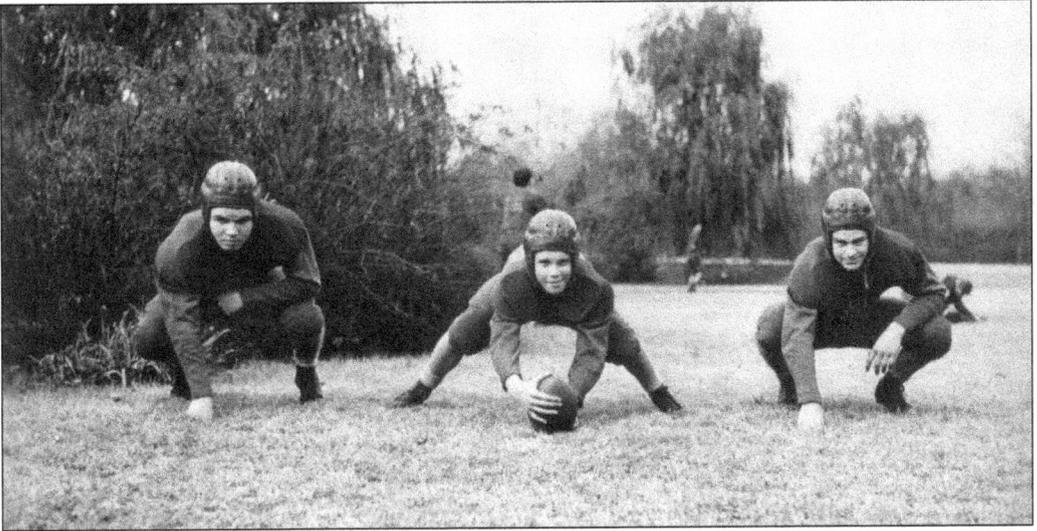

LITTON FOOTBALL PLAYERS SERVE IN WORLD WAR II. Joe T. Ellis was one of four Litton football players who joined the service at the same time in 1941. Above from left to right, players Bob Bingham, Ernest Bartholomew, and team captain Joe Ellis pose for a photograph. The men standing in front of the Navy banner are (from left) Bubba Adwell, Joe T. Ellis, O. J. Cline, and Morton Powell. When these young men returned home, Isaac Litton gave them honorary diplomas for service to their country. According to Virginia King Gee, more than 500 Litton boys served in the Pacific and Atlantic theaters. At least 32 of these young men lost their lives. Each casualty was announced during morning chapel, and a gold star was added to the Litton U.S. flag. (EF.)

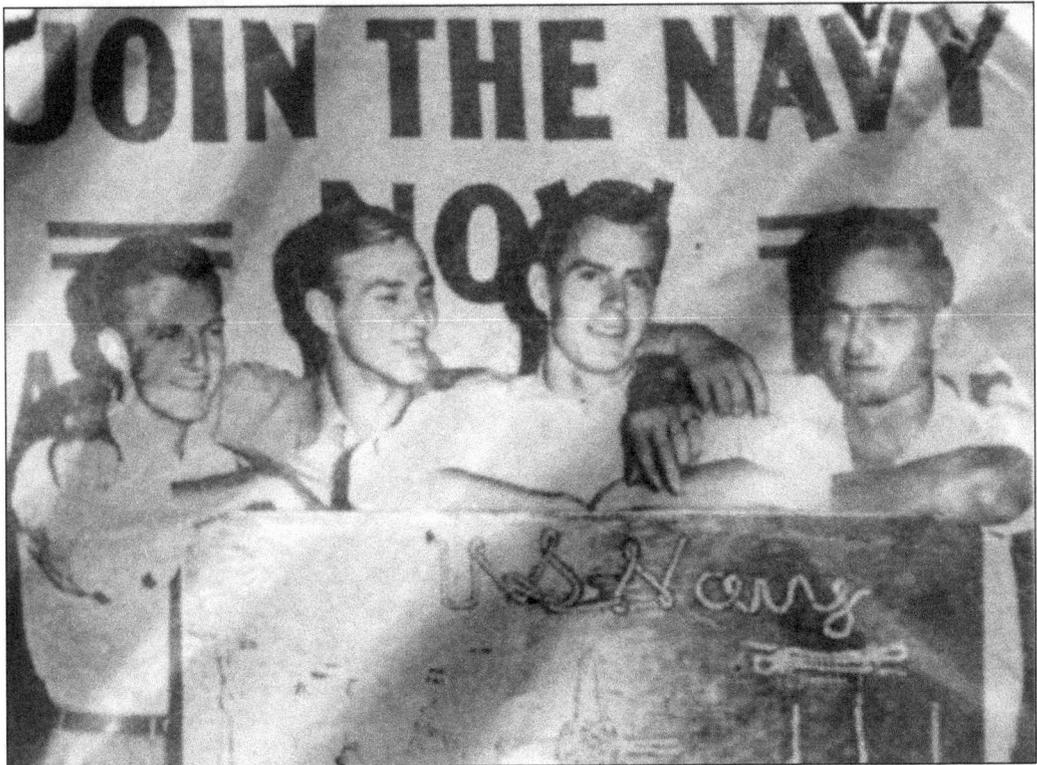

THE CLINIC BOWL CHARITY FOOTBALL GAME. Out of an exciting Litton football game in 1949 was born a Nashville tradition, the Clinic Bowl. Established in 1950, the Clinic Bowl started out of an end-of-season game between Litton and Montgomery Bell Academy (MBA). The Nashville Area Junior Chamber of Commerce had the idea to host the best high school teams each year, with all proceeds going to help adults and kids pay for care at the Vanderbilt Clinic. The bowl's motto is "Strong legs run so weak legs can walk." Shown here are the 1954 Clinic Bowl Program and Patsy Borum with Bill Greenwood (left) and Bill Akers holding tickets for the 1958 Clinic Bowl. Litton would play in the Clinic Bowl seven times over the next two decades. It is ironic that Litton's last Clinic Bowl was against MBA in 1966. (Left, CHF; below, photograph by Bill Preston, courtesy of Patsy McCullough.)

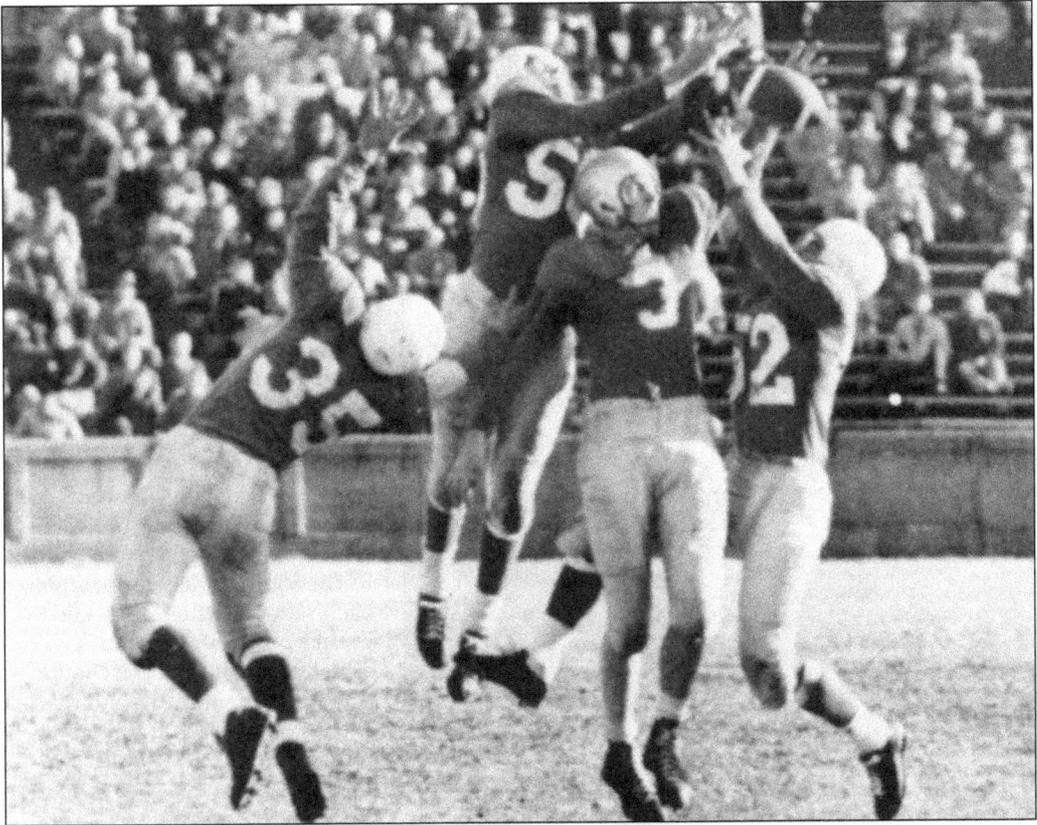

FOOTBALL TRADITIONS AT ISAAC LITTON. Coached by Bob Cummings, members of the 1952 all-star AA championship team Jerry Kemp, Gray Potter, and George Volkert are shown here defending against a pass from the opponent Father Ryan High School. Volkert and Kemp were known as the "Touch-Down Twins." George Volkert was chosen as Nashville's first All-American player that year and eventually led Georgia Tech to four bowl wins as cocaptain. Homecoming was, as always, a big event, and Betty Cherry, the 1952 homecoming queen, is pictured flanked by football cocaptains Rip Nix (left) and Charles Harmon (right). (Above, JH; right, Betty Odom.)

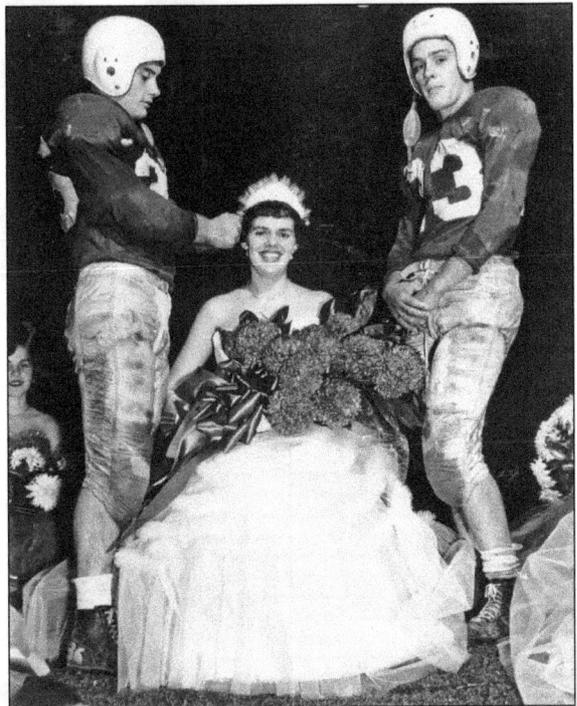

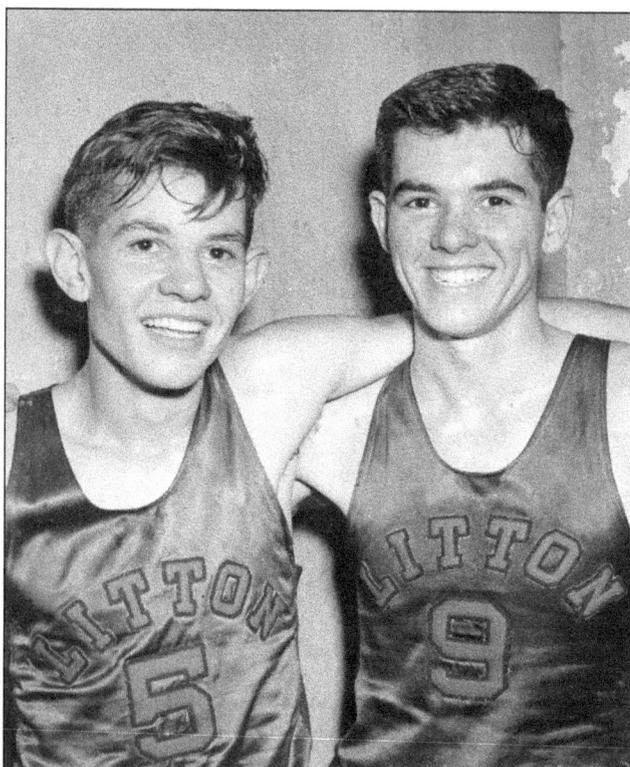

SPORTS AT ISAAC LITTON. Whether it was football, baseball, or basketball, Isaac Litton faculty, students, and supporters were passionate about Isaac Litton's teams. Thousands of people packed into the Hume Marshall football field each Friday night to watch Isaac Litton football and the Marching 100 band. Gallatin Road was backed up for miles after a game. Brothers Henry and Jimmy Garrett played basketball for Litton and are pictured after a grueling game. Women's sports flourished at Litton as well. The big sports rivalry was always with East High School, Litton's closest neighbor to the south. One season, after each school's athletes played pranks on the other school, Chief Cannon took the captain of both football teams and had them shake hands and literally bury a hatchet. (Both GBF.)

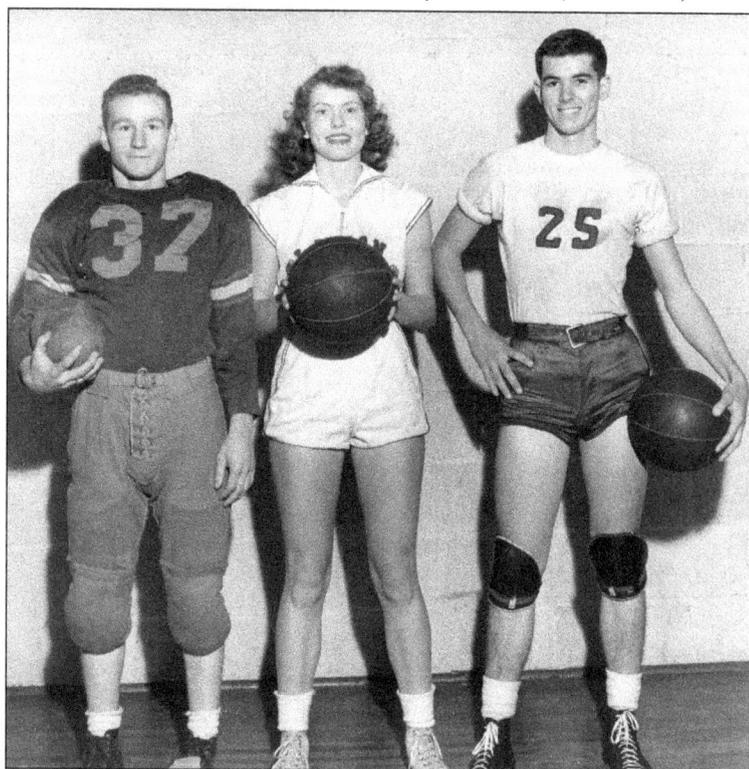

TEENAGE LIFE, 1940S THROUGH 1960S. Teenagers will be teenagers regardless of the year. Here some Isaac Litton girls are smoking cigars in honor of Election Day in 1941. Teen hangouts changed depending on the generation. In the late 1930s and early 1940s, Burrus Filling Station on Gallatin Road, near where Kroger is today, was the place. In the late 1940s, Creamland became the spot. In the mid-1950s, Krystal had opened on Cahal Avenue, and it became the rage. By the 1960s, the Dairy Dip was a popular hangout. At right is a group of teenagers from that era, including Larry Collier (center) and Sue Swor in front of Larry to the left. (Above, EF; right, LC.)

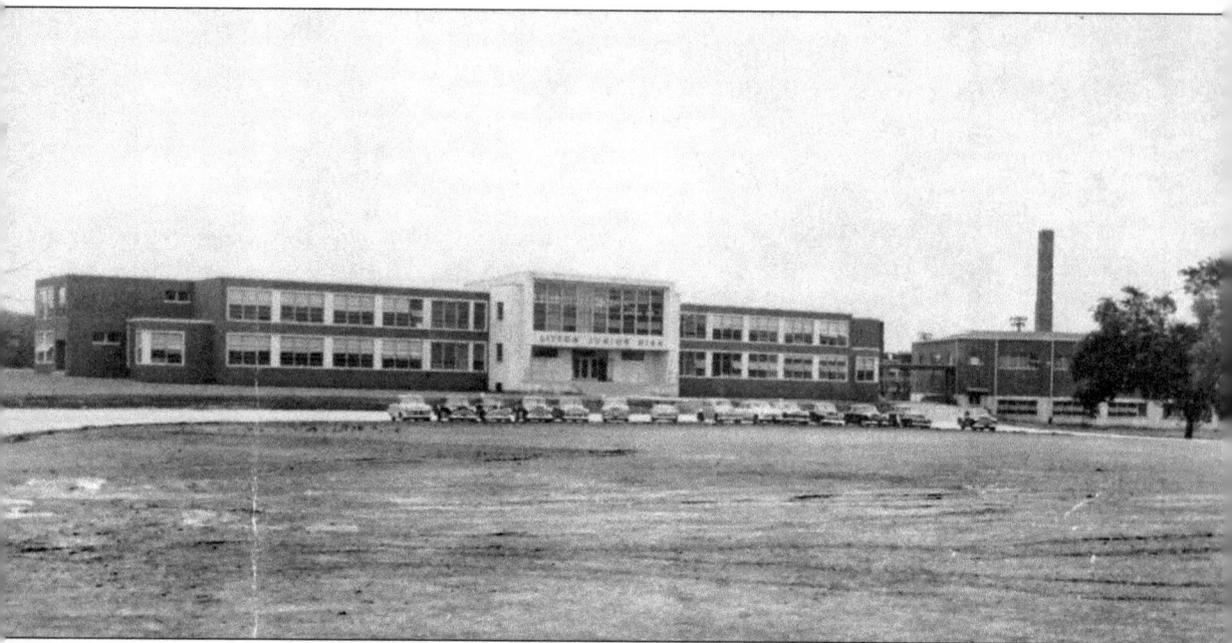

ISAAC LITTON JUNIOR HIGH. In order to support the growing Inglewood community, a new junior high school was built behind the high school in 1954, making Isaac Litton the biggest school in the county. In 1966, the junior high and high schools were administratively separated. When the high school was phased out in 1971, the junior high remained open, and it continues today. Many of the Isaac Litton Junior High teachers today are graduates of Isaac Litton. (CJF.)

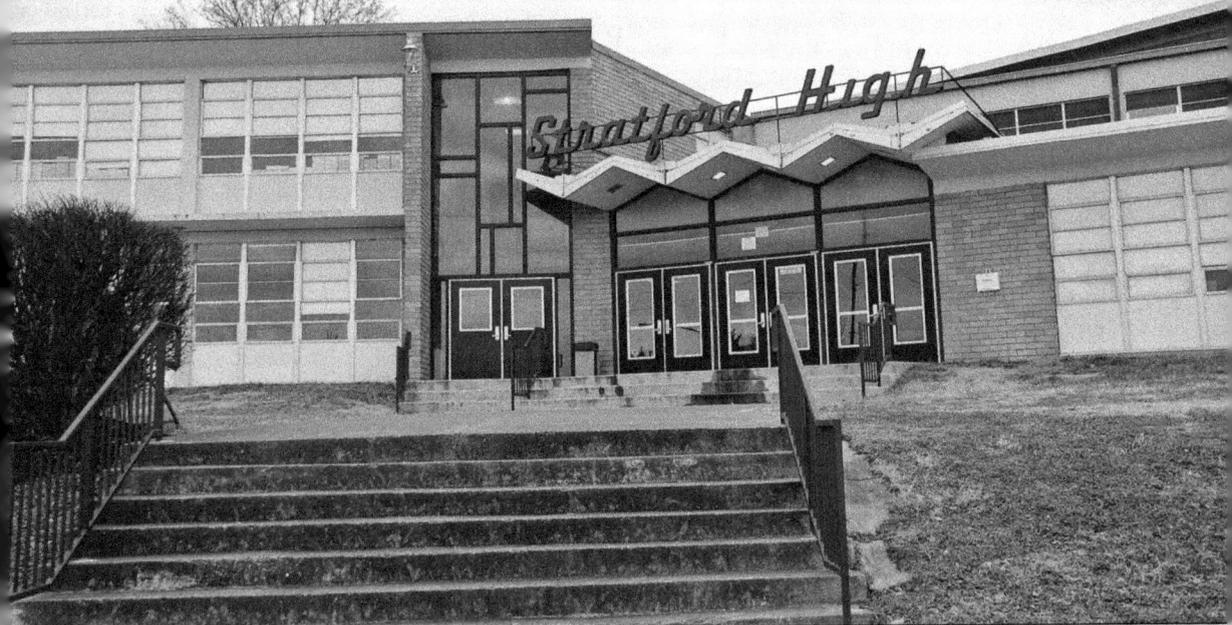

STRATFORD HIGH SCHOOL WAS BUILT IN 1961 ON LANDS ONCE PART OF THE RIVERWOOD FARM. As Inglewood grew after World War II, overcrowding at Isaac Litton became more and more of a problem. To resolve the urgent overcrowding issue at Isaac Litton, the Davidson County Board of Education authorized the building of a new high school. This was the last school built by the old Davidson County School System. The school was originally going to be called Rosebank High but was eventually named Stratford after the street on which it is located. Built on land originally owned by the Burch family and part of the Riverwood farm, it was completed in 1961. The school was originally a junior and high school for grades 7 through 12. Due to overcrowding issues, the school became just a high school with grades 10 through 12 in 1971. The first graduating class was in 1965. Today grades 9 through 12 are taught at Stratford High School.

THE MARCHING ONE

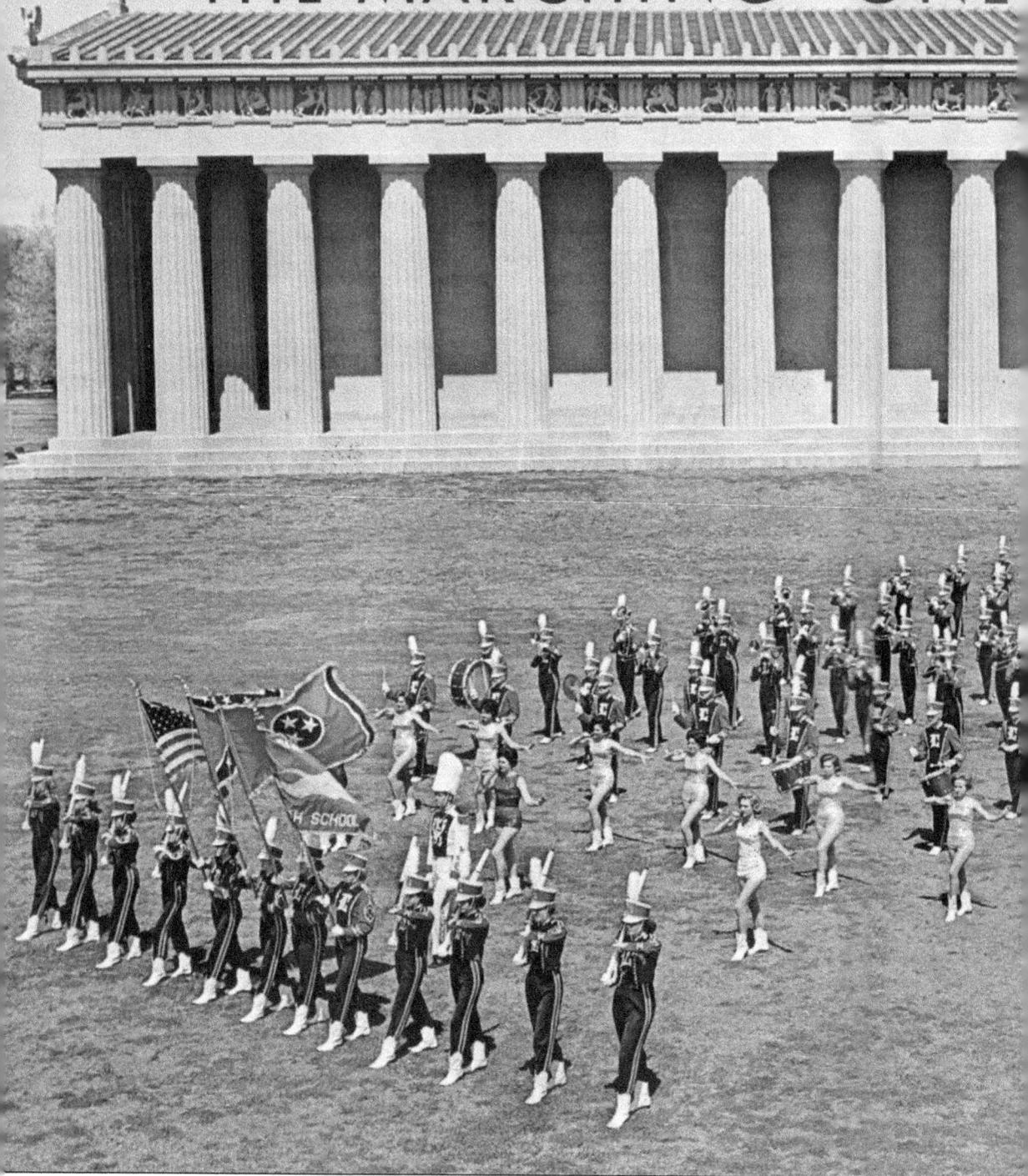

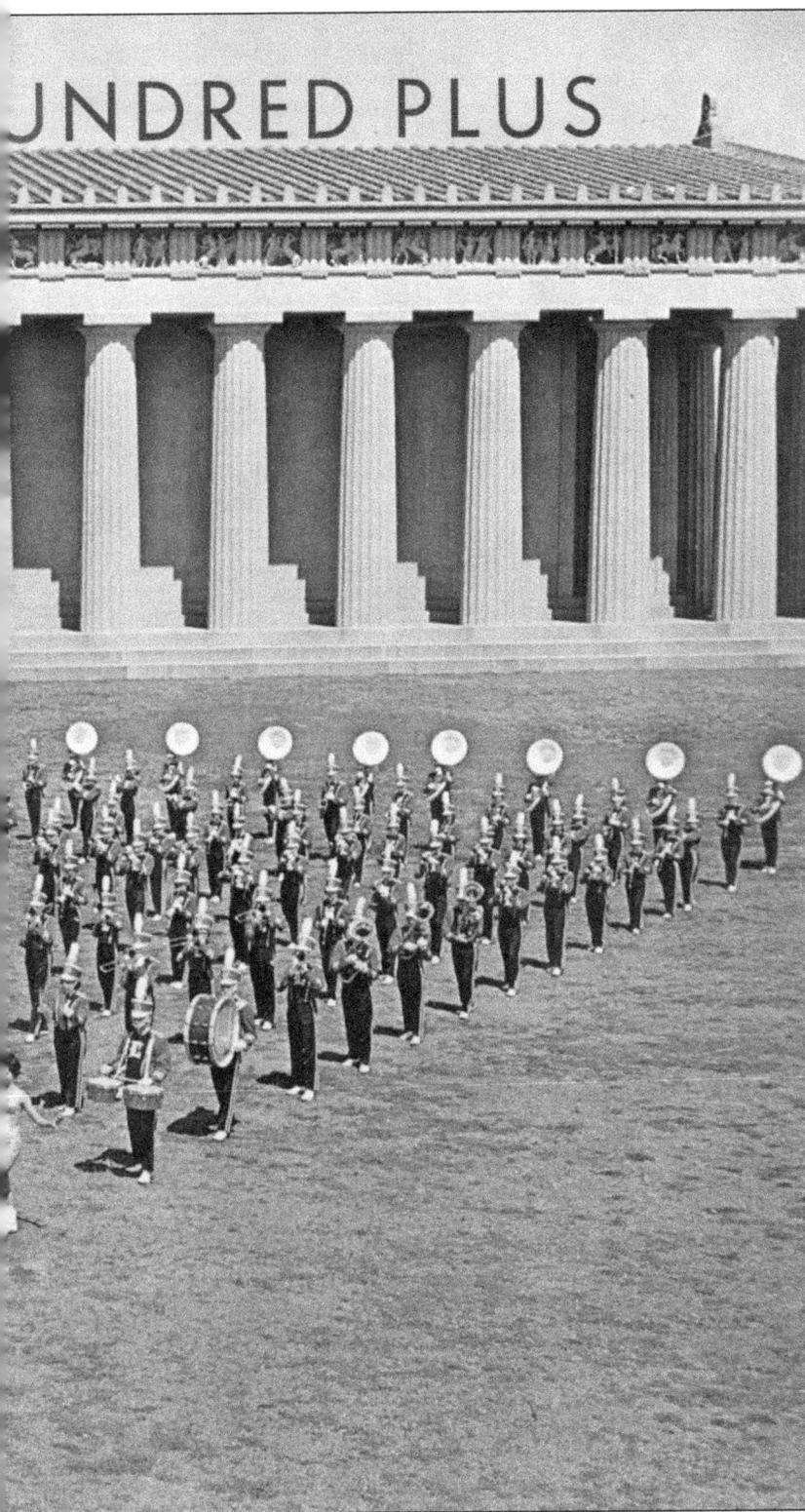

THE MARCHING 100. Isaac Litton's Marching 100 was Middle Tennessee's most respected and renowned band. Beginning life in 1937, Litton's original band consisted of pupils from both the area grammar and high schools. In 1939, the band became only a high school band and was already winning honors at band contests. However, it was under the direction of Sammy Swor that the band became one of the best in the country. Dubbed the Marching 100 by Janice Hamrick in a "Name the Band" contest in 1954, the band won 20 consecutive A ratings at marching festivals and more than 65 trophies. The band was also selected to march at several NFL halftime shows and marched in the Rose Bowl and the famous Macy's Thanksgiving Day parade. (LC.)

Litton Band Director Sammy Swor. Sammy Swor, born and raised in Shreveport, Louisiana, was a world-class trumpet player, beating the great Al Hirt in a statewide competition. He was also first-chair trumpeter with the Nashville Symphony from 1946 until 1962. Sammy valued family life over playing professionally, however, and chose teaching rather than performing with bands on the road. When he took over the 35-member band in the fall of 1948, he turned a group that was largely beginners into a world-class band. His mother emphasized the importance of excellence and stoicism, and he brought these values to everything he did, including his work with the Marching 100. The photograph below shows Swor as a young boy in Louisiana. (Left, photograph by Wiles-Hood Photography, LC; below, LC.)

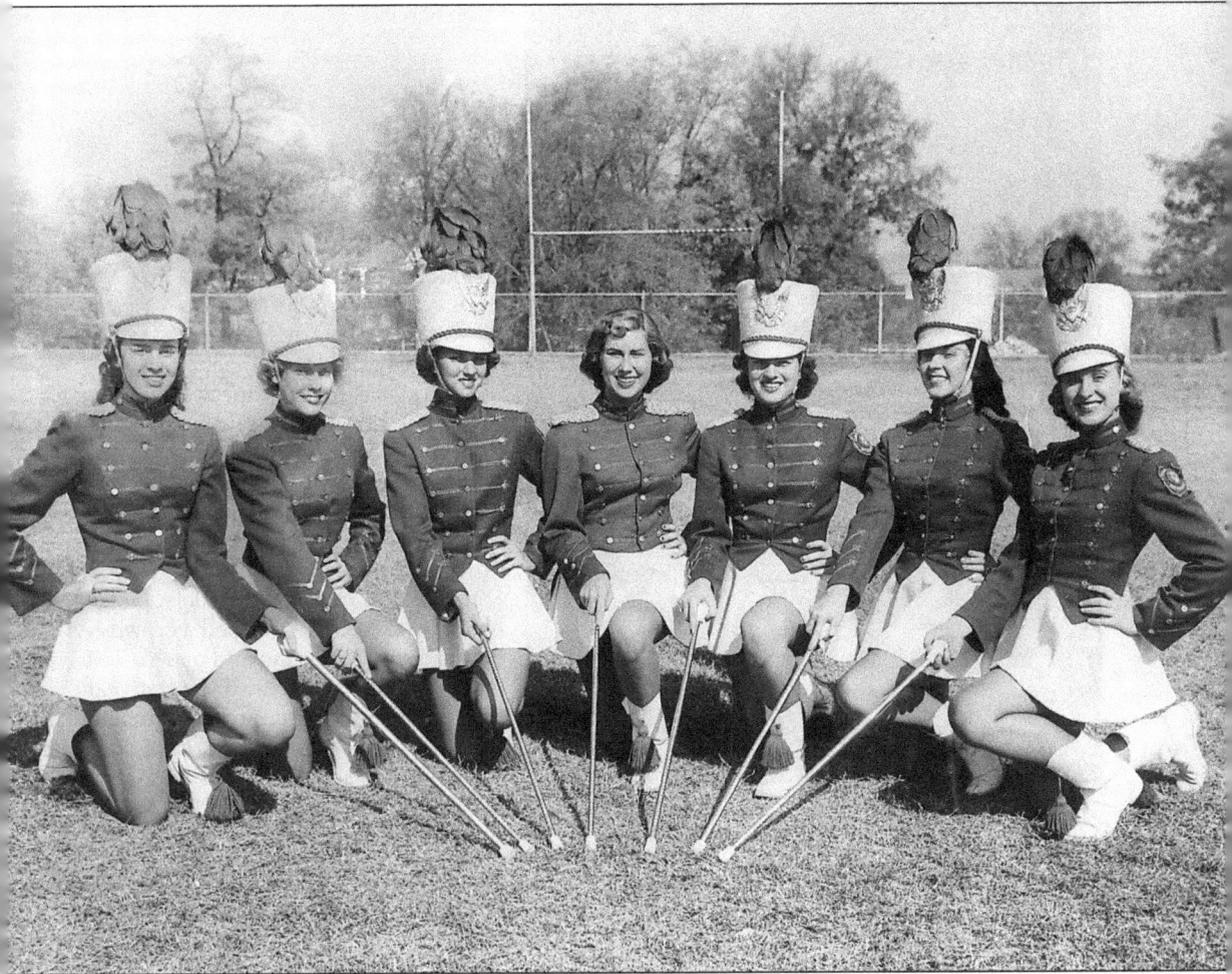

LITTON'S AWARD-WINNING MAJORETTES IN 1954. Most bands today have at least one director's assistant to help with the mammoth task of getting a large band organized and trained. A band director must accomplish a variety of complex tasks: teaching, selecting and arranging the music, and choreographing the marching. Sammy did it all by himself. He even led the band majorettes and color guard. The majorettes went on to win several state and Southeastern competitions and the national championship from the National Twirling Association in 1962. The color guard won the American Legion Junior State Championship in 1963 and 1964, placing sixth in the nation. If a majorette dropped her baton, Sammy would say, "You owe me a cup of hot chocolate." Later he used the demerit system, which was probably a bit more effective. Regardless of his discipline method, according to many band members, Sammy Swor was the type of teacher one never wanted to disappoint, not out of fear but out of respect. (CJF.)

ISAAC LITTON BAND QUEENS AND
KINGS SUE SWOR AND LARRY COLLIER
(1968) AND GRACE HILL AND JACK
WILLIAMS (1954). In 1953, a new
tradition was started at Isaac Litton
when the first band court was held
during the final football game of the
regular season. Each court had its own
band king and queen and attendants
who were voted by band members. The
king and queen rode onto the field in
cars on loan from local dealers. During
the court, the band formed a crown
around the band king and queen. This
tradition continued until the last year
Isaac Litton was open; David Luna and
Connie Gibbs were the last king and
queen in 1971. (Left, LC; below, CJF.)

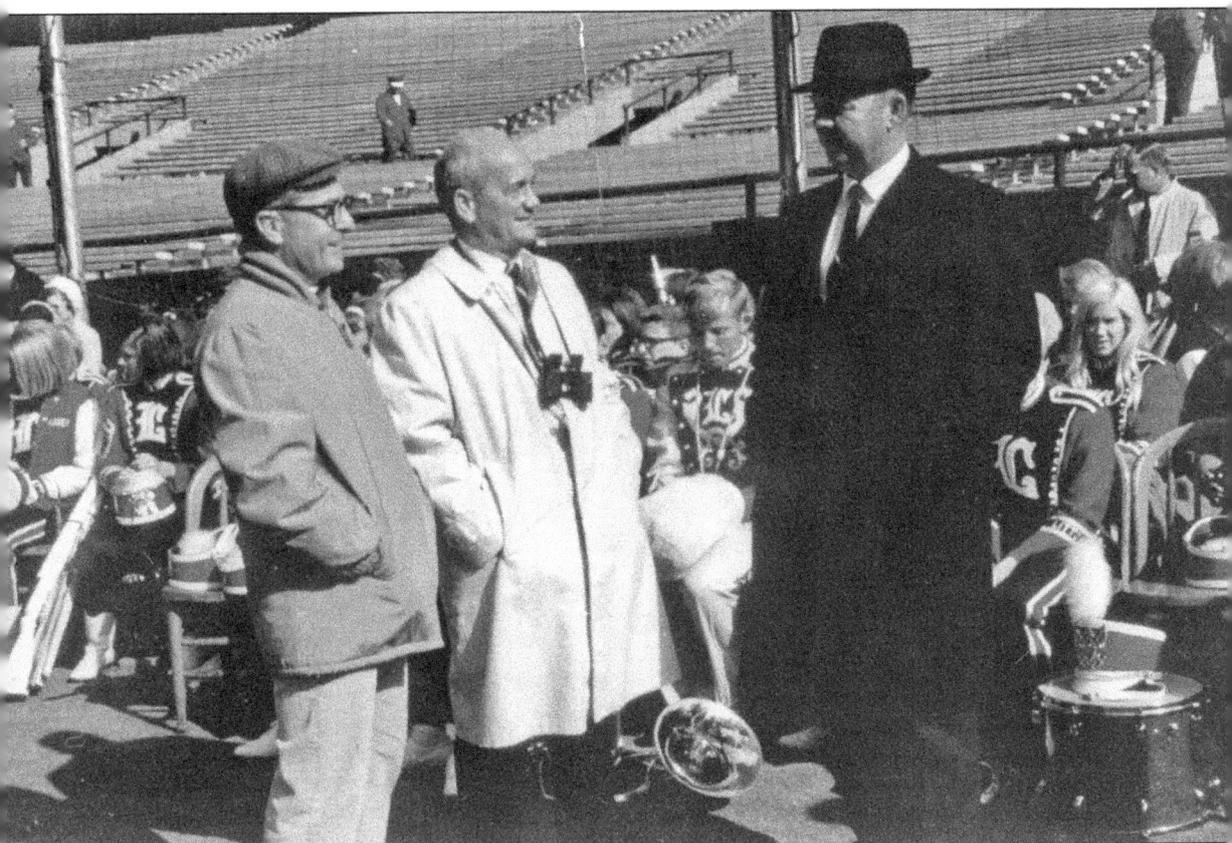

Isaac Litton Band Plays NFL Games. The Litton band played several NFL halftime shows, including this game at Yankee Stadium in 1966, where a band parent stands with team doctor Cleo Miller (left) and Sammy Swor (center). Later that same year, the band played at the highest scoring NFL game in history between the Washington Redskins and New York Giants at D.C. Stadium. According to Larry Collier, a junior band member at the time, as soon as the band began to play at halftime, they could see people heading to the concession stop in their tracks and turn in unison to watch this incredible band. When the band started playing the U.S. Marine hymn the crowd "went nuts." After the game, Larry had to go back into the stadium to pick up his hat. Every 10 to 15 feet, people stopped him to congratulate the band and tell him how good they were. (LC.)

Mr. Don Warren
Club President
Isaac Litton Band Boosters Club
908 Potter Lane
Nashville, Tennessee

Dear Mr. Warren:

On behalf of President Hilles M. Bedell and the Executive
Committee of the Tournament of Roses, we are pleased
to invite the Isaac Litton High School Band to participate
in the 75th Annual Tournament of Roses Parade on New
Year's Day, 1964.

Your band has been chosen to represent your area of the
United States in the belief that your band is a superior
organization, certain to reflect credit upon your home
community and prove popular with millions of parade
viewers.

Within the next few days you will hear from a member
of the Music Committee who will serve as liaison to your
group. He will assist you in every way possible to make
your visit to Pasadena a memorable one.

All expenditures (including transportation, food, and
housing) must be assumed by the participant.

ISAAC LITTON BAND IN CALIFORNIA FOR THE ROSE BOWL. By the 1960s, known as the "Marching 100 Plus" due to its increased size, the Isaac Litton band marched in the 1964 Pasadena Rose Bowl parade. While in California for the Rose Bowl, the band was invited to the Lawrence Welk Show. Welk brought Sammy Swor onstage in order to direct the orchestra. Ann Richards, a young band member who also appeared onstage, would spend her career as a flutist in the Nashville Symphony. When the parade finished and the band was on the plane to come back home, Walter Benedict, one of the directors of the Rose Bowl parade, boarded the plane. He told them that they were the best band to ever play in the parade. (Both LC.)

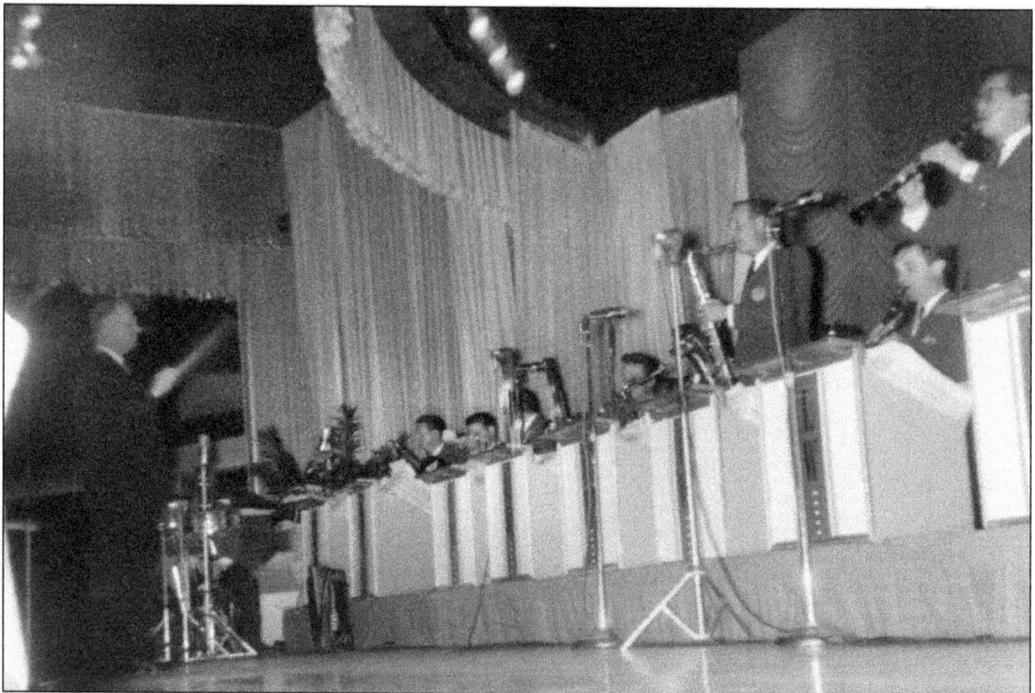

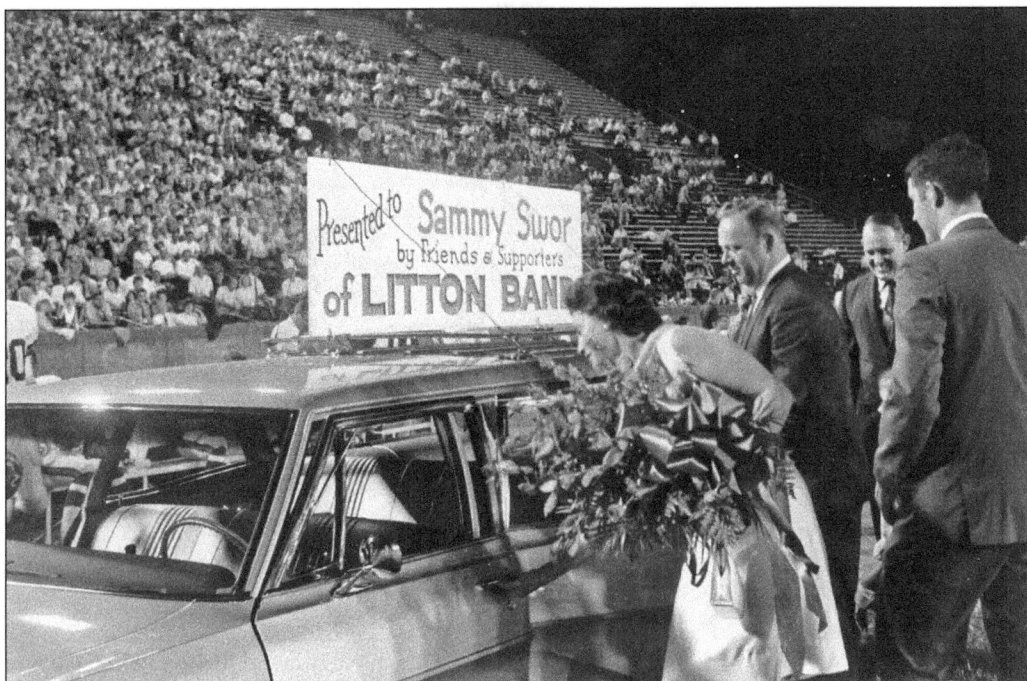

INGLEWOOD COMMUNITY RALLIES BEHIND SAMMY SWOR AND THE MARCHING 100. The trips to the competitions, parades, and NFL games and the sharp new uniforms would not have been possible if it weren't for the band boosters and the Inglewood community, which wholeheartedly supported the band. From the annual spaghetti dinner to the Cool School Stools and fruitcakes they sold, they raised thousands of dollars within the community each year to support band needs. Roy Acuff even persuaded "Colonel" Tom Parker and Elvis Presley to donate $1,000 each for the trip to Pasadena for the Rose Bowl. Sammy Swor's last night as the Marching 100's band director was on August 17, 1968. For more than 20 years, Swor taught the values of excellence to his students. They became teachers, lawyers, musicians, and parents who would never forget the experience. Sammy Swor Sr. passed away in 2001. (LC.)

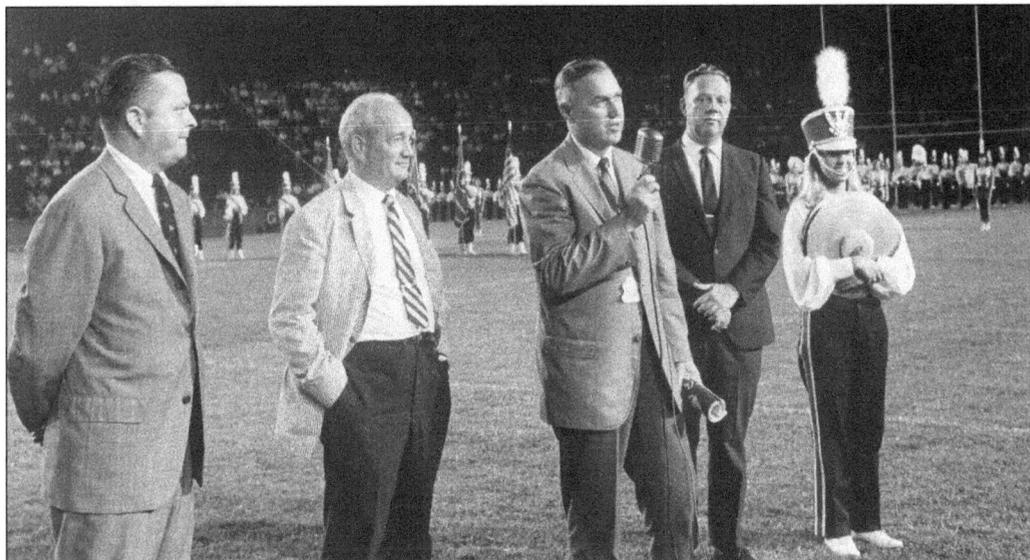

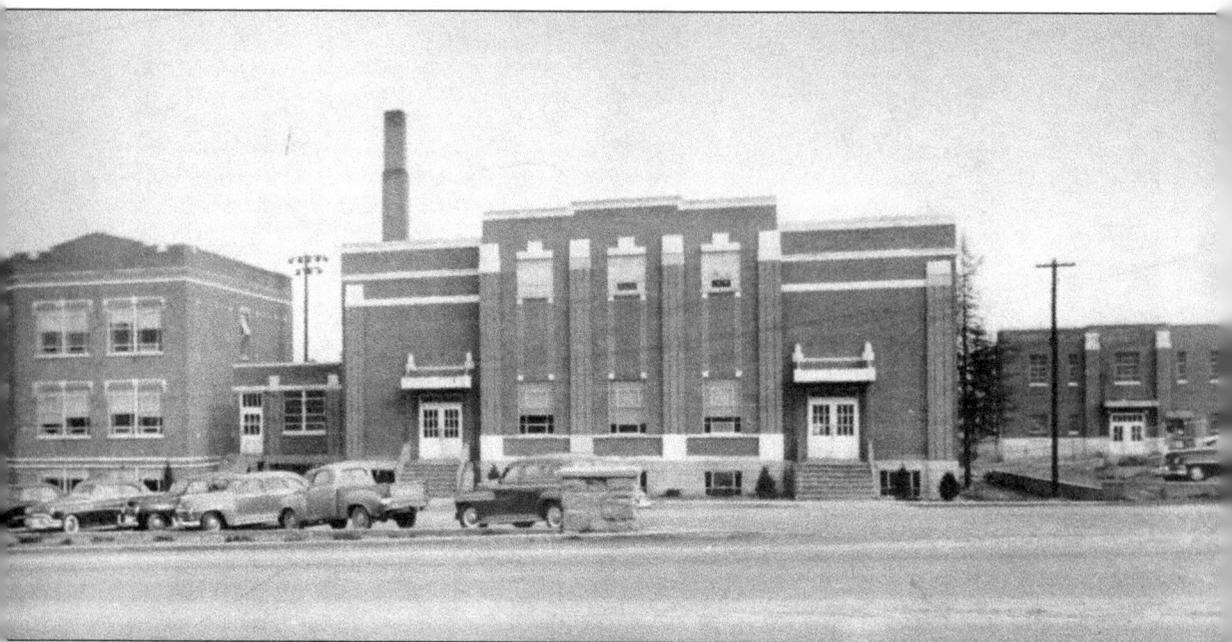

ISAAC LITTON GYM. Without warning, a 40-year tradition came to an end in 1971, when a court order closed Isaac Litton High School. From 1971 through 1984, the building was used as a junior high. Eventually, continued deterioration caused its closure. In 1993, the main building was torn down, but the efforts of a strong alumni association saved the gym and the stadiums for use as a city park. Isaac Litton High School remains a special memory for many of its former students. They have created one of the strongest, most organized alumni associations in the country. Litton Alumni, along with Youth, Inc., and the Inglewood Neighborhood Association, are also behind the project to renovate the Litton gym (shown here) through donations from area residents, community leadership, and businesses. The renovated gym will be a memorial to the school, its faculty, and students. It will serve the Inglewood community as both a meeting place and a place where at-risk youth can seek and receive assistance. (CJF.)

Five

INGLEWOOD TODAY

As often happens, progress damaged Inglewood. Families moved to modern subdivisions, shopping malls became the fashion, and fast food was the new norm. The downward spiral had begun. Property values fell, neighborhood schools changed, and businesses and organizations slipped away. Yet residents still loved the winding, tree-lined streets, still attended the churches where their parents had worshipped, and still enjoyed the convenient location. Inglewood families had firm ties to their history and shared many common ideals. Neighborhood pride was still strong; neighborhood energy was even stronger.

Slowly, the rebirth began. It began with changes in lifestyles and a rise in urban values. It was propelled by the growing environmental movement and the need to conserve and reuse. Shorter commutes were "green" and also convenient. Inglewood houses had Craftsman details, porches, and mature trees not found in suburbia. Exercise was increasingly popular, and people sought sidewalks, bike trails, and other spaces. Shared experiences started knitting the old and new Inglewood folks together. Watching for break-ins grew into watching a neighbor's garden or playing with a neighbor's dog. Neighbors began to work together to create positive changes. Two of the strongest neighborhood organizations today are the Inglewood Neighborhood Alliance and the Concerned Citizens of South Inglewood.

The renewed pride and striving for neighborhood improvements has resulted in changes that were unimaginable a few years ago: elections of strong city council members for Inglewood, improvements to schools, libraries, and parks, the attraction of new businesses, and assistance for existing businesses. Inglewood today is not the Inglewood of yesterday. Isaac Litton High School is no more, parents can't rent a horse for a child's birthday party at the riding academy, and some traditions are distant memories. This is as it should be. Change is inevitable, but the memories being made today will link the past to the present. Inglewood today is vibrant, growing, and moving boldly into the future.

SCHOOL ATTENDANCE CENTER. Karl Dean, elected mayor in 2007, set as his priorities improving schools, making neighborhoods safer, and increasing employment. One of his first initiatives was creating an attendance center in the old police precinct building. Managed by juvenile court, the center provides a safe location for truants while providing services to address the needs of the students.

EAST POLICE PRECINCT. This new precinct building gave officers much-needed space to work. The building also features a community meeting room, which has increased interaction between officers and the community. Officers attend neighborhood meetings, and citizens hold appreciation events to express thanks to the men and women who work each day to keep Inglewood safe.

SOUTH INGLEWOOD COMMUNITY CENTER. Organized recreation began in South Inglewood when a basketball court was built in the Rock City neighborhood. Through the years, a building was formed around the court, and a neighborhood center was born. This new center features a gym, indoor walking track, fitness center, and rooms for classes and meetings with no fees. William Hassell, the longtime center manager, is highly respected in the community.

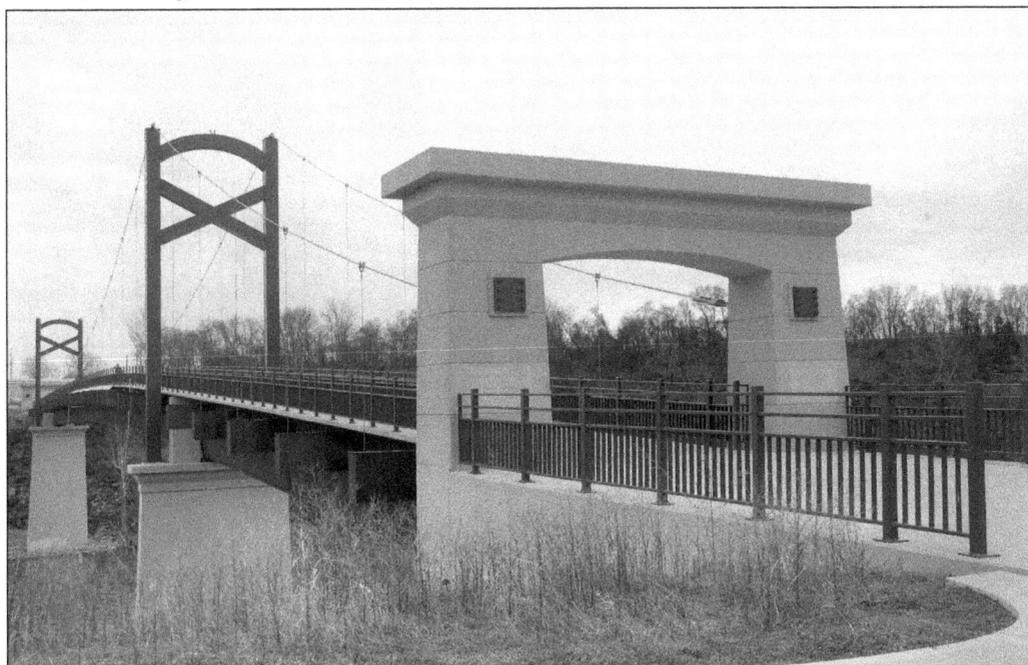

WALKING ACROSS THE CUMBERLAND RIVER. Nashville's Greenway System has grown to nearly 40 miles of linear parks linking the city's neighborhoods to nature and to each other. The 700-foot Cumberland River Pedestrian Bridge opened in 2008 and connects Inglewood and East Nashville to Donelson. In Inglewood, people can access Shelby Bottoms Greenway at multiple trailheads.

RIVERSIDE VILLAGE. The transformation of the buildings on McGavock and Riverside brought excitement to the corner unseen since Charles Jones built his new pharmacy at the location in 1965. Entrepreneur Dan Heller lives nearby and has worked to create affordable spaces for businesses. This entrance leads into the courtyard and community garden, which serve as seating for the restaurants and gathering space for the neighborhood.

SAFE PLAYGROUND AT ROSEBANK ELEMENTARY. Metro Parks has replaced out-dated playgrounds at every elementary school. The new play areas are designed to be accessible for all children and to provide a surface that is both appealing and safe. The school playgrounds contribute to the city's initiative to provide recreational space within one-half mile of each residence.

BIBLIOGRAPHY

Bockmon, Guy Alan. *Madison Station*. Franklin, TN: Hillsboro Press, 1997.

Clements, Paul. *A Past Remembered: A Collection of Antebellum Houses*. Photographs by Ron Harr. Nashville, TN: Clearview Press, 1987.

Davis, Louise. "Rosebank Home Nominated to National Register." *The Tennessean*, January 16, 1989: 5F.

Flake, Tom. "Spaghetti, Demerits and Tape: Isaac Litton Band." *Nashville Magazine*, October 1963: 21–26.

"Fortland Acquired by Sanders Firm Executive." *The Nashville Banner*, May 9, 1952.

McGuaghey, Mrs. A. J. (Marina). "Further Historical Facts on Old Haysboro Related." *The Nashville Banner*, December 1, 1927.

Paine, Grace Benedict. "Lady in Gray: Martha Watson Porter Still Roaming at Riverwood." *The Historic Register* Vol. 5 (Spring 1984): 4, 5.

Rudy, Jeanette C. *A Bend in the Cumberland*. Nashville, TN: Favorite Recipes Press, 1991.

Speer, William S. *Sketches of Prominent Tennesseans*. Baltimore, MD: Genealogical Publishing Company, 2003.

Waller, William. *Nashville in the 1890s*. Nashville, TN: Vanderbilt University Press, 1970.

Walker, Hugh. "Silent Riverwood Stands in a Deepening Twilight." *The Tennessean*, July 3, 1975.

Zepp, George. "County Farm Was Once Innovative in Care." *The Tennessean*, May 12, 2007.

———. "Key to Isaac Litton High School's Fame Was Its People." *The Tennessean*, October 4, 2006.

Visit us at
arcadiapublishing.com